ANDREW VOLCKENS

MATERIALS,
STRUCTURES,
AND STANDARDS

First published in the United States of America by
Rockport Publishers, a member of
Quayside Publishing Group
100 Cummings Center
Suite 406-L
Beverly, Massachusetts 01915-6101
Telephone: (978) 282-9590
Fax: (978) 283-2742
www.rockpub.com

Library of Congress Cataloging-in-Publication Data

McMorrough, Julia.
 Materials, structures, and standards : all the details architects need to know but can
 never find / Julia McMorrough.
 p. cm.
 ISBN 1-59253-193-8 (vinyl)
 1. Architecture—Handbooks, manuals, etc. 2. Building—Handbooks, manuals, etc. I.
 Title.
 NA2540.M43 2006
 720—dc22 2005019669
 CIP

ISBN-13: 978-1-59253-193-6
ISBN-10: 1-59253-193-8

10 9 8 7

DISCLAIMER
The content of this book is for general information purposes only and has been obtained from many sources, professional organizations, manufacturers' literature, and codes. All illustrations in this book (except photographs) are those of the author. The author and publisher have made every reasonable effort to ensure that this work is accurate and current, but do not warrant, and assume no liability for, the accuracy or completeness of the text or illustrations, or their fitness for any particular purpose. It is the responsibility of the users of this book to apply their professional knowledge to the content, to consult sources referenced, as appropriate, and to consult a professional architect for expert advice if necessary.

Editor and Art Director: Alicia Kennedy
Design and Illustrations: Julia McMorrough

Production Design: Leslie Haimes
Cover Design: King Design

Printed in China

MATERIALS, STRUCTURES, AND STANDARDS

ALL THE DETAILS

ARCHITECTS NEED TO KNOW

BUT CAN NEVER FIND

BEVERLY MASSACHUSETTS

ROCKPORT PUBLISHERS

JULIA MCMORROUGH

Contents

i.

INTRODUCTION

ARCHITECTURAL DESIGN is a complex activity that involves multiple levels of knowledge, communication, and production, even on a small project. Architects often speak their own language, both in terminology and through conventions of drawings, models, and diagrams. Moreover, to make a piece of architecture requires following countless rules of which an able practitioner must remain ever knowledgeable: building codes, human dimensions, drawing standards, material properties, and relevant technologies. Familiarity with so many issues comes with schooling and long years of experience, but even the most seasoned architect must avail him- or herself of a vast and exhaustive array of resources, from code books to graphic standards, from materials libraries to manufacturers' catalogs.

Materials, Structures, and Standards is a unique compilation of essential information for architects, students of architecture, and anyone contemplating an architectural project. Included here are the tables, charts, diagrams, dimensions, standards, codes, and general data that many architects need on a daily basis. This book is not a replacement for other sources that architects might consult regularly, but rather a handy "first-stop" reference that is always at the ready, on a desk or in a bag.

Parts 1 through 4, "Measure and Drawing," "Proportion and Form," "Codes and Guidelines," and "Systems and Components," address the major aspects of undertaking an architectural project. Topics include basic measurements and geometry, architectural drawing types and conventions, digital technologies, the human scale, parking, building codes, accessibility, structural and mechanical systems, and building components. Part 5, "Characteristics of Materials," provides a detailed catalog of the most common building materials—wood, masonry, concrete, metals—as well as various interior finishes. Part 6, "Compendium," brings together a glossary, an illustrated inventory of architectural elements, and a timeline of key moments in the history of architecture. Finally, because such a compact book cannot possibly contain everything, a directory of resources offers an extensive guide to the most helpful publications, organizations, and websites.

For every project, architects must take into account an endless number of external forces, not least of which are the codes and standards of design and construction. But these codes and standards should certainly not be viewed as limiting: Knowledge of them and their creative use can, in fact, liberate and empower.

MEASURE AND DRAWING 1.

For an architect's ideas to evolve into fully considered designs, they require constant evaluation, investigation, and experimentation. Scribbled notes and sketches are quickly put to the test as real scales and measures are applied; flat plans grow into volumes, and spaces are examined inside and out. To become built form, ideas must be communicated to the various groups involved in the design process, and so the architect embarks on a cycle of production and presentation.

For presentation to the client whose building this will become, communication can take the form of sketches, cardboard models, computer models, and digital animations—whatever is needed to ensure that the design is understood. In preparing such materials, the architect often discovers new aspects of the design that prompt further study and presentation.

For construction, the architect prepares documents to certain standards. Technical measured drawings describe everything necessary to erect the building. Depending on the size of the project, many other parties will also be involved, from structural and mechanical engineers to electrical engineers and lighting designers. Each of these trades also produces construction documents specific to their work and coordinated with the entire set. In every case, these drawings and written specifications must be clear and precise to ensure a well-built structure.

Chapter 1: Measurements

The two primary measurement systems used in the world today are the metric system, also known as the Système International d'Unités and commonly abbreviated to SI in all languages, and the U.S. customary units system, referred to in the United States as English units or standard units. The latter is an irregular system based on imperial units once used in the United Kingdom and the British Commonwealth.

The metric system has become the universally accepted system of units in science, trade, and commerce. In the United States, however, where the Metric Conversion Act of 1975 established SI as the preferred system of weights and measures for trade and commerce, federal laws have yet to mandate SI as the official system, making its use still primarily voluntary. Several U.S. agencies, including the American National Metric Council (ANMC) and the United States Metric Association (USMA), are working to establish SI as the official measurement system, a process known as metrication. Though the architectural, engineering, and building trades have been slow to make a full transition, nearly all federally funded building projects are now required to be in SI units.

UNITS OF MEASURE: CUSTOMARY UNIT DATA

Customary units may be shown in a number of ways, including as fractions ($1 1/2''$) or as decimals ($1.5''$ or $0.125'$), depending on the more common usage for a particular situation. It should be noted that, though not the case here, exponents can be used with abbreviations that designate area or volume; for example, 100 ft.2 for area or 100 ft.3 for volume.

Linear Equivalents

Customary Unit of Measure	Relation to Other Customary Units
inch (in. or ")	$1/12$ ft.
foot (ft. or ')	12 in. $1/3$ yd.
yard (yd.)	36 in. 3 ft.
rod (rd.), pole, or perch	$16 1/2$ ft. $5 1/2$ yd.
chain	4 rd. 22 yd.
furlong	220 yd. or 40 rd. or 10 chains or $1/8$ mi.
mile (mi.), statute	5,280 ft. or 1,760 yd. or 8 furlongs
mile (mi.), nautical	2,025 yd.

Area Equivalents

Customary Unit of Measure	Relation to Other Customary Units
square inch (sq. in.)	0.007 ($1/142$) sq. ft.
square foot (sq. ft.)	144 sq. in.
square yard (sq. yd.)	1,296 sq. in. 9 sq. ft.
square pole	$30 1/4$ sq. yd.
acre	43,560 sq. ft. 40 rd. (1 furlong) x 4 rd. (1 chain)
square mile (sq. mi.)	640 acres

Volume Equivalents

Customary Unit of Measure	Relation to Other Customary Units
cubic inch (cu. in.)	0.00058 cu. ft.
cubic foot (cu. ft.)	1,728 cu. in. 0.037 cu. yd.
cubic yard (cu. yd.)	46,656 cu. in. 27 cu. ft.
acre foot (acre ft.)	1,613.343 cu. yd.
cubic mile (cu. mi.)	3,379,180 acre ft.

Liquid Volume Equivalents

Customary Unit of Measure	Relation to Other Customary Units
1 ounce (oz.)	0.0313 ($1/32$) qt. 0.0625 ($1/16$) pt. 0.0078 gal.
1 pint (pt.)	16 oz. 0.5 ($1/2$) qt. 0.125 ($1/8$) gal.
1 quart (qt.)	32 oz. 2 pt. 0.25 ($1/4$) gal.
1 gallon (gal.)	128 oz. 8 pt. 4 qt.

Weight and Mass Equivalents

Customary Unit of Measure	Relation to Other Customary Units
1 dram (dr.)	0.0625 ($1/16$) oz.
1 ounce (oz.)	16 dr. 0.0625 ($1/16$) lb.
1 pound (lb.)	256 dr. 16 oz. 0.0005 short ton 0.00045 long ton
1 short ton (customary)	512,000 dr. 32,000 oz. 2,000 lb.

Fraction to Decimal Equivalents

Fraction	Decimal
$1/32$	0.03125
$1/16$	0.0625
$3/32$	0.0938
$1/8$	0.1250
$5/32$	0.1563
$3/16$	0.1875
$7/32$	0.2188
$1/4$	0.2500
$9/32$	0.2813
$5/16$	0.3125
$11/32$	0.3438
$3/8$	0.3750
$13/32$	0.4063
$7/16$	0.4375
$15/32$	0.4688
$1/2$	0.5000
$17/32$	0.5313
$9/16$	0.5625
$19/32$	0.5938
$5/8$	0.6250
$21/32$	0.6563
$11/16$	0.6875
$23/32$	0.7188
$3/4$	0.7500
$25/32$	0.7813
$13/16$	0.8125
$27/32$	0.8438
$7/8$	0.8750
$29/32$	0.9063
$15/16$	0.9375
$31/32$	0.9688
$1/1$	1.0000

UNITS OF MEASURE: SI METRIC UNIT DATA

The General Conference on Weights and Measures (abbreviated to CGPM from the French *Conférence Générale des Poids et Mesures*), which meets every four years concerning issues related to the use of the metric system, has established specific rules for use, type style, and punctuation of metric units. The National Institute of Standards and Technology (NIST)—formerly the National Bureau of Standards (NBS)—determines metric usage in the United States. Millimeters are the preferred unit for dimensioning buildings, with no symbol necessary if they are used consistently. Meters and kilometers are reserved for larger dimensions such as land surveying and transportation.

Unit names and symbols employ standard, lowercase type, except for symbols derived from proper names (for example, N for newton). Another exception is L for liter, to avoid confusing the lowercase l with the numeral 1. Prefixes describing multiples and submultiples are also lowercase, except for M, G, and T (mega-, giga-, and tera-), which are capitalized in symbol form to avoid confusion with unit symbols, but which maintain the lowercase standard when spelled out. No space is left between the prefix and the letter for the unit name (mm for millimeter and mL for milliliter). A space is left between the numeral and the unit name or symbol; for example, 300 mm.

Linear Metric Equivalents

Millimeters (mm)	Centimeters (cm)	Decimeters (dm)	Meters (m)	Decameters (dam)	Hectometers (hm)	Kilometers (km)
1	0.1	0.01	0.001	0.000 1	0.000 01	0.000 001
10	1	0.1	0.01	0.001	0.000 1	0.000 01
100	10	1	0.1	0.01	0.001	0.000 1
1 000	100	10	1	0.1	0.01	0.001
10 000	1 000	100	10	1	0.1	0.01
100 000	10 000	1 000	100	10	1	0.1
1 000 000	100 000	10 000	1 000	100	10	1

Area Metric Equivalents

Square Millimeters (mm²)	Square Centimeters (cm²)	Square Decimeters (dm²)	Square Meters (m²)	Ares	Hectares (ha)	Square Kilometers (km²)
1	0.0 1	0.001	0.000 001			
100	1	0.01	0.000 1	0.000 001		
10 000	100	1	0.01	0.000 1	0.000 001	
1 000 000	10 000	100	1	0.01	0.000 1	0.000 001
	1 000 000	10 000	100	1	0.01	0.000 1
		1 000 000	10 000	100	1	0.01
			1 000 000	10 000	100	1

Although the United States and Canada mark the decimal with a point, other countries use a comma (for example: 5,00 vs. 5.00). For this reason, commas should not be used to separate groups of digits. Instead, the digits should be separated into groups of three, both to the left and the right of the decimal point, with a space between each group of three digits (for example, 1,000,000 is written as 1 000 000). This convention for metric units is used throughout the book.

Units with Compound Names

Physical Quantity	Unit	Symbol
Area	square meter	m^2
Volume	cubic meter	m^3
Density	kilogram per cubic meter	kg/m^3
Velocity	meter per second	m/s
Angular velocity	radian per second	rad/s
Acceleration	meter per second squared	m/s^2
Angular acceleration	radian per second squared	rad/s^2
Volume rate of flow	cubic meter per second	m^3/s
Moment of inertia	kilogram meter squared	$kg\ m^2$
Moment of force	newton meter	N m
Intensity of heat flow	watt per square meter	W/m^2
Thermal conductivity	watt per meter kelvin	W/m K
Luminance	candela per square meter	cd/m^2

Area in Metrics

SI metric units for area, like volume, are derived from the base units for length. They are expressed as powers of the base unit: for example, square meter $= m^2 = 10^6\ mm^2$.

The square centimeter is not a recommended unit for construction and should be converted to square millimeters.

The hectare is acceptable only in the measurement of land and water.

When area is expressed by linear dimensions, such as 50 x 100 mm, the width is written first and the depth or height second.

SOFT AND HARD CONVERSIONS

Conversions of customary and SI units can be either "soft" or "hard." In a soft conversion, 12 inches equals 305 millimeters (already rounded up from 304.8). In a hard conversion of this same number, 12 inches would equal 300 millimeters, which makes for a cleaner and more rational equivalency. This is the ultimate goal of total metrication within the building trades. The process, however, is an extensive one, which will require many building products whose planning grid is in customary units to undergo a hard metric conversion of their own, making 6 inches equal 150 millimeters (instead of 152) and 24 inches equal 600 millimeters (instead of 610). Thus, to conform to a rational metric grid, the actual sizes of standard products such as drywall, bricks, and ceiling tiles will need to change.

Every attempt has been made in this book to represent accurately the relationship between customary and SI units. Except where noted, soft conversions are used throughout and, due to constraints of space, are usually written as follows: 1'-6" (457).

METRIC CONVERSION

Inches and Millimeters Scale (1:1)

Feet and Meters Scale

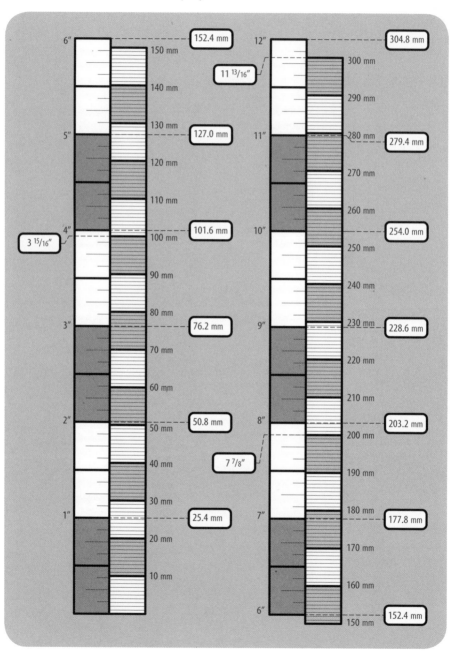

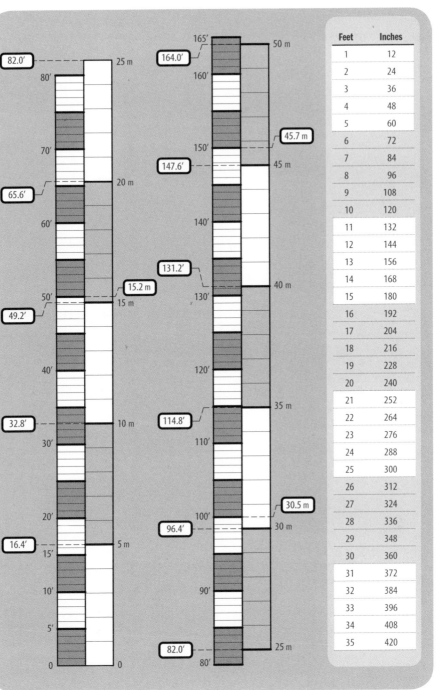

Feet	Inches
1	12
2	24
3	36
4	48
5	60
6	72
7	84
8	96
9	108
10	120
11	132
12	144
13	156
14	168
15	180
16	192
17	204
18	216
19	228
20	240
21	252
22	264
23	276
24	288
25	300
26	312
27	324
28	336
29	348
30	360
31	372
32	384
33	396
34	408
35	420

Conversion Factors for Length

Customary	Metric
1 in.	25.4 mm
1 ft.	0.304 8 m *or* 304.8 mm
1 yd.	0.914 4 m
1 chain	20.116 8 m
1 mi.	1.609 344 km

Conversion Factors for Area

Customary	Metric
1 sq. in.	645.16 mm^2
1 sq. ft.	0.092 903 m^2
1 sq. yd.	0.836 127 m^2
1 acre	0.404 686 ha *or* 4 046.86 m^2
1 sq. mi.	2.590 00 km^2

Conversion Factors for Volume

Customary	Metric
1 cu. in.	16 387.1 mm^3 *or* 16.387 1 cm^3
1 cu. ft.	28 316 846.712 mm^3 *or* 28 316.847 cm^3
100 board ft.	0.235 974 m^3
1 cu. yd.	0.764 555 m^3
1 acre ft.	1 233.49 m^3

Conversion Factors for Mass

Customary	Metric
1 pennyweight (dwt.)	1.555 17 g
1 oz.	28.349 523 g
1 lb.	0.453 592 kg
1 short ton	0.907 185 metric ton (t) *or* 0.907 185 megagram (Mg) *or* 907.185 kg

Conversion Factors for Liquid Capacity

Customary	Metric
1 fl. oz. (U.S.)	29.573 5 mL
1 pt. (U.S.)	473.177 mL
1 qt. (U.S.)	946.353 mL
1 gal. (U.S.)	3.785 41 L

Conversion Factors for Length

Metric	Customary
1 micrometer (μm)	0.0000394 in. *or* 0.03937 mils
1 mm	0.0393701 in.
1 m	3.28084 ft. *or* 1.09361 yd.
1 km	0.621371 mi. *or* 49.7096 chains

Conversion Factors for Area

Metric	Customary
1 mm²	0.001550 sq. in.
1 m²	10.7639 sq. ft. *or* 1.19599 sq. yd.
1 ha	2.47105 acres
1 km²	0.368102 sq. mi.

Conversion Factors for Volume

Metric	Customary
1 mm³	61.0237×10^{-6} cu. in.
1 m³	0.810709×10^{3} acre ft. 1.30795 cu. yd. *or* 35.3147 cu. ft. *or* 423.776 board ft.

Conversion Factors for Mass

Metric	Customary
1 g	0.035274 oz. *or* 0.643015 dwt.
1 kg	2.20462 lb. *or* 35.274 oz.
1 metric ton	1.10231 short ton *or* 2,204.62 lb.

Conversion Factors for Liquid Capacity

Metric	Customary
1 mL	0.0610237 cu. in.
1 L	0.0353147 cu. ft. 0.264172 gal. *or* 1.05669 qt.

Inches to Millimeters

	0″	1″	2″	3″	4″	5″
0	–	25.40 mm	50.80 mm	76.20 mm	101.60 mm	127.00 mm
1/16″	1.59 mm	26.99 mm	52.39 mm	77.79 mm	103.19 mm	128.59 mm
1/8″	3.18 mm	28.58 mm	53.98 mm	79.38 mm	104.78 mm	130.18 mm
3/16″	4.76 mm	30.16 mm	55.56 mm	80.96 mm	106.36 mm	131.76 mm
1/4″	6.35 mm	31.75 mm	57.15 mm	82.55 mm	107.95 mm	133.35 mm
5/16″	7.94 mm	33.34 mm	58.74 mm	84.14 mm	109.54 mm	134.94 mm
3/8″	9.53 mm	34.93 mm	60.33 mm	85.73 mm	111.13 mm	136.53 mm
7/16″	11.11 mm	36.51 mm	61.91 mm	87.31 mm	112.71 mm	138.11 mm
1/2″	12.70 mm	38.10 mm	63.50 mm	88.90 mm	114.30 mm	139.70 mm
9/16″	14.29 mm	39.69 mm	65.09 mm	90.49 mm	115.89 mm	141.29 mm
5/8″	15.88 mm	41.28 mm	66.68 mm	92.08 mm	117.48 mm	142.88 mm
11/16″	17.46 mm	42.86 mm	68.26 mm	93.66 mm	119.06 mm	144.46 mm
3/4″	19.05 mm	44.45 mm	69.85 mm	95.25 mm	120.65 mm	146.05 mm
13/16″	20.64 mm	46.04 mm	71.44 mm	96.84 mm	122.24 mm	147.64 mm
7/8″	22.23 mm	47.63 mm	73.03 mm	98.43 mm	123.83 mm	149.23 mm
15/16″	23.81 mm	49.21 mm	74.61 mm	100.01 mm	125.41 mm	150.81 mm

	6″	7″	8″	9″	10″	11″
0	152.40 mm	177.80 mm	203.20 mm	228.60 mm	254.00 mm	279.40 mm
1/16″	153.99 mm	179.39 mm	204.79 mm	230.19 mm	255.59 mm	280.99 mm
1/8″	155.58 mm	180.98 mm	206.38 mm	231.78 mm	257.18 mm	282.58 mm
3/16″	157.16 mm	182.56 mm	207.96 mm	233.36 mm	258.76 mm	284.16 mm
1/4″	158.75 mm	184.15 mm	209.55 mm	234.95 mm	260.35 mm	285.75 mm
5/16″	160.34 mm	185.74 mm	211.14 mm	236.54 mm	261.94 mm	287.34 mm
3/8″	161.93 mm	187.33 mm	212.73 mm	238.13 mm	263.53 mm	288.93 mm
7/16″	163.51 mm	188.91 mm	214.31 mm	239.71 mm	265.11 mm	290.51 mm
1/2″	165.10 mm	190.50 mm	215.90 mm	241.30 mm	266.70 mm	292.10 mm
9/16″	166.69 mm	192.09 mm	217.49 mm	242.89 mm	268.29 mm	293.69 mm
5/8″	168.28 mm	193.68 mm	219.08 mm	244.48 mm	269.88 mm	295.28 mm
11/16″	169.86 mm	195.26 mm	220.66 mm	246.06 mm	271.46 mm	296.86 mm
3/4″	171.45 mm	196.85 mm	222.25 mm	247.65 mm	273.05 mm	298.45 mm
13/16″	173.04 mm	198.44 mm	223.84 mm	249.24 mm	274.64 mm	300.04 mm
7/8″	174.63 mm	200.03 mm	225.43 mm	250.83 mm	276.23 mm	301.63 mm
15/16″	176.21 mm	201.61 mm	227.01 mm	252.41 mm	277.81 mm	303.21 mm

Millimeters to Inches

1 mm = 0.039″	2 mm = 0.079″	3 mm = 0.118″
4 mm = 0.157″	5 mm = 0.197″	6 mm = 0.236″
7 mm = 0.276″	8 mm = 0.315″	9 mm = 0.354″

	0 mm	100 mm	200 mm	300 mm	400 mm
0	—	3.94″	7.87″	11.81″	15.75″
10 mm	0.39″	4.33″	8.27″	12.20″	16.14″
20 mm	0.79″	4.72″	8.66″	12.60″	16.54″
30 mm	1.18″	5.12″	9.06″	12.99″	16.93″
40 mm	1.57″	5.51″	9.45″	13.39″	17.32″
50 mm	1.97″	5.91″	9.84″	13.78″	17.72″
60 mm	2.36″	6.30″	10.24″	14.17″	18.11″
70 mm	2.76″	6.69″	10.63″	14.57″	18.50″
80 mm	3.15″	7.09″	11.02″	14.96″	18.90″
90 mm	3.54″	7.48″	11.42″	15.35″	19.29″

	500 mm	600 mm	700 mm	800 mm	900 mm
0	19.69″	23.62″	27.56″	31.50″	35.43″
10 mm	20.08″	24.02″	27.95″	31.89″	35.83″
20 mm	20.47″	24.41″	28.35″	32.28″	36.22″
30 mm	20.87″	24.80″	28.74″	32.68″	36.61″
40 mm	21.26″	25.20″	29.13″	33.07″	37.01″
50 mm	21.65″	25.59″	29.53″	33.46″	37.40″
60 mm	22.05″	25.98″	29.92″	33.86″	37.80″
70 mm	22.44″	26.38″	30.31″	34.25″	38.19″
80 mm	22.83″	26.77″	30.71″	34.65″	38.58″
90 mm	23.23″	27.17″	31.10″	35.04″	38.97″

Feet to Millimeters

	0	1'	2'	3'	4'
0	—	305 mm	610 mm	914 mm	1 219 mm
10'	3 048 mm	3 353 mm	3 658 mm	3 962 mm	4 267 mm
20'	6 096 mm	6 401 mm	6 706 mm	7 010 mm	7 315 mm
30'	9 144 mm	9 449 mm	9 754 mm	10 058 mm	10 363 mm
40'	12 192 mm	12 497 mm	12 802 mm	13 106 mm	13 411 mm
50'	15 240 mm	15 545 mm	15 850 mm	16 154 mm	16 459 mm
60'	18 288 mm	18 593 mm	18 898 mm	19 202 mm	19 507 mm
70'	21 336 mm	21 641 mm	21 946 mm	22 250 mm	22 555 mm
80'	24 384 mm	24 689 mm	24 994 mm	25 298 mm	25 603 mm
90'	27 432 mm	27 737 mm	28 042 mm	28 346 mm	28 651 mm
100'	30 480 mm	30 785 mm	31 090 mm	31 394 mm	31 699 mm

	5'	6'	7'	8'	9'
0	1 524 mm	1 829 mm	2 134 mm	2 438 mm	2 743 mm
10'	4 572 mm	4 877 mm	5 182 mm	5 486 mm	5 791 mm
20'	7 620 mm	7 925 mm	8 230 mm	8 534 mm	8 839 mm
30'	10 668 mm	10 973 mm	11 278 mm	11 582 mm	11 887 mm
40'	13 716 mm	14 021 mm	14 326 mm	14 630 mm	14 935 mm
50'	16 764 mm	17 069 mm	17 374 mm	17 678 mm	17 983 mm
60'	19 812 mm	20 117 mm	20 422 mm	20 726 mm	21 031 mm
70'	22 860 mm	23 165 mm	23 470 mm	23 774 mm	24 079 mm
80'	25 908 mm	26 213 mm	26 518 mm	26 822 mm	27 127 mm
90'	28 956 mm	29 261 mm	29 566 mm	29 870 mm	30 175 mm
100'	32 004 mm	32 309 mm	32 614 mm	32 918 mm	33 223 mm

Millimeters to Feet

	1 000 mm	2 000 mm	3 000 mm	4 000 mm	5 000 mm
0 mm	3.28′	6.56′	9.84′	13.12′	16.40′
100 mm	3.61′	6.89′	10.17′	13.45′	16.73′
200 mm	3.94′	7.22′	10.50′	13.78′	17.06′
300 mm	4.27′	7.55′	10.83′	14.11′	17.39′
400 mm	4.59′	7.87′	11.15′	14.44′	17.72′
500 mm	4.92′	8.20′	11.48′	14.76′	18.04′
600 mm	5.25′	8.53′	11.81′	15.09′	18.37′
700 mm	5.58′	8.86′	12.14′	15.42′	18.70′
800 mm	5.91′	9.19′	12.47′	15.75′	19.03′
900 mm	6.23′	9.51′	12.80′	16.08′	19.36′

	6 000 mm	7 000 mm	8 000 mm	9 000 mm	10 000 mm
0 mm	19.69′	22.97′	26.25′	29.53′	32.81′
100 mm	20.01′	23.29′	26.57′	29.86′	33.14′
200 mm	20.34′	23.62′	26.90′	30.18′	33.46′
300 mm	20.67′	23.95′	27.23′	30.51′	33.79′
400 mm	21.00′	24.28′	27.56′	30.84′	34.12′
500 mm	21.33′	24.61′	27.89′	31.17′	34.45′
600 mm	21.66′	24.93′	28.22′	31.50′	34.78′
700 mm	21.98′	25.26′	28.54′	31.82′	35.10′
800 mm	22.31′	25.59′	28.87′	32.15′	35.43′
900 mm	22.64′	25.92′	29.20′	32.48′	35.76′

SLOPES AND PERCENTAGE GRADE

Note: Entries in blue indicate frequently used slopes. Slopes gentler than 1:20 do not require handrails; 1:12 is the maximum ADA-approved slope for ramps and 1:8 is the maximum code-approved slope for ramps (non-ADA).

Degrees	Gradient	% Grade	Degrees	Gradient	% Grade	Degrees	Gradient	% Grade
0.1	1:573.0	0.2	23.0	1:2.4	42.4	57.0	1:0.6	154.0
0.2	1:286.5	0.3	24.0	1:2.2	44.5	58.0	1:0.6	160.0
0.3	1:191.0	0.5	25.0	1:2.1	46.6	59.0	1:0.6	166.4
0.4	1:143.2	0.7	26.0	1:2.1	48.8	60.0	1:0.6	173.2
0.5	1:114.6	0.9	27.0	1:2.0	51.0	61.0	1:0.6	180.4
0.6	1:95.5	1.0	28.0	1:1.9	53.2	62.0	1:0.5	188.1
0.7	1:81.8	1.2	29.0	1:1.8	55.4	63.0	1:0.5	196.2
0.8	1:71.6	1.4	30.0	1:1.7	57.7	64.0	1:0.5	205.0
0.9	1:63.7	1.6	31.0	1:1.7	60.1	65.0	1:0.5	214.5
1.0	1:57.3	1.7	32.0	1:1.6	62.5	66.0	1:0.4	224.6
2.0	1:28.6	3.5	33.0	1:1.5	64.9	67.0	1:0.4	235.6
2.86	1:20.0	5.0	34.0	1:1.5	67.5	68.0	1:0.4	247.5
3.0	1:19.1	5.2	35.0	1:1.4	70.0	69.0	1:0.4	260.5
4.0	1:14.3	7.0	36.0	1:1.4	72.7	70.0	1:0.4	274.7
4.76	1:12.0	8.3	37.0	1:1.3	75.4	71.0	1:0.3	290.4
5.0	1:11.4	8.7	38.0	1:1.3	78.1	72.0	1:0.3	307.8
6.0	1:9.5	10.5	39.0	1:1.2	81.0	73.0	1:0.3	327.1
7.0	1:8.1	12.3	40.0	1:1.2	83.9	74.0	1:0.3	348.7
7.13	1:8.0	12.5	41.0	1:1.2	86.9	75.0	1:0.3	373.2
8.0	1:7.1	14.1	42.0	1:1.1	90.0	76.0	1:0.2	401.1
9.0	1:6.3	15.8	43.0	1:1.1	93.3	77.0	1:0.2	433.1
10.0	1:5.7	17.6	44.0	1:1.0	96.6	78.0	1:0.2	470.5
11.0	1:5.1	19.4	45.0	1:1.0	100.0	79.0	1:0.2	514.5
12.0	1:4.7	21.3	46.0	1:1.0	103.6	80.0	1:0.2	567.1
13.0	1:4.3	23.1	47.0	1:0.9	107.2	81.0	1:0.2	631.4
14.0	1:4.0	24.9	48.0	1:0.9	111.1	82.0	1:0.1	711.5
15.0	1:3.7	26.8	49.0	1:0.9	115.0	83.0	1:0.1	814.4
16.0	1:3.5	28.7	50.0	1:0.8	119.2	84.0	1:0.1	951.4
17.0	1:3.3	30.6	51.0	1:0.8	123.5	85.0	1:0.1	1,143.0
18.0	1:3.1	32.5	52.0	1:0.8	128.0	86.0	1:0.1	1,430.1
19.0	1:2.9	34.4	53.0	1:0.8	132.7	87.0	1:0.1	1,908.1
20.0	1:2.7	36.4	54.0	1:0.7	137.6	88.0	1:0.0	2,863.6
21.0	1:2.6	38.4	55.0	1:0.7	142.8	89.0	1:0.0	5,729.0
22.0	1:2.5	40.4	56.0	1:0.7	148.3	90.0	1:0.0	∞

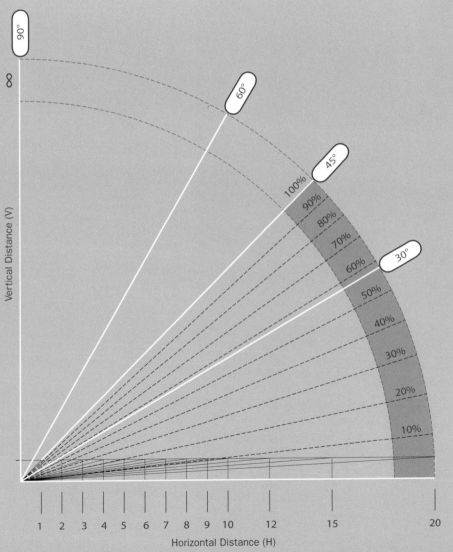

Calculating Slope Degrees:

$$\text{Slope} = \frac{\text{Vertical Rise Distance (V)}}{\text{Horizontal Distance (H)}} = \text{tangent } m$$

Slope Angle = tangent m

Calculating Gradient:

$$= 1 \text{ unit in } \frac{\text{Horizontal Distance (H)}}{\text{Vertical Distance (V)}}$$

Calculating % Grade:

$$= 100 \times \text{Tangent (Slope) or } 100 \times V/H$$

90°

∞

60°

45°

100%

90%

80%

70%

60%

50%

40%

30%

20%

10%

30°

Vertical Distance (V)

1 2 3 4 5 6 7 8 9 10 12 15 20

Horizontal Distance (H)

Chapter 2: Basic Geometry and Drawing Projections

PLANE FIGURE FORMULAS

Rectangle

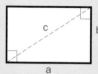

area = ab
perimeter = 2(a+b)
$a^2 + b^2 = c^2$

Equilateral Triangle
(all sides equal)

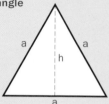

area = $a^2 \frac{\sqrt{3}}{4}$ = 0.433 a^2
perimeter = 3a $h = \frac{a}{2}\sqrt{3}$ = 0.866a

Parallelogram

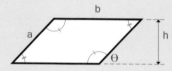

area = ah = ab sinΘ
perimeter = 2(a+b)

Triangle

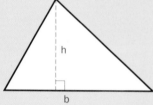

area = $\frac{bh}{2}$
perimeter = sum of length of all sides

Trapezoid

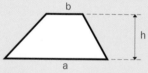

area = $\frac{(a+b)}{2}h$

perimeter = sum of length of sides

Trapezium
(irregular quadrilateral)

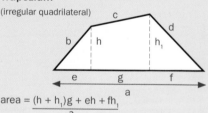

area = $\frac{(h + h_1)g + eh + fh_1}{2}$

perimeter = sum of length of all sides

Quadrilateral

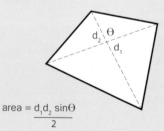

area = $\frac{d_1 d_2 \sin\Theta}{2}$

or

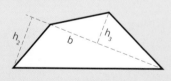

area = $\frac{bh_2}{2} + \frac{bh_3}{2}$

(Divide figure into two triangles and add their areas together.)

Regular Polygons

(all sides equal)

n = number of sides

$$\text{area} = \frac{nar}{2} = nr^2 \tan \Theta = \frac{nR^2}{2} \sin 2\Theta$$

perimeter = n a

Polygon	Sides	Area
Triangle (equilateral)	3	$0.4330\,a^2$
Square	4	$1.0000\,a^2$
Pentagon	5	$1.7205\,a^2$
Hexagon	6	$2.5981\,a^2$
Heptagon	7	$3.6339\,a^2$
Octagon	8	$4.8284\,a^2$
Nonagon	9	$6.1818\,a^2$
Decagon	10	$7.6942\,a^2$
Undecagon	11	$9.3656\,a^2$
Dodecagon	12	$11.1962\,a^2$

VOLUMES

Prism or Cylinder (right or oblique, regular or irregular)

volume = area of base x altitude

Altitude (h) = distance between parallel bases, measured perpendicular to the bases. When bases are not parallel, then altitude = perpendicular distance from one base to the center of the other.

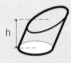

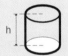

Pyramid or Cone (right or oblique, regular or irregular)

volume = area of base x ⅓ altitude

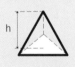

Altitude (h) = distance from base to apex, measured perpendicular to base.

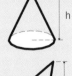

CIRCLE

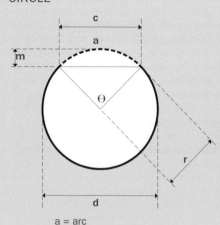

a = arc
r = radius
d = diameter
c = cord
m = distance
Θ = degrees
π = 3.14159

circumference = $2\pi r = \pi d = 3.14159\,d$

area = $\pi r^2 = \pi\dfrac{d^2}{4} = 0.78539\,d^2$

length of arc a = $\Theta\dfrac{\pi}{180}r = 0.017453\,\Theta\,r$

$r = \dfrac{m^2 + c^2/4}{2m} = \dfrac{c/2}{\sin \frac{1}{2}\Theta}$

$c = 2\sqrt{2mr - m^2} = 2r\sin \frac{1}{2}\Theta$

$m = r \pm \dfrac{\sqrt{r^2 - c^2}}{4}$ *use + if arc \geq 180°*
 use − if arc < 180°

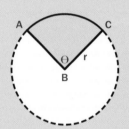

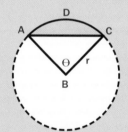

Sector of Circle

arc length AC = $\dfrac{\pi r\Theta}{180}$

area ABCA = $\dfrac{\pi\Theta r^2}{360}$

or

area ABCA = $\dfrac{\text{arc length AC} \times r}{2}$

Segment of Circle

area ACDA =
$\dfrac{r^2}{2} \times \left(\dfrac{\pi\Theta}{180} - \sin\Theta\right)$

r = radius
Θ = degrees
A, B, C, D = points
π = 3.14159

Circular Zone

area 2 =
circle area − area 1
− area 3

1 = segment
2 = zone
3 = segment

ELLIPSE

perimeter (approximate) =

$$\pi\,[1.5\,(x + y) - \sqrt{x\,y}]$$

(Assume point G is the center point of the ellipse, with x,y coordinates of 0,0, and point B coordinates of B_x and B_y.)

area ABFEA =
$(B_x \times B_y) + ab \sin^{-1}(B_x/a)$

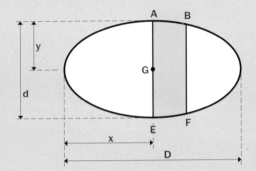

DOUBLE-CURVED SOLIDS

Sphere

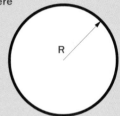

$$\text{volume} = \frac{4\,\pi\,R^3}{3}$$

$$\text{surface} = 4\,\pi\,R^2$$

Segment of Sphere

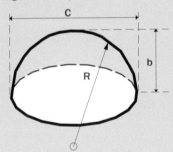

$$\text{volume} = \frac{\pi\,b^2\,(3R - b)}{3}$$

(sector − cone)

$$\text{surface} = 2\pi R b$$

Sector of Sphere

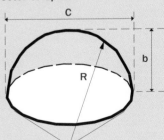

$$\text{volume} = \frac{2\pi\,R^2\,b}{3}$$

$$\text{surface} = \frac{\pi\,R(4b + C)}{2}$$

(segment + cone)

Ellipsoid

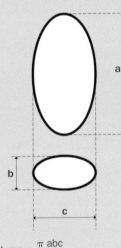

$$\text{volume} = \frac{\pi\,abc}{6}$$

surface = no simple equation

THREE-DIMENSIONAL DRAWINGS

Paraline Drawings

Paraline drawings are projected pictorial representations of the three-dimensional qualities of an object. These drawings can be classified as orthographic projections, with a rotated plan view and a tilted side view. They are also commonly referred to as axonometric or axiometric drawings. Unlike in perspective drawings, the projection lines in a paraline drawing remain parallel instead of converging to a point on the horizon.

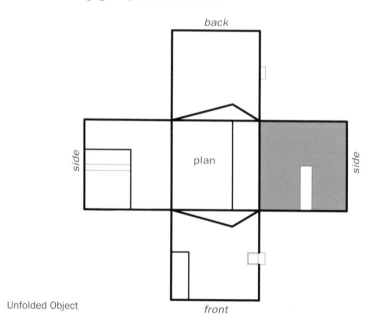

Unfolded Object

Oblique

In an oblique drawing, one face (either plan or elevation) is drawn directly on the picture plane. Projected lines are drawn at a 30- or 45-degree angle to the picture plane. The length of the projecting lines is determined as shown in the diagrams opposite.

Isometric

An isometric drawing is a special type of dimetric drawing, where all axes of the object are simultaneously rotated away from the picture plane and kept at the same angle (30 degrees) of projection. All legs are equally distorted in length and maintain an exact 1:1:1 proportion.

Dimetric

A dimetric drawing is similar to an oblique drawing, except that the object is rotated so that only one corner touches the picture plane.

Trimetric

A trimetric drawing is similar to a dimetric drawing, except that the plan of the object is rotated so that the two exposed sides are not at equal angles to the picture plane.

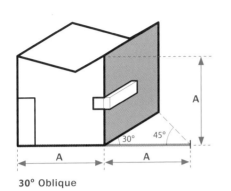

30° Oblique

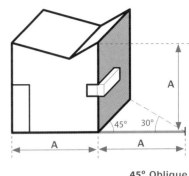

45° Oblique

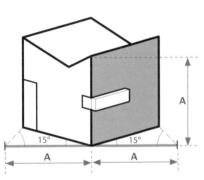

15° Dimetric

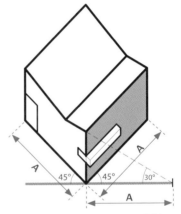

45° Dimetric

Isometric
(30° Dimetric)

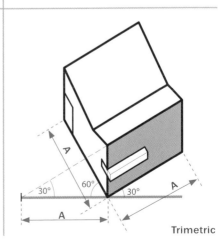

Trimetric

Two-Point Common Method Perspective

Station Point (SP): Locates the fixed position of the viewer.

Picture Plane (PP): Flat, two-dimensional surface that records the projected perspective image and aligns perpendicular to the viewer's center of vision. The picture plane is the only true-size plane in the perspective field: Objects behind the picture plane project to its surface smaller than true scale, whereas those between the viewer and the picture plane project to its surface larger than true scale.

Measuring Line (ML): Located on the picture plane, the measuring line is the only true-scale line in a perspective drawing. Most commonly, this is a vertical line from which can be projected the key vertical dimensions of the object.

Horizon Line (HL): Lies at the intersection of the picture plane and a horizontal plane through the eye of the viewer.

Vanishing Point: Point at which parallel lines appear to meet in perspective. The left (vpL) and right (vpR) vanishing points for an object are determined by the points at which a set of lines originating from the station point and parallel to the object lines intersect the picture plane.

Ground Line (GL): Lies at the intersection of the picture plane and the ground plane.

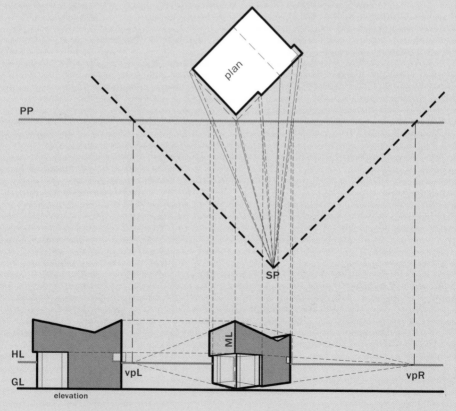

One-Point Common Method Perspective

One-point perspectives use a single vanishing point, and all edges and planes that are perpendicular to the picture plane vanish toward this point. To locate this point (C), draw a vertical line from the station point to the horizon line. Building edges that are parallel to the picture plane appear as parallel lines in perspective, with no vanishing point.

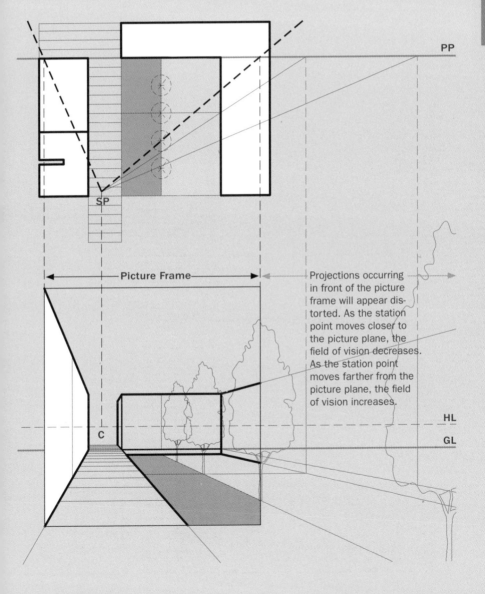

Projections occurring in front of the picture frame will appear distorted. As the station point moves closer to the picture plane, the field of vision decreases. As the station point moves farther from the picture plane, the field of vision increases.

Chapter 3: Architectural Drawing Types

An architect uses eight basic drawing types within the drawing set to most completely describe the design of a building.

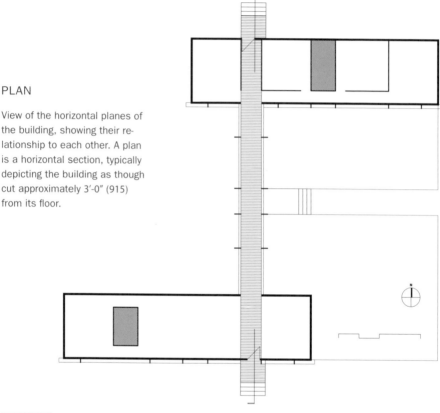

PLAN

View of the horizontal planes of the building, showing their relationship to each other. A plan is a horizontal section, typically depicting the building as though cut approximately 3'-0" (915) from its floor.

SECTION

View of a vertical cut through the building's components. A section acts as a vertical plan and often contains elevational information, such as doors and windows. This information is shown with a lighter line weight than the section cuts.

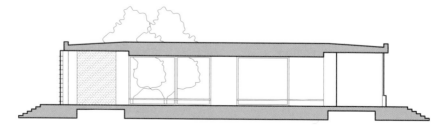

ELEVATION

View of the vertical planes of the building, showing their relationship to each other. An elevation is viewed perpendicularly from a selected plane.

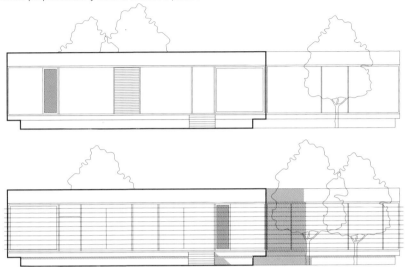

THREE-DIMENSIONAL REPRESENTATIONS

Perspectives (not scaled), axonometrics, and isometrics describe the building or space in a way that conventional plans, elevations, and sections cannot. Perspectives are particularly effective in producing a view that would actually be experienced by being in the space designed.

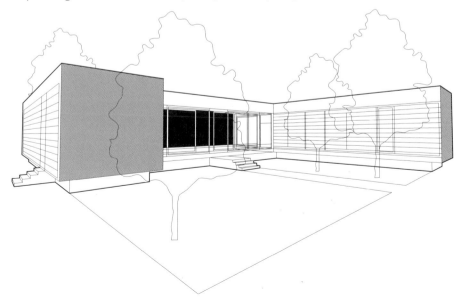

LARGE-SCALE VIEW

View of plans, elevations, or sections
at a larger scale and with more detail
than the base drawings. Large-scale
views typically show materials,
specific dimensions, and notes.

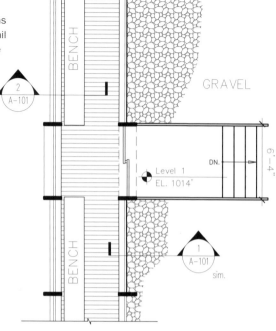

DETAIL

Large-scale plan, elevation, or
section that provides very specific
information about the materials and
construction of a chosen area of a
project component. Details are
keyed into larger-scale drawings.

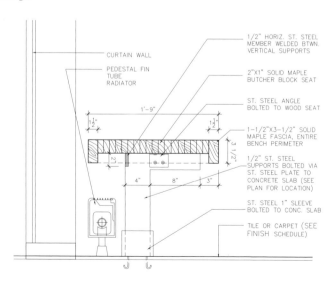

DIAGRAM

Drawing at no particular scale, depicting organizing principles, thought processes, system components, or connections that have informed the design of the building but are not part of the conventional scaled views.

1

2

3

SCHEDULE

Chart or table that includes data about materials, finishes, equipment, products, window types, door types, signage, and so on. Schedules are keyed into other drawings in the set.

Room Finish Schedule									
Room No.	Room Name	Floor	Walls				Ceiling		Notes
			N	S	E	W	mat'l	height	

Chapter 4: Project Management and Architectural Documents

THE PRACTICE OF ARCHITECTURE

To speak an architectural language is to do many things: It could involve the art of form and style or the more prosaic aspects of contract administration. Architecture and its practice move, sometimes with effort, among realms not only of art, science, and engineering, but also of business, economics, and sociology. All professional groups speak their own language to some extent. To their written and spoken language architects add drawings and symbols, organizing them into accepted standards of presentation and legibility. As with good manners, the point of these standards is not to complicate but to ease communication and interaction.

Most countries have a governing body in architectural practice—in the United States it is the American Institute of Architects (AIA)—which oversees ethics and professional conduct and establishes guidelines for issues ranging from project delivery schedules to contracts and legal documents. The architect who has complete mastery of every aspect of the multiple personalities of architectural practice may be rare. However, all responsible practicing architects are compelled to understand the business of the profession, because the art of architecture depends on the practice of getting it built.

COMMON PROJECT TERMS

Addendum: Written information that clarifies or modifies the bidding documents, often issued during the bidding process.

Alternate: Additional design or material options added to the construction documents and/or specifications to obtain multiple possible cost estimates for a project. "Add-alternates" imply added material and cost; "deduct-alternates" imply removal of certain elements to lower the project cost, as necessary.

ANSI: American National Standards Institute.

As-built drawings: Contract drawings that have been marked up to reflect any changes to a project during construction, differentiating them from the bid documents. Also known as record drawings.

Bid: Offer of a proposal or a price. When a project is "put out to bid," contractors are asked to submit their estimates as to the time and the cost of a project.

Building permit: Written document issued by the appropriate government authority permitting the construction of a specific project in accordance with the drawings and specifications that the authority has approved.

Certificate of occupancy: Document issued by the appropriate local governmental agency, stating that a building or property meets local standards for occupancy and is in compliance with public health and building codes.

Change order: Written document between and signed by the owner and the contractor authorizing a change in the work, or an adjustment in the contract sum or length of time. Architects and engineers may also sign a change order, but only if authorized (in writing) by the owner to do so.

Charrette: Intensive design process for solving an architectural problem quickly; often undertaken by students of architecture, but also employed by professionals in various stages of the design process. The instructors of the École des Beaux Arts in Paris would use a *charrette*, French for "small wooden cart," for collecting the design work of the students after such a process.

Construction cost: Direct contractor costs for labor, material, equipment, and services, as well as overhead and profit. Excluded from construction cost are fees for architects, engineers, consultants, costs of land, or any other items that, by definition of the contract, are the responsibility of the owner.

Construction management: Organization and direction of the labor force, materials, and equipment to build the project as designed by the architect.

Construction management contract: Written agreement giving responsibility for coordination and accomplishment of overall project planning, design, and construction to a construction management firm or individual, called the construction manager (CM).

Consultant: Professional hired by the owner or architect to provide information and to advise the project in the area of his or her expertise.

Contract administration: Contractual duties and responsibilities of the architect and engineer during a project's construction.

Contract over- (or under-) run: Difference between the original contract price and the final completed cost, including all change order adjustments.

Contractor: Licensed individual or company that agrees to perform the work as specified, with the appropriate labor, equipment, and materials.

Date of substantial completion: Date certified by the architect when the work is to be completed.

Design-build construction: Arrangement wherein a contractor bids or negotiates to provide design and construction services for the entire project.

Estimating: Calculation of the amount of material, labor, and equipment needed to complete a given project.

Fast-track construction: Method of construction management in which construction work begins before completion of the construction documents, resulting in a continuous design-construction situation.

FF&E: Moveable furniture, fixtures, or equipment that do not require permanent connection to the structure or utilities of a building.

Field order: Written order calling for a clarification or minor change in the construction work and not involving any adjustment to the terms of the contract.

General contractor: Licensed individual or company with prime responsibility for the work.

Indirect cost: Expenses that are not chargeable to a specific project or task, such as overhead.

Inspection list: List prepared by the owner or authorized owner's representative of work items requiring correction or completion by the contractor; generally done at the end of construction. Also called a punch list.

NIBS: National Institute of Building Sciences.

Owner-architect agreement: Written contract between the architect and client for professional architectural services.

Parti: Central idea governing and organizing a work of architecture, from the French *partir* "to depart with the intention of going somewhere."

Program: Desired list of spaces, rooms, and elements, as well as their sizes, for use in designing the building.

Progress schedule: Line diagram showing proposed and actual starting and completion times in a project.

Project cost: All costs for a specific project, including those for land, professionals, construction, furnishings, fixtures, equipment, financing, and any other project-related expenses.

Project directory: Written list of names and addresses of all parties involved in a project, including the owner, architect, engineer, and contractor.

Project manager: Qualified individual or firm authorized by the owner to be responsible for coordinating time, equipment, money, tasks, and people for all or portions of a project.

Project manual: Detailed written specifications describing acceptable construction materials and methods.

Request for Information (RFI): Written request from a contractor to the owner or architect for clarification of the contract documents.

Request for Proposal (RFP): Written request to a contractor, architect, or subcontractor for an estimate or cost proposal.

Schedule: Plan for performing work; also, a chart or table within the drawing set.

Scheme: Chart, diagram, or outline of a system being proposed.

Scope of work: Written range of view or action for a specific project.

Shop drawings: Drawings, diagrams, schedules, and other data specially prepared by the contractor or a subcontractor, sub-subcontractor, manufacturer, supplier, or distributor to illustrate some portion of the work being done. These drawings show the specific way in which the particular contractor or shop intends to furnish, fabricate, assemble, or install its products. The architect is obligated by the owner-architect agreement to review and approve these drawings or to take other appropriate action.

Site: Location of a structure or group of structures.

Soft costs: Expenses in addition to the direct construction cost, including architectural and engineering fees, permits, legal and financing fees, construction interest and operating expenses, leasing and real estate commissions, advertising and promotion, and supervision. Soft costs and construction costs add up to the project cost.

Standards of professional practice: Listing of minimum acceptable ethical principals and practices adopted by qualified and recognized professional organizations to guide their members in the conduct of specific professional practice.

Structural systems: Load-bearing assembly of beams and columns on a foundation.

Subcontractor: Specialized contractor who is subordinate to the prime or main contractor.

Substitution: Proposed replacement or alternate for a material or process of equivalent cost and quality.

Tenant improvements (TIs): Interior improvements of a project after the building envelope is complete.

Time and materials (T&M): Written agreement wherein payment is based on actual costs for labor, equipment, materials, and services rendered, in addition to overhead.

Value engineering (VE): Process of analyzing the cost versus the value of alternative materials, equipment, and systems, usually in the interest of achieving the lowest total cost for a project.

Zoning: Restrictions of areas or regions of land within specific areas based on permitted building size, character, and uses as established by governing urban authorities.

Zoning permit: Document issued by a governing urban authority that permits land to be used for a specific purpose.

PROJECT TIMELINE

The information presented here is a generalization of the phases and events within a typical architectural project. It does not attempt to account for all project sizes and client types. The length of each phase is a rough estimation for a normal, medium-sized project, but the timeframes can vary wildly. The expectations and duration of any of these phases are subject to the stipulations of the project's owner-architect agreement.

Pre-design

Even before beginning the actual design of a project, the architect may be asked to perform the following tasks, alone or in conjunction with other consultants: site selection and evaluation, environmental analysis, community participation, feasibility studies, programming, cost analysis, and conceptual design. It is not unusual for the architect to do many of these services as a (paid or unpaid) marketing effort, in anticipation of being awarded the project.

varies

SD Schematic Design

Major design ideas are proposed and explored, including alternate schemes. Drawings produced in this phase include site plan, plans, elevations, and sections sufficient for cost estimation. SD often requires multiple presentations to the client for review and approval and can encompass the production of perspectives, renderings, and models to describe the design concept.

3 months

Marketing

In the competitive environment of architecture, procuring a project can be more time- and labor-intensive than getting it built. Marketing takes many forms, but common modes of obtaining work are:

Competitions: Firms or individuals submit a design for a specified program and site, for which a winner is chosen. Competitions vary in form—they may be paid or unpaid, open or invited—and do not always result in a project being built.

Requests for Qualifications (RFQs): A potential client asks architects to submit their qualifications, sometimes to a specified format.

Requests for Proposal (RFPs): Similar to RFQs, though often firms are specifically asked to supply information about other relevant projects they have completed. Proposals may include a wide variety of information types, including proposed budget and schedule, and sometimes may require a design for the project.

Interviews: A potential client will want to meet the architect, sometimes with his or her prospective consultants. At this meeting, the design team may be asked to present a proposal for the project in question.

DD Design Development

The detailed development of the design (as established in SD) results in a drawing set suitable for a more accurate cost estimate. Coordination with consultants is key in this phase to identify and address potential problems before the design has proceeded too far. Presentations to the client turn more to these issues of coordination and cost control and take into account more specific feedback about the nature of rooms and spaces. The design is documented inside and out, including construction details, interior elevations, schedules, and specifications, all of which will be further refined in the CD phase.

6 months

CD Construction Documents

The "working drawing" phase of the project, in which every aspect of the design is drawn to scale and appropriately specified, is time- and energy-intensive, and project teams usually grow larger to accommodate the work involved. The design of the project must be well established by this point, and most owner-architect agreements stipulate that any requests for major design changes made after DD must be part of an "Additional Services" agreement, to make up for the time it has taken to document the project to date.

The CD set is the official documentation of the project and is distributed to contractors for bids as well as to the building department and other officials for all necessary permits. The architect is responsible for assisting the client in this process.

A CD set contains, at a minimum, a site plan, floor plans, reflected ceiling plans, exterior and interior building elevations, building sections, wall sections depicting construction detailing, interior details, door and window schedules, equipment schedules (if applicable), finishes schedules, and written specifications, as well as the drawings of engineers and other consultants.

9 months

CA Construction Administration

Though the project is under construction, the architect must still maintain control over its outcome, both through regular site visits, in which construction quality is observed for its conformance with the CD set, and by overseeing solutions to unanticipated problems as they arise. The architect must review shop drawings, change orders, and requests for information from the contractor, always acting in the best interest of the client and the budget. At the end of construction, the architect prepares the punch list and assists in obtaining a Certificate of Occupancy.

duration of construction

Marketing

Once completed, the project is photographed and documented. The architect may submit it for publication in any number of professional magazines, include it in the firm's brochure, or post it on the firm's website. It now serves as a marketing tool for obtaining more projects, and the process continues.

READING THE DRAWING SET

Drawing Symbols

Symbols and reference markers are necessary for navigating the drawing set. They tell whoever is looking at a drawing where to go to find out more information about certain elements.

DET / SHT	building section
DET / SHT	wall or detail section
DET / SHT	detail section (nondirectional)
DET / SHT	enlarged detail reference
FIRST FLOOR EL. 100'–0"	elevation target
DET / SHT	exterior elevation
1 / 4 DET SHT 2 / 3	interior elevation
OFFICE 046	room name and room number
(8'–0")	ceiling height
⟨001⟩	window number
(001)	door number

partition type	1
north arrow	
column grid and bubbles	1 / A
centerline	₵
drawing label	1 First Floor Plan 1/8"=1'–0"
graphic scale	0 5' 10' 20'
break line	
revision cloud and number	2
spot elevation	+101'–0"
align note	ALIGN

Floor Plans

Overall building plans are usually drawn at a scale that enables one to see the whole plan. Most elements of the overall plan are keyed to other drawings in the set, as in the case of larger-scale plans, details, sections, and elevations. Some information may be keyed and cross-referenced among multiple drawings. Keys shown on the plan below reappear on the drawings to follow.

DRIVEWAY

BENCH

CARPORT
006

KITCHEN
005

PATIO

A3
A-201

C

LIVING
004

A1
A-301

POOL
+92'-0"

1
A3.01

30'-0"

A4
A-202

FP

BATH
003

B

A3
A-202

BED
ROOM
002

1
A6.02

30'-0"

PATIO
+100'-0"

C3
A-201

6
A6.05

BED
ROOM
001

A

DN

40'-0"

20'-0"

C1
A-201

79'-6"

1
A1
A-201

2

1· First Floor Plan
 1/4"=1'-0"

0 5' 10' 20'

N

Building Elevations

Building elevations depict the exterior conditions of the building, describing materials and important vertical dimensions. In instances where a drawing is too large to fit on a standard sheet, it must be broken apart and continued on the same sheet or another sheet, requiring the use of match lines for alignment.

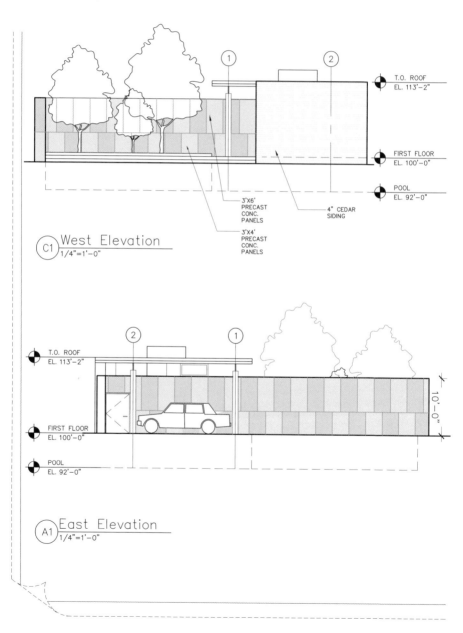

West Elevation
C1 1/4"=1'-0"

East Elevation
A1 1/4"=1'-0"

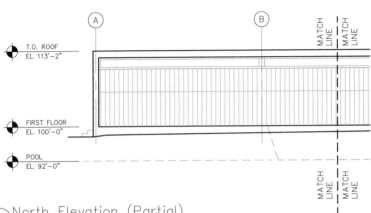

T.O. ROOF
EL. 113'-2"

FIRST FLOOR
EL. 100'-0"

POOL
EL. 92'-0"

MATCH LINE | MATCH LINE

A B

C3 North Elevation (Partial)
1/4"=1'-0"

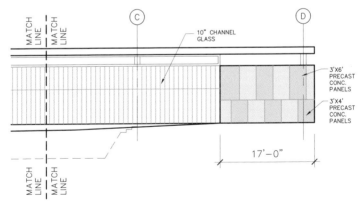

MATCH LINE | MATCH LINE

C D

10" CHANNEL GLASS

3'X6' PRECAST CONC. PANELS

3'X4' PRECAST CONC. PANELS

17'-0"

MATCH LINE | MATCH LINE

A3 North Elevation (Partial)
1/4"=1'-0"

Exterior
Building
Elevations

A-201

Reflected Ceiling Plans

Reflected ceiling plans (RCPs) may be thought of as upside-down floor plans, for they are literally a plan of the ceiling. They are used to describe light fixture placement and types, ceiling heights and materials, and anything else found on the ceiling plane. RCPs employ standard keys and symbols as well as some specific to the ceiling plan.

Light fixtures often bear tags that refer to their descriptions in the lighting specifications.

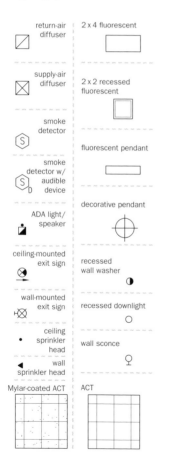

return-air diffuser	2 x 4 fluorescent
supply-air diffuser	2 x 2 recessed fluorescent
smoke detector	fluorescent pendant
smoke detector w/ audible device	decorative pendant
ADA light/ speaker	
ceiling-mounted exit sign	recessed wall washer
wall-mounted exit sign	recessed downlight
ceiling sprinkler head	wall sconce
wall sprinkler head	
Mylar-coated ACT	ACT

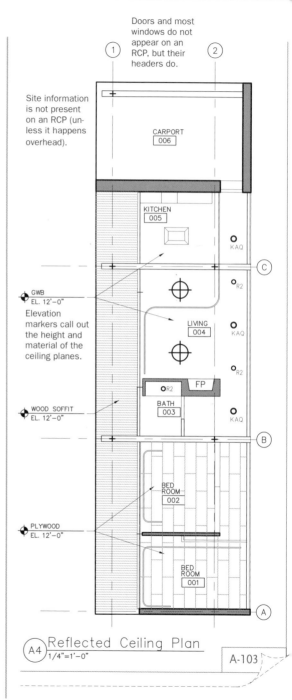

Doors and most windows do not appear on an RCP, but their headers do.

Site information is not present on an RCP (unless it happens overhead).

CARPORT 006

KITCHEN 005

Elevation markers call out the height and material of the ceiling planes.

GWB EL. 12'–0"

WOOD SOFFIT EL. 12'–0"

PLYWOOD EL. 12'–0"

LIVING 004

BATH 003

FP

BED ROOM 002

BED ROOM 001

(A4) Reflected Ceiling Plan
1/4"=1'–0"

A-103

Interior Elevations

Interior elevations are drawn at a larger scale than the overall building plans, allowing for more details, notes, and dimensions to be represented. Keyed from the building plan, interior elevations are, in turn, keyed to other, larger-scale views, such as section and plan details of cabinetry construction and wall sections.

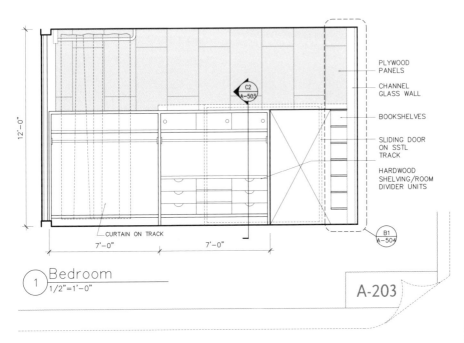

PLYWOOD PANELS

CHANNEL GLASS WALL

BOOKSHELVES

SLIDING DOOR ON SSTL TRACK

HARDWOOD SHELVING/ROOM DIVIDER UNITS

C2
A-503

12'-0"

CURTAIN ON TRACK

7'-0" 7'-0"

B1
A-504

(1) Bedroom
1/2"=1'-0"

A-203

CH. 18

Details

Details are drawn at scales such as 1 1/2" = 1'-0", 3" = 1'-0", 6" = 1'-0", and sometimes even at full scale, and are keyed from and to numerous other drawings.

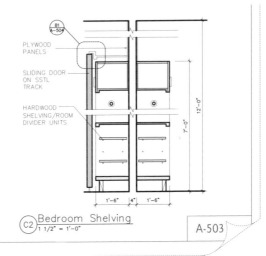

B1
A-504

PLYWOOD PANELS

SLIDING DOOR ON SSTL TRACK

HARDWOOD SHELVING/ROOM DIVIDER UNITS

12'-0"

7'-0"

1'-6" 4" 1'-6"

(C2) Bedroom Shelving
1 1/2" = 1'-0"

A-503

DRAWING SET ABBREVIATIONS

When all drawings were done by hand, architectural lettering—an art form of its own—could be tedious and time-consuming. As a result, architects and draftspersons abbreviated words. Though many standards were created, they have not always been consistent and historically have led to interpretive errors by contractors. CAD technology makes much shorter work of text production and arrangement and enables less frequent use of abbreviations. If space dictates that abbreviations must be used, omit spaces or periods and capitalize all letters. Though variations still exist, the following is a widely accepted list.

ACT: acoustical ceiling tile
ADD: additional
ADJ: adjustable
AFF: above finish floor
ALUM: aluminum
APPX: approximately

BD: board
BIT: bituminous
BLDG: building
BLK: block
BLKG: blocking
BM: beam
BOT: bottom
BC: brick course
BUR: built-up roofing

CB: catch basin
CBD: chalkboard
CI: cast iron
CIP: cast-in-place
CJ: control joint
CMU: concrete
masonry unit
CEM: cement
CLG: ceiling
CLR: clearance
CLO: closet
COL: column
COMP: compressible
CONC: concrete
CONST: construction
CONT: continuous

CPT: carpet
CRS: courses
CT: ceramic tile
CUB: column utility box

DF: drinking fountain
DET: detail
DIA: diameter
DN: down
DR: door
DWG: drawing

EA: each
ENC: enclosure
EJ: expansion joint
EL: elevation or electrical
ELEV: elevator
EQ: equal
EQUIP: equipment
ERD: emergency roof
drain
EWC: electric
water cooler
EXIST: existing
EXP: expansion
EXT: exterior

FE: fire extinguisher
FEC: fire extinguisher
cabinet
FHC: fire hose cabinet
FD: floor drain

FDN: foundation
FFT: finished
floor transition
FIN: finish
FLR: floor
FLUOR: fluorescent
FOC: face of concrete
FOF: face of finish
FOM: face of masonry
FTG: footing
FIXT: fixture
FR: fire-rated
FT: feet
FUB: floor utility box

GA: gauge
GALV: galvanized
GC: general contractor
GL: glass
GWB: gypsum wallboard
GYP: gypsum

HC: hollow core or
handicap accessible
HDW: hardware
HM: hollow metal
HORIZ: horizontal
HP: high point
HGT: height
HTR: heater
HVAC: heating,
ventilating, and
air conditioning

IN: inch
INCAN: incandescent
INCL: including
INS: insulation
INT: interior

JAN: janitor
JC: janitor's closet
JT: joint

LP: low point
LAM: laminated
LAV: lavatory
LINO: linoleum
LTG: lighting

MAT: material
MO: masonry opening
MAX: maximum
MECH: mechanical
MEMB: member
MFR: manufacturer
MIN: minimum
MISC: miscellaneous
MTL: metal

NIC: not in contract
NTS: not to scale
NO: number

OC: on center
OD: outside diameter
 or overflow drain
OHD: overhead door
OHG: overhead grille
OPNG: opening
OPP: opposite
OPPH: opposite hand

PC: precast
PGL: plate glass
PTN: partition
PL: plate
PLAM: plastic laminate

PLUM: plumber
PTD: painted
PT: paint
PVC: polyvinyl chloride

QT: quarry tile
QTY: quantity

R: radius or riser
RA: return air
RD: roof drain
REG: register
RO: rough opening
REINF: reinforcing
REQD: required
RM: room
REV: revision or reverse
RSL: resilient flooring

SC: solid core
SECT: section
SHT: sheet
SIM: similar
SPEC: specifications
STD: standard
SSTL: stainless steel
STL: steel
SUSP: suspended
SQ: square
STRUC: structural
STOR: storage
STA: station

T: tread
TBD: tackboard
TD: trench drain
THK: thickness
TEL: telephone
TO: top of
TOC: top of concrete
TOF: top of footing
TOR: top of rail
TOS: top of steel
TRT: treated

TOW: top of wall
TYP: typical

UNO: unless noted
 otherwise

VCT: vinyl
 composition tile
VERT: vertical
VIF: verify in field
VP: veneer plaster
VWC: vinyl wall covering

W/: with
WD: wood
WC: water closet
WF: wide flange
WPR: waterproofing
W/O: without
WWF: welded wire fabric
WDW: window
WUB: wall utility box

&: and
<: angle
": inch
': foot
@: at
CL: centerline
[: channel
#: number
Ø: diameter

DRAWING SET ORDER

Typical Order for Disciplines

Standards for the order of disciplines in the drawing set may vary within different offices. The order below is recommended by the Uniform Drawing System (UDS) to minimize confusion among the many trades that will use the set. Note that most projects will not contain all the disciplines listed here, and others might have need for additional, project-specific disciplines.

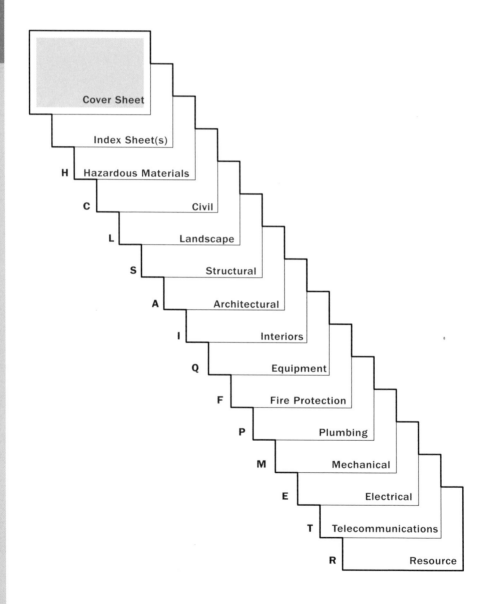

Typical Order for Sheets within the Architecture Discipline

A-0: General

A-001 Notes and Symbols

A-1: Architectural Floor Plans

A-101 First-Floor Plan
A-102 Second-Floor Plan
A-103 Third-Floor Plan
A-104 First-Floor RCP
A-105 Second-Floor RCP
A-106 Third-Floor RCP
A-107 Roof Plan

A-2: Architectural Elevations

A-201 Exterior Elevations
A-202 Exterior Elevations
A-203 Interior Elevations

A-3: Architectural Sections

A-301 Building Sections
A-302 Building Sections
A-303 Wall Sections

A-4: Large-Scale Views

A-401 Enlarged Toilet Plans
A-402 Enlarged Plans
A-403 Stair and Elevator Plans and Sections

A-5: Architectural Details

A-501 Exterior Details
A-502 Exterior Details
A-503 Interior Details
A-504 Interior Details

A-6: Schedules and Diagrams

A-601 Partition Types
A-602 Room Finish Schedule
A-603 Door and Window Schedules

COMMON PAPER SIZES

Paper Size	Inches	Millimeters
ANSI-A	8 1/2 x 11	216 x 279
ANSI-B	11 x 17	279 x 432
ANSI-C	17 x 22	432 x 559
ANSI-D	22 x 34	559 x 864
ANSI-E	34 x 44	864 x 1 118

Architectural

Paper Size	Inches	Millimeters
Arch-A	9 x 12	229 x 305
Arch-B	12 x 18	305 x 457
Arch-C	18 x 24	432 x 559
Arch-D	24 x 36	610 x 914
Arch-E	36 x 48	914 x 1 219

ISO (International Organization for Standardization)—based on one square meter

Paper Size	Inches	Millimeters
4A0	66 1/4 x 93 3/8	1 682 x 2 378
2A0	25 1/2 x 36 1/8	1 189 x 1 682
A0	33 1/8 x 46 3/4	841 x 1 198
A1	23 3/8 x 33 1/8	610 x 914
A2	16 1/2 x 23 3/8	914 x 1 219
A3	11 3/4 x 16 1/2	297 x 420
A4	8 1/4 x 11 3/4	210 x 297

Paper Size	Inches	Millimeters
B0	39 3/8 x 55 5/8	1 000 x 1 414
B1	27 7/8 x 39 3/8	707 x 1 000
B2	19 5/8 x 27 7/8	500 x 707
B3	12 7/8 x 19 5/8	353 x 500
B4	9 7/8 x 12 7/8	250 x 353

Paper Size	Inches	Millimeters
C0	36 1/8 x 51	917 x 1 297
C1	25 1/2 x 36 1/8	648 x 917
C2	18 x 25	458 x 648
C3	12 3/4 x 18	324 x 458
C4	9 x 12 1/2	229 x 324

SHEET FOLDING

Individual sheets that must be folded (for reasons of file storage or mailing) should be folded in a logical and consistent manner that allows the title and sheet number information to be visible in the bottom-right corner of the folded sheet. Large numbers of sheets are best bound into sets and rolled for shipping or laid flat for storage.

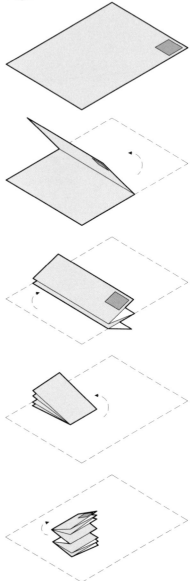

DRAWING SHEET LAYOUT AND SET ASSEMBLY

In the NIBS Standard sheet layout (in accordance with the National CAD Standard), drawings within a sheet are numbered by coordinate system modules as described below. The graphic or text information modules are known as drawing blocks and their numbers are established by the coordinates for the bottom-left corner of their module. This system enables new drawing blocks to be added to a sheet without having to renumber the existing blocks, saving considerable time once drawings begin to be keyed to other drawings and schedules.

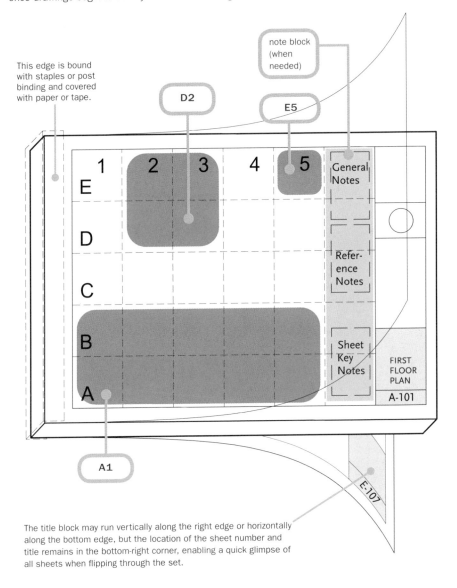

note block (when needed)

This edge is bound with staples or post binding and covered with paper or tape.

D2

E5

General Notes

Refer-ence Notes

Sheet Key Notes

FIRST FLOOR PLAN

A-101

A1

E-107

The title block may run vertically along the right edge or horizontally along the bottom edge, but the location of the sheet number and title remains in the bottom-right corner, enabling a quick glimpse of all sheets when flipping through the set.

CH. 6 CH. 7

Chapter 5: Specifications

Architectural specifications act as written instructions to the contractor and all parties involved in the construction of a building. Specifications are part of the construction document set, usually as a separate project manual. They provide detailed descriptions of the acceptable construction materials for all aspects of a building, from the type and color of paint to the type and method of structural fireproofing. Specification writing is time-consuming and exacting work; it is most often undertaken by specification writers or architects who specialize in the writing of specifications. Certified spec writers list the suffix CCS (Certified Construction Specifier) after their name. A well-written set of specs is imperative to keep a project safe and on budget and to ensure that the needs of both architect and owner have been met.

CSI MASTERFORMAT SYSTEM

The Construction Specifications Institute (CSI) was established in 1948 to bring order to the post–World War II building boom. CSI governs standardization of specification writing and formatting, and its Manual of Practice (MOP) is the industry reference. Spec writers might avail themselves of prewritten master guide specs that serve as a basis for many projects, or they might begin a set of specs entirely from scratch.

The CSI MasterFormat system has become the standard formatting system for nonresidential building projects in the United States and Canada. It consists of a list of numbers and titles that organize the information contained in the specification project manual.

Division Numbering

0 0 0 0 0 0 . 0 0

Level One (division number) Level Two Level Three Level Four (separated by a decimal point; used only when the amount of detail warrants further classification)

Sample Specification Section

<div>

SECTION 00 00 00
MATERIAL

PART 1 GENERAL
1.1 SECTION INCLUDES
 A.
1.2 RELATED SECTIONS
 A.
 B.
1.3 REFERENCES
 A.
1.4 SUBMITTALS
 A.
 B.
1.5 QUALITY ASSURANCE
 A.
1.6 DELIVERY, STORAGE, AND HANDLING
 A.
 B.
1.7 PROJECT CONDITIONS
 A.
1.8 EXTRA MATERIALS
 A.

PART 2 PRODUCTS
2.1 MANUFACTURERS
 A.
 B.
2.2 PRODUCTS
 A.
 1.
 2.

PART 3 EXECUTION
3.1 EXAMINATION
 A.
 B.
3.2 PREPARATION
 A.
3.3 INSTALLATION
 A.
 B.
3.4 PROTECTION
 A.
 B.

END OF SECTION

</div>

CSI MasterFormat Division Titles

Reserved divisions provide space for future development and expansion, and CSI recommends that users not appropriate these divisions for their own use.

PROCUREMENT AND CONTRACTING REQUIREMENTS GROUP

00—Procurement and Contracting Requirements

SPECIFICATIONS GROUP

General Requirements Subgroup

01—General Requirements

Facility Construction Subgroup

02—Existing Conditions
03—Concrete
04—Masonry
05—Metals
06—Wood, Plastics, and Composites
07—Thermal and Moisture Protection
08—Openings
09—Finishes
10—Specialties
11—Equipment
12—Furnishings
13—Special Construction
14—Conveying Equipment
15—Mechanical
16—Electrical
17—*Reserved*
18—*Reserved*
19—*Reserved*

Facility Services Subgroup

20—*Reserved*
21—Fire Suppression
22—Plumbing
23—Heating, Ventilating, and Air-Conditioning
24—*Reserved*
25—Integrated Automation
26—Electrical
27—Communications
28—Electronic Safety and Security
29—*Reserved*

Site and Infrastructure Subgroup

30—*Reserved*
31—Earthwork
32—Exterior Improvements
33—Utilities
34—Transportation
35—Waterway and Marine Construction
36—*Reserved*
37—*Reserved*
38—*Reserved*
39—*Reserved*

Process Equipment Subgroup

40—Process Integration
41—Material Processing and Handling Equipment
42—Process Heating, Cooling, and Drying Equipment
43—Process Gas and Liquid Handling, Purification, and Storage Equipment
44—Pollution Control Equipment
45—Industry-Specific Manufacturing Equipment
46—*Reserved*
47—*Reserved*
48—Electrical Power Generation
49—*Reserved*

Chapter 6: Hand Drafting

Though rapidly being replaced by computer-aided drafting, hand drafting continues to be used by some practitioners, and its principles can still be applied to computer drawing. The practice of hand drafting employs a number of key instruments.

WORK SURFACE

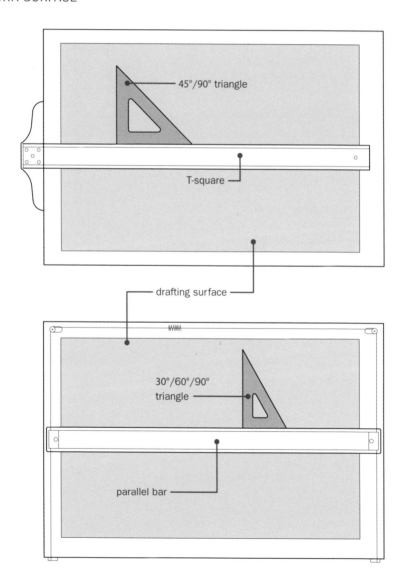

45°/90° triangle

T-square

drafting surface

30°/60°/90° triangle

parallel bar

PAPERS AND BOARDS

Paper Type	Qualities	Format	Best Uses	Use for Overlay
Tracing paper	white, buff or yellow; inexpensive	Rolls in multiple sizes (12", 18", 24", 36", 48"); pads	sketch overlay; layouts	yes
Vellum	oil-treated to achieve transparency	rolls, sheets, and pads	pencil and technical pen work; overlay work	yes
Mylar (drafting film)	nonabsorbent polyester film (1- and 2-sided)	rolls and sheets	pencil and tech. pen work; ideal for archival work	yes
Bond and drawing papers	variety of weights, textures, and colors	rolls and sheets	smooth best for pens; textured best for pencils	no
Illustration board	high-quality white rag affixed to board	large-scale sheet sizes	finished work in watercolor, pencil, chalk, or pen	no
Chip board	variety of plies; mostly gray	large-scale sheet sizes	model making; some dry mounting	no
Foam board	polystyrene foam between paper liners; white/black	large-scale boards; $1/8$", $3/16$", $1/4$", $1/2$" thick	model making; dry-mounting sheets	no

translucent paper and film

sheets

boards

DRAFTING SUPPLIES

1. Drafting brush:
Implement used to
brush away erasures
and drafting powder.

2. Drafting powder:
Finely ground white
compound that prevents
dust, dirt, and smudges
from being ground into
the drafting media.

3. French curve:
Template used as guide
to draw smoothly most
desired curvatures.

4. X-Acto knife:
Cutting tool used in
model making and in
Letratone application.

5. Erasing shield:
Device used to erase
specific lines and areas
without affecting others.

6. Adjustable triangle:
Tool used alone or in
combination with other
triangles to achieve
any angle.

7. Template:
Pattern guides available
in a wide variety of types
(lettering, toilets, people)
and scales.

8. Compass:
Hinge-legged instrument
that accommodates a
pen or pencil to describe
precise circles or
circular arcs.

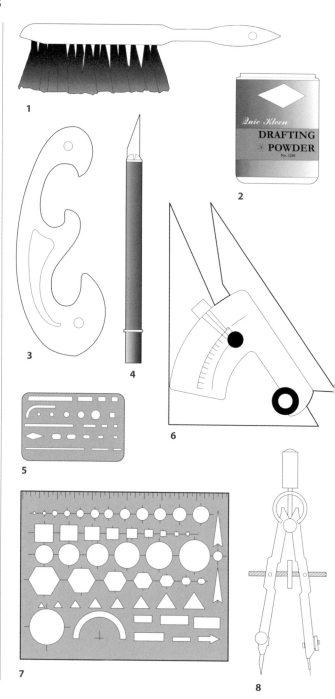

Triangular Architect's Scale (1:1)

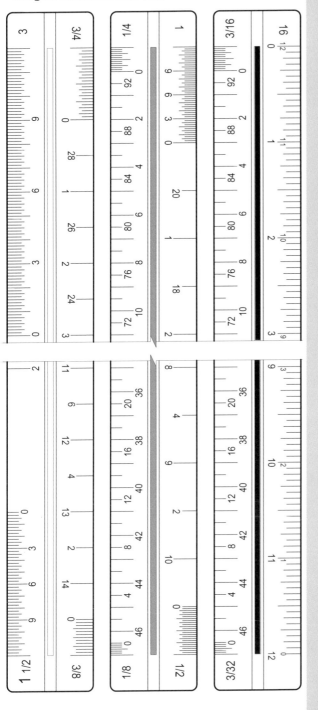

With the exception of perspectives and some other three-dimensional representations, most architectural drawings are made "to scale." Simply put, a floor plan or elevation, too large to be represented at full scale (1″=1″), must be reduced to fit on a sheet of paper. To do so, a standard architect's scale is employed. A representation made at a quarter-inch scale (1/4″=1′-0″), for instance, indicates that a distance of a quarter-inch on the drawing equals one foot in reality.

The three sides of a triangular architect's scale provide a total of eleven scales, which are written as follows:

$$1/16″=1′-0″$$
$$3/32″=1′-0″$$
$$1/8″=1′-0″$$
$$3/16″=1′-0″$$
$$1/4″=1′-0″$$
$$3/8″=1′-0″$$
$$1/2″=1′-0″$$
$$3/4″=1′-0″$$
$$1″=1′-0″$$
$$1 1/2″=1′-0″$$
$$3″=1′-0″$$

Engineer's scales are often used for larger-scale drawings such as site plans; they follow the same principle as architect's scales but with larger increments of ten (1″=10′, 1″=50′, 1″=100′, and so forth). Scales are also available in metric units.

PENCILS

Harder leads contain more clay, whereas softer leads contain more graphite. Lead holders employ a push-button that advances the 2 mm lead, which comes in a wide array of hardnesses, colors, and nonphoto blue (does not appear on reproductions). Leads are sharpened in lead pointers or with simple emery paper or sandpaper blocks.

Pencil Hardness Range

wood pencil

clutch lead holder

lead refills for lead holder

Grade	Weight and Use	
9H	very hard and dense	
8H		
7H		ideal range for guidelines and underlay work
6H		
5H		
4H		
3H		
2H	medium-hard	
H	medium	best range for finished drawings
F	medium, general purpose	
HB	medium-soft, bold line work	
B		
2B		range for bold lines and shading, less suitable for drafting purposes
3B		
4B		
5B		
6B	very soft	

TECHNICAL INK PENS

Technical pens, which use an ink flow–regulating wire with a tubular point (the pen nib), can produce very precise line widths. Depending on the pen type, the ink may come in a prepackaged cartridge or the barrel of the pen may be filled with ink as needed. The finer the pen nib, the more fragile and prone to clogging it is. All nibs require cleaning and maintenance to keep them in working order. Ink should be waterproof, nonfading, and opaque. Ink pens can be used on most paper types and are ideal for vellum and Mylar; they can even be erased from Mylar film with a nonabrasive drafting eraser or electric eraser.

Technical Pen Line Weights

7	
2.0	
6	
1.4	
4	
1.2	
3 1/2	
1.0	
3	
.80	
2 1/2	
.70	
2	
.60	
1	
.50	
0	
.35	
00	
.30	
3x0	
.25	
4x0	
.18	
6x0	
.13	

pen nib

technical pen body

Chapter 7: Computer Standards and Guidelines

Building design and construction involves enormous amounts of information in need of organization and dissemination among numerous groups of interested and active parties. The introduction of computers into this process has understandably changed the way in which buildings are conceived, designed, and documented. Truly, many things can now be done faster and with more ease, but computers have given rise to new issues involving management of computer files, quality standards for deliverable materials, and the constant need to stay current with rapidly evolving technologies. The prospect of documenting computer standards and guidelines as static and absolute is therefore neither productive nor possible—the only thing that is certain is that things will change. With this in mind, this chapter focuses on guidelines affecting AutoCAD, at this printing still the de facto industry standard for construction document production. Notable programs related to modeling, rendering, and animation are presented in brief, with an eye toward likely future trends.

COMPUTER PROGRAMS

Architectural production can be divided into two major groups: contract document deliverables and general presentation materials.

Deliverables are usually understood as the construction document set composed of the basic two-dimensional drawing types (plan, section, elevation, details, and schedules) that describe the building sufficiently for the contractors to build it.

The computer programs used to produce a standard set of deliverables are primarily drafting programs. In essence, they provide efficient, precise, and easily modifiable mechanical drawings. AutoCAD remains the drafting program of choice for most architects and engineers. Though it does have three-dimensional capabilities and can also accommodate rendering plug-ins, for high-quality presentation drawings, AutoCAD is still most valued for its precision as a versatile drafting program.

Presentation materials can include standard plan, section, and elevation drawings as well as physical three-dimensional models, computer renderings, and animations. Computer modeling and rendering programs are numerous and varied, depending on the desired output. Predictably, the more sophisticated the intended product, the more expensive the tool.

Modeling programs are not limited to production output. Many are employed extensively to design complex forms that would simply be impossible otherwise. Increasingly, architecture is taking advantage of programs developed for use in other fields, such as the automotive industry, aerospace engineering, video game development, and animated film production.

AUTOCAD TERMS

Aspect ratio: Ratio of display width to height.

Block: Grouping of one or more objects combined to form a single object. On creation, blocks are given a name and an insertion point.

CAD: Computer-aided design or computer-aided drafting. Also CADD, for computer-aided design and drafting.

Command line: Text area reserved for keyboard input, messages, and prompts.

Coordinates: *X*, *y*, and *z* location relevant to a model's origin (0,0,0).

Crosshairs: Type of cursor.

Cursor: Active object on a video display that enables the user to place graphic information or text.

Drawing file: Electronic representation of a building or object.

Drawing web format (DWF): Compressed file format that is created from a DWG file, ideal for publishing and viewing on the Web.

DWG: File format for saving vector graphics from within AutoCAD.

Drawing interchange format (DXF): ASCII or binary file format of an AutoCAD drawing, for exporting AutoCAD drawings to other applications or importing those from other applications into AutoCAD.

Entity: Geometric element or piece of data in a CAD drawing, such as a line, a point, a circle, a polyline, a symbol, or a piece of text.

Explode: Disassemble complex objects such as blocks and polylines.

External reference: File or drawing that is used as background in another drawing but cannot be edited, except in its original drawing. Examples include building grids and site information. Also called X-Ref.

Layer: Entity used for classification in a CAD drawing, whose properties allow for manipulation and flexibility of information in the drawing.

Model: In AutoCAD, a two- or three-dimensional representation of an object; or a three-dimensional replica of a design, whether physical or digital.

Model space: One of two primary spaces in which AutoCAD entities exist. Model space is a three-dimensional coordinate space in which both two-dimensional and three-dimensional drafting and design are done at full (1:1) scale.

Paper space: Other primary AutoCAD space. Used for creating a finished printable or plottable layout; usually contains a title block.

Polyline: Object made up of one or more connected segments or arcs, treated as a single object.

Sheet file: Print- or plot-ready electronic representation of a presentation sheet, containing a view or views of the model, text, symbols, and a title block.

User coordinate system (UCS): System that defines the orientation of *x*, *y*, and *z* in three-dimensional space.

UCS icons: Keys that indicate the direction of *x*, *y*, and *z* planes, as well as whether the user is in paper space or model space.

paper
space
icon

model
space
icon

Viewport: Bounded area that displays some portion of the model space of a drawing.

Window: Drawing area, including the command line and surrounding menus.

AUTOCAD WINDOWS

Active Model Space

Model may be edited
in model space. —

Tilemode = 1 (on)

All drawing done in model
space should be at 1:1.

UCS icon —

Active Paper Space

Title block or other non–model
space information may be edited
in the paper space viewport. —

Tilemode = 0 (off).
When tilemode is off,
viewports are objects that
can be moved and resized. —

UCS icon —

Paper Space with Active
Model Space Viewport

To enter the viewport, type
ms at command line; note
the model space icon.

Tilemode = 0 (off)

Paper space scales (XP) may
be set by zooming while in this
mode. Editing of the model is
possible though not encouraged.

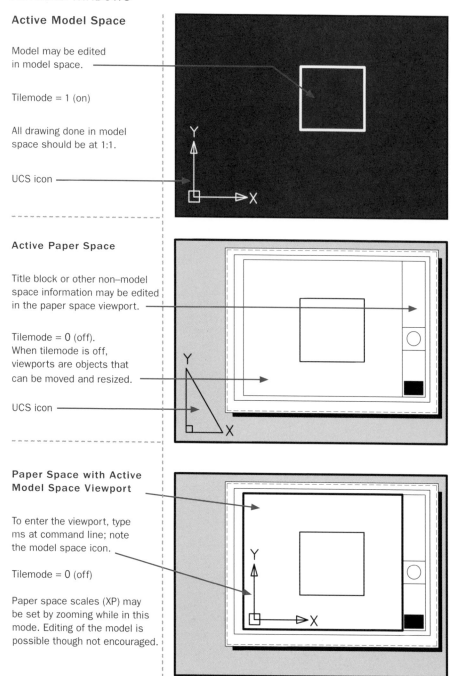

EXTERNAL REFERENCES

External reference (X-Ref) drawings contain architectural information common to multiple sheet files. Typically, these drawings are floor plans that can serve many purposes; each has its own sheet file. For example, the same plan model can be used for floor plans, reflected ceiling plans, and large-scale plans.

The following diagram describes the interaction between X-Ref drawings and sheet files.

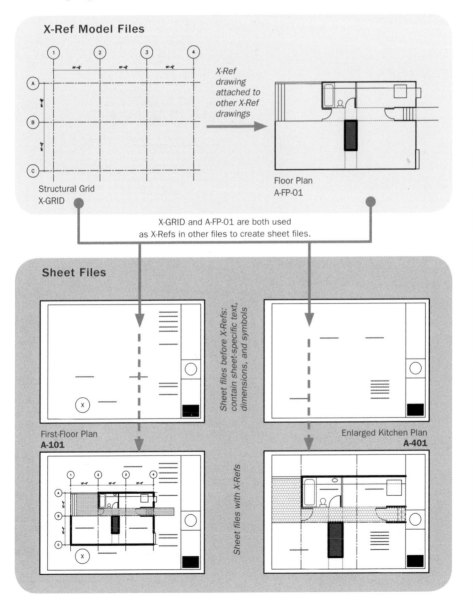

MODEL SPACE AND PAPER SPACE SCALES

All AutoCAD models and drawings, from detailed wall sections to expansive site plans, are drawn in model space at full scale (1:1). Paper space is used to set up print- and plot-worthy sheets (often with the use of a title block) that enable the information in model space to be printed to a specific and accurate scale. Such a system allows the architect considerable flexibility when designing and drawing, because one drawing can be used at many different scales and for many different purposes and need not be drawn "to scale."

A simple way to envision the relationship between model and paper space is to think of the paper space title block as an actual piece of paper, with a hole cut out (the viewport). Through this hole model space is visible. Using XP factors (see following page), the model in the viewport is scaled in relation to the paper space title block.

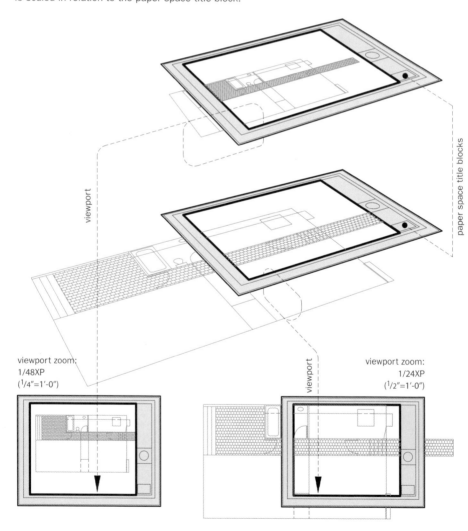

viewport

paper space title blocks

viewport zoom:
1/48XP
($^1/_4$"=1'-0")

viewport

viewport zoom:
1/24XP
($^1/_2$"=1'-0")

AutoCAD Text Scale Chart (in inches)

DWG Scale	Scale Factor	XP Factor	Desired Text Height									
			$1/16''$	$3/32''$	$1/8''$	$3/16''$	$1/4''$	$5/16''$	$3/8''$	$1/2''$	$3/4''$	$1''$
Full	1	1	.0625	.09375	.125	.1875	.25	.3125	.375	.5	.75	1
$6''=1'$.5	1/2	.125	.1875	.25	.375	.5	.625	.75	1	1.5	2
$3''=1'$.25	1/4	.25	.375	.5	.75	1	1.25	1.5	2	3	4
$1^1/_2''=1'$.125	1/8	.5	.75	1	1.5	2	2.5	3	4	6	8
$1''=1'$.08333	1/12	.75	1.125	1.5	2.25	3	3.75	4.5	6	9	12
$3/4''=1'$.0625	1/16	1	1.5	2	3	4	5	6	8	12	16
$1/2''=1'$.04167	1/24	1.5	2.25	3	4.5	6	7.5	9	12	18	24
$3/8''=1'$.03125	1/32	2	3	4	6	8	10	12	16	24	32
$1/4''=1'$.02083	1/48	3	4.5	6	9	12	15	18	24	36	48
$3/16''=1'$.015625	1/64	4	6	8	12	16	20	24	32	48	64
$1/8''=1'$.01042	1/96	6	9	12	18	24	30	36	48	72	96
$1/16''=1'$.005208	1/192	12	18	24	36	48	60	72	96	144	192
$1''=10'$.0083	1/120	7.5	11.25	15	22.5	30	37.5	45	60	90	120
$1''=20'$.004167	1/240	15	22.5	30	45	60	75	90	120	180	240
$1''=30'$.002778	1/360	22.5	33.75	45	67.5	90	112.5	135	180	270	360

Using This Chart

Because all work done in AutoCAD models should be at 1:1, text and labels must be adjusted to appropriate sizes based on the scale at which they will be printed.

For example: if a detail drawing will be printed at $3''=1'-0''$, and the desired height of the text when printed is $1/8''$, the text in the model must be set to 0.5''. If the same drawing will be printed at $1/4''=1'-0''$, and that text also needs to be $1/8''$ high, any text related to the $1/4''$ scale output would be set to 6'' in the model. Many clients, including government agencies, will require a minimum text size for legibility.

Using Paper Space Scales (XP)

The XP scale is the relationship between the desired plotted scale and the sheet of paper on which it will be plotted. With hand drafting, one would typically use an architect's or engineer's scale to assist in correctly making a drawing "to scale." On such a scale, if using $1/4''=1'-0''$, 1' is shown on the scale as $1/4''$ in length; 2' are shown as $1/2''$, and so on. In reality, the scale has already done much of the calculation necessary to draw at the desired scale. To describe this process accurately, one could say that, for the drawing to fit on a certain sheet of paper, the drawing has been made at $1/48$th its full scale (if $1/4''=12''$, $1/4 \times 1/12 = X$, therefore $X = 1/48$).

In AutoCAD the process is much the same. To set the scale of a viewport while inside the viewport (ms) in paper space, zoom to 1/48XP (also equal to 0.02083XP). XP literally means "times paper space." This action will zoom the viewport window to $1/4''=1'-0''$ in relation to the paper space title block, which is printed at 1:1.

AUTOCAD FILE-NAMING CONVENTIONS

File types have a direct bearing on the format of the file and the manner in which it should be named. File types include models, details, sheets, schedules, text, databases, symbols, borders, and title blocks. The file- and layer-naming system discussed here follows the AIA CAD Guidelines, as established by the U.S. National CAD Standard.

Drawing Types

(specific to particular disciplines)

A-CP	Ceiling Plans
A-EP	Enlarged Plans
A-NP	Finish Plans
A-RP	Furniture Plans
C-EP	Environmental
C-GP	Grading
C-RP	Roads/Topographic
C-SV	Survey
C-UP	Utility
E-CP	Communication
E-GP	Grounding
E-LP	Lighting
E-PP	Power
*-VP	Evacuation Plan
F-KP	Sprinkler Plan
I-CP	Ceiling Plans
I-EP	Enlarged Plans
I-NP	Finish Plans
I-RP	Furniture Plans
M-CP	Control Plans
M-HP	HVAC Ductwork Plans
M-PP	Piping Plans
P-PP	Plumbing Plans
S-FP	Framing Plans
S-NP	Foundation Plans
T-DP	Data
T-TP	Telephone

Level 1 Discipline Designators

Both file names and layer names are classified by discipline. The discipline code is a two-character field in which the second character is either a hyphen or a modifier defined by the user.

A	Architectural
B	Geotechnical
C	Civil
D	Process
E	Electrical
F	Fire Protection
G	General
H	Hazardous Materials
I	Interiors
L	Landscape
M	Mechanical
O	Operations
P	Plumbing
Q	Equipment
R	Resource
S	Structural
T	Telecommunications
V	Survey/Mapping
X	Other Disciplines
W	Works
Z	Contractor/Shop Drawings

Model Files

A building model file is an electronic representation of the building. Models may be two- or three-dimensional and are created at a true 1:1 scale. All geometry in a model file contains a three-dimensional coordinate (x, y, z). In two-dimensional drawings, the z coordinate is 0.

Sheet Files

The electronic sheet file contains one or more views of one or more model files, as well as text, symbols, and, often, a border or title block. The title block generally contains graphic and text information common to all other sheets in a project or section.

Standard Model File Identification

Model File Types

FP	Floor Plans
SP	Site Plans
DP	Demolition Plans
QP	Equipment Plans
XP	Existing Plans
EL	Elevations
SC	Sections
DT	Details
SH	Schedules
3D	Three-Dimensional Drawings
DG	Diagrams

discipline
designator
(same as for sheet file naming)

hyphen
(serves as a placeholder and makes name more readable)

model file type defined by user
(optional alphanumeric modifiers)

Examples: **A-FP-01** (Architectural Floor Plan, Level 1)
P-DP-010 (Plumbing Demolition Plan, Level 1)

Standard Sheet Identification

Sheet Type Designators

0	General
1	Plans
2	Elevations
3	Sections
4	Large-scale Views
5	Details
6	Schedules and Diagrams
7	User Defined
8	User Defined
9	Three-Dimensional Drawings

discipline
designator
(discipline character plus optional modifier character)

sheet type
designator

sheet
sequence
numbers

defined by user
(optional alphanumeric modifiers)

Examples: **A-103** (Architectural Plan, Level 3)
AD206 (Architectural Demolition Elevation, Level 6)

AIA CAD LAYER GUIDELINES

Most vector-based CAD systems use and support the concept of layers. Layers allow for building design information to be systematically organized so as to facilitate maximum coordination and flexibility, especially as drawing files are shared among multiple users. Through controlling the visibility of selected layers, data can be created, reviewed, and edited in multiple fashions: by how the building is organized, by the sequence of construction, or by building trades. Many members of the design team, including the consulting trades, will examine and edit the drawing files, precipitating a need for a clear and orderly system of layer naming. The same discipline designators that are applied to drawing and sheet files are used to classify layers.

Layer Name Format

Discipline Designator (Level 1)
An optional second character may be used to further define the discipline character. In this case, the optional modifier does not replace the hyphen, but simply works with the discipline character to create a two-character field.

Status (Phase)
As an optional, single-character field that comes at the end of the layer name, the status designator is used to distinguish the status of the phase of work or construction.

N	New Work
E	Existing To Remain
D	Existing To Demolish
F	Future Work
T	Temporary Work
M	Items To Be Moved
X	Not in Contract
1–9	Phase Numbers

A-WALL-FULL-TEXT

Major Group
Four-character field that identifies a major building system. When using this system, user-defined major group field codes are forbidden.

Minor Group
Optional, four-character field for further defining the major groups. Any reasonable combination of the prescribed major and minor groups is permitted. User-defined minor group field codes are permitted and must be four characters in length.

Minor Group
Optional, second minor group for further clarification, as needed.

Layer Name Components

The tables on the following pages provide the primary components of possible major and minor group designations, as well as general and specialized discipline designators. Taken all together, these tables should provide sufficient information for most layers needed in the discipline of architecture. Space does not permit such lists for all related disciplines.

Drawing View Field Codes

Drawing view field codes are specialized codes for layers organized primarily by drawing type (details, elevations, and sections) rather than by major building systems. DETL, ELEV, and SECT are the only field codes allowed as either a major or a minor group.

Where layers are organized by drawing type, an optional alphanumeric minor group field code (ANNN) can be used to modify a drawing view as a major group. The code cannot be used to modify any other major group, and it must consist of an alphabetic character followed by a three-digit number between 001 and 999. The definition of the ANNN code is determined by the user.

Minor group field codes for material cut (MCUT), material beyond cut (MBND), textures and hatch patterns (PATT), component identification numbers (IDEN), and outline of object (OTLN) may be used to modify either major or minor groups.

Layer Name	Description
**-DETL	Detail
**-ELEV	Elevation
**-SECT	Section
-**-ANNN	Drawing view major group–optional number (A = letter, NNN = number between 001 and 999)
-**-ANNN-IDEN	Drawing view major group–optional number component identification numbers
-**-ANNN-MBND	Drawing view major group–optional number material beyond cut
-**-ANNN-MCUT	Drawing view major group–optional number material cut by the view
-**-ANNN-PATT	Drawing view major group–optional number textures and hatch patterns
-**-ANNN-OTLN	Drawing view major group–optional number outline of object drawn

* designates a placeholder

Annotation Layer List*

Layer Name	Description
**-ANNO	Annotation
-**-BRNG	Bearing and distance labels (survey coordinates)
-**-DIMS	Dimensions
-**-IDEN	Identification tags
-**-KEYN	Keynotes
-**-LABL	Labels
-**-LEGN	Legends, symbol keys
-**-MARK	Markers, break marks, leaders
-**-MATC	Match lines
-**-NOTE	Notes
-**-NPLT	Non-plotting graphic information (construction lines)
-**-RDME	Read-me layer (not plotted)
-**-REDL	Redlines
-**-REFR	Reference, external files
-**-REVC	Revision clouds
-**-REVS	Revisions
-**-SCHD	Schedules
-**-SYMB	Reference symbols
-**-TABL	Data tables
-**-TEXT	Text
-**-TITL	Drawing or detail titles
-**-TTLB	Border and title block

*Annotation consists of text, dimensions, notes, sheet borders, symbols, and any other elements that do not represent physical aspects of the building. The minor groups listed may be used to modify any major or minor group in the layer list. When they modify the major group ANNO, all annotation can be placed in a defined group of layers.

Architectural Discipline Designators

Designator	Description
A	Architectural
A S	Architectural Site
A D	Architectural Demolition
A E	Architectural Elements
A I	Architectural Interiors
A F	Architectural Finishes
A G	Architectural Graphics
A J	User defined
A K	User defined

Architectural Layer List

(a complete list of prescribed major and minor group field codes for the discipline of architecture)

Layer Name	Description
A*-****-CASE	Any major group: casework
A*-****-FIXT	Any major group: plumbing fixtures
A*-****-FNSH	Any major group: finishes
A*-****-GRID	Any major group: grid
A*-****-SIGN	Any major group: signs
A*-AREA	Area
A*-CLNG	Ceiling
A*-CLNG-ACCS	Ceiling: access
A*-CLNG-OPEN	Ceiling: openings
A*-CLNG-SUSP	Ceiling: suspended elements
A*-CLNG-TEES	Ceiling: main tees
A*-COLS	Columns
A*-CONV	Conveying systems
A*-DOOR	Doors
A*-DOOR-FULL	Doors: full-height (swing and leaf)
A*-DOOR-PRHT	Doors: partial-height (swing and leaf)

continued

Architectural Layer List *(continued)*

Layer Name	Description	Layer Name	Description
A*-EQPM	Equipment	A*-FURN-PNLS	Furnishings: system panels
A*-EQPM-ACCS	Equipment, access	A*-FURN-SEAT	Furnishings: seating
A*-EQPM-FIXD	Equipment, fixed	A*-FURN-STOR	Furnishings: system storage components
A*-EQPM-MOVE	Equipment, moveable		
A*-EQPM-NICN	Equipment: not in contract	A*-FURN-WKSF	Furnishings: work surface systems
A*-EQPM-OVHD	Equipment: overhead		
A*-FLOR	Floor	A*-GLAZ	Glazing
A*-FLOR-CASE	Floor: casework	A*-GLAZ-FULL	Glazing: full-height
A*-FLOR-EVTR	Floor: elevator cars and equipment	A*-GLAZ-PRHT	Glazing: partial-height
		A*-GLAZ-SILL	Glazing: window sills
A*-FLOR-HRAL	Floor: handrails and guardrails	A*-HVAC	HVAC
		A*-HVAC-RDFF	HVAC: return-air diffusers
A*-FLOR-LEVL	Floor: level changes, ramps, pits, depressions	A*-HVAC-SDFF	HVAC: supply-air diffusers
		A*-LITE	Lighting fixtures
A*-FLOR-OTLN	Floor: outline	A*-ROOF	Roof
A*-FLOR-OVHD	Floor: overhead (objects above)	A*-ROOF-HRAL	Roof: handrails
		A*-ROOF-LEVL	Roof: level changes
A*-FLOR-RAIS	Floor: raised	A*-ROOF-OTLN	Roof: outline
A*-FLOR-RISR	Floor: stair risers	A*-ROOF-RISR	Roof: stair risers
A*-FLOR-SIGN	Floor: signs	A*-ROOF-STRS	Roof: stair treads and ladders
A*-FLOR-SPCL	Floor: specialties (toilet room accessories, display cases)	A*-WALL	Walls
		A*-WALL-CAVI	Walls: cavity
A*-FLOR-STRS	Floor: stair treads, escalators, ladders	A*-WALL-CNTR	Walls: centerline
		A*-WALL-FIRE	Walls: fire wall
A*-FLOR-TPTN	Floor: toilet partitions	A*-WALL-FULL	Walls: full-height
A*-FLOR-WDWK	Floor: architectural woodwork	A*-WALL-HEAD	Walls: door and window headers
A*-FURN	Furnishings	A*-WALL-JAMB	Walls: door and window jambs
A*-FURN-FILE	Furnishings: file cabinets	A*-WALL-MOVE	Walls: moveable partitions
A*-FURN-FIXD	Furnishings: fixed in place	A*-WALL-PATT	Walls: texture or hatch patterns
A*-FURN-FREE	Furnishings: freestanding		
A*-FURN-PLNT	Furnishings: plants	A*-WALL-PRHT	Walls: partial-height

CH. 26

LINETYPES

BATTING	DIVIDE2
BORDER	DOT
BORDER2	DOT2
BORDERX2	DOTX2
CENTER	FENCELINE1
CENTER2	FENCELINE2
CENTERX2	GAS_LINE
CONTINUOUS	HIDDEN
DASHDOT	HIDDEN2
DASHDOT2	HIDDENX2
DASHDOTX2	HOT_WATER_SUPPLY
DASHED	PHANTOM
DASHED2	PHANTOM2
DASHEDX2	PHANTOMX2
DIVIDE	TRACKS
DIVIDEX2	ZIGZAG

HATCHES

Hatches can be used at any scale, angle, or line weight. Standard libraries contain a large variety of common material symbols.

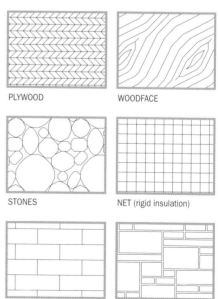

SOLID

AR-CONC (concrete)

AR-PARQ1 (earth)

NET (at 45°, masonry)

STEEL

PLAST (aluminum)

PLYWOOD

WOODFACE

STONES

NET (rigid insulation)

AR-BRSTD (brickwork)

4H-STONE

OTHER SYSTEMS

Virtually all architectural drafting is now done with the use of computers. Computer drafting, modeling, and rendering programs are taught extensively in schools of architecture, and where once the odd computer course was a novel anomaly, the situation is now reversed: Hand drafting is taught, but often as though it were Latin (a good language to learn, but one that won't come up much after graduation). For many architects of all ages, even those comfortable with computers, it is inconceivable to imagine designing without also drawing or sketching by hand. Others, though, who learn to draft by hand in school, will never use these skills in an office.

Computers are arguably a young person's domain, and understandably, many architects tend to be most comfortable working in the manner in which they were trained. The dizzying speed of advances in computer technology has effectively collapsed generations of architects into exponentially shorter time spans. The issue is not whether a designer has computer skills, but which of an ever-growing list of cutting-edge programs he or she has mastered. This situation can be awkward in a profession known for its slow reaction times, but architecture is becoming accustomed to such growing pains, and keeping up with the times is imperative for most practices to stay in business.

Parametric Design

Despite their ubiquity and versatility in document production, computer drafting programs cannot escape the fundamental fact that they are essentially reproducing the actions and effects of hand drafting. Parametric modeling pushes such production into a completely new realm with programs like Revit,* a three-dimensional Parametric Building Information Modeler (3DPBIM) that employs a parametric change engine to automatically coordinate changes made anywhere—in model views or drawing sheets, schedules, sections, or plans. Standard two-dimensional CAD designs are object driven, meaning that if the object is changed, the dimension will change. By contrast, parametric modeling designs are dimension driven, so changing the dimension will change the object.

Projects using 3DPBIM work with models rather than geometry; every building element has three-dimensional qualities, regardless of how it will be printed. With parametric building elements, a wall exists only once (instead of being drawn separately in plan, section, and elevation) and has encoded in it everything about its identity, such as height, thickness, type of construction, fire resistance, and relationship to other elements.

All drawings in a set are produced from the same parametric building model, and updates to any aspect of the model will result in updates to reflected views and schedules. This eliminates both the time-consuming process of coordinating changes as they ripple through the drawing set and the possibility for error and omission that accompanies such coordination.

Parametric building modelers provide a data store into which all the information about a project can be entered, and from which different building professionals can view and manage the information they need. This process aids greatly in sizing and quantifying materials, producing project schedules, and maintaining consistency throughout the project.

*Revit® and AutoCAD® are both Autodesk® products.

Modeling, Rendering, and Animation

Physical three-dimensional scale models are still widely used to help clients understand the design of their buildings, and many feel more comfortable with models than with sets of plans and sections. Models can be quick studies or intricate and involved presentations of the final result. A highly finished model is expensive and time-consuming to produce and cannot accommodate easily any changes to a design. Computer modeling provides a flexibility not possible with standard models and plans. It allows designers to try many things, including working out complex geometries, studying materials, and performing solar studies. Computer models are easily edited, and a single model can produce infinite views and levels of detail, so that one seems to inhabit specific spaces in the design.

Rendering models can produce realistic depictions of materials, light, and reflections. Animations allow movement through a space, movement of objects, or both. Present modeling capabilities appear almost boundless, and even very basic programs can produce impressive effects. For many programs, their limits seem to be defined only by the ability of the person using them.

Helpful Terms

Mapping: Quick rendering method that simulates light reflecting on an object by mapping light over the image instead of computing the light's path.

Radiosity: Rendering method that simulates reflection of light off one surface and onto another, producing more accurate methods of rendering light and shadows (such as producing the soft shadows that exist in the real world) than ray tracing.

Raster graphics: Data files or structures representing a rectangular grid of pixels, or points of color, and whose quality is determined by the number of pixels, or resolution. Also known as digital images or bitmaps.

Ray tracing: Time- and process-intensive rendering method that simulates light reflections, refractions, and shadows by following a light path from a source and computing each pixel in the image to create the effect of the light.

Vector graphics: Computer images stored and displayed in terms of geometric primitives such as points, lines, curves, and polygons, rather than as a collection of pixels (as in raster graphics).

Modeling Systems

Wireframe: Simplest form of three-dimensional modeling description, comprising lines and curves that have x, y, and z coordinates within the model space.

Surface modeling: Next level of modeling description. Usually requires wireframe elements to generate surfaces. Surfaces can be used to generate sections and determine area calculations, and can be rendered.

Solid modeling: Solid primitives can be built without previous wireframe or surface elements. Solids have a mass, can be used to calculate volume as well as area, and can be rendered.

Modeling Programs

To commit to modeling software is a big decision for many firms, because it involves an investment of both money to purchase the program and time for employees to learn it. The decision depends on the priorities of the office and its clients (or the clients they'd like to attract). In abbreviated form, the following list highlights a range of modeling possibilities.

Sketchup *(from @Last Software)*

Sketch-based 3-D modeler that works with planes and surfaces instead of solids. Easy to learn and use, it can exchange data with most standard CAD, 3-D modeling, and illustration applications. It does not use ray tracing or radiosity, but designers can create many levels of output quality and effect using materials, colors, and shadows. Basic animations are also possible. Sketchup is an inexpensive modeling tool capable of producing images of considerable detail and quality.

FormZ *(from auto-des-sys)*

General-purpose solid and surface modeler with good 2-D and 3-D capabilities. Performs Boolean operations and generates NURBS (Non-Uniform Rational Bézier Spline) curves, terrain, meshes, contours, among other forms. FormZ RenderZone can produce photorealistic rendering effects; it also allows 2-D drafting.

3D Studio Viz *(from Autodesk)*

Modeling, rendering, and animation program with an AutoCAD interface.

Rhinoceros

Reasonably priced 3-D solid modeling, rendering, and animation program with a CAD interface. Designs can be developed using sketches, images, illustration files, CAD files, multimedia scenes, or physical models. Predominantly used in industrial and jewelry design.

Maya

NURBS-based 3-D modeling, animation, and rendering program for creating full-motion effects. Realistic rendering of natural effects like wind blowing or clothes moving has made it useful for special effects in movies.

CATIA *(from Dassault Systemes, sold through IBM)*

High-end solid model and 3-D Product Lifecycle Management (PLM) software capable of managing the entire life cycle of a design, from the concept and design phase through documentation, construction, and occupancy. Used extensively in the automotive and aerospace industries, CATIA is built on a knowledge-based architecture that enables the integration of many forms of intelligence in and from CAD, CAE (Computer-Aided Engineering), and CAM (Computer-Aided Manufacturing).

Digital Project for CATIA *(from Gehry Technologies)*

Package of elements for building industry solutions, used as add-ons to CATIA V5. For architecture offices, this is a less expensive alternative to the full-scale CATIA program.

PROPORTION AND FORM 2.

Since most architecture, even that designed for a large-scale use (such as an airplane hangar or an elephant barn), requires some human interface, our own bodies serve as useful reference points for inhabiting space. Similarly, no matter how complicated structures may be, most are reducible to the point, line, or plane that evolved into the more complex combinations of forms and spaces that constitute a design.

Throughout history, architects have devised and employed ordering and proportioning systems for architecture based on the logics of harmonics, arithmetic, geometry, and the human body, often producing a visual and physical order that is apparent to the observer even if the organizing logic is not known or understood.

Daily life brings us into contact with endless numbers of systems of arrangement and order, much of it centered on how our bodies and our cars (extensions of our bodies) use and navigate our immediate surroundings and share them with others. The standards presented here describe the basic clearances demanded of an assortment of programs that architects regularly encounter. They do not propose specific designs, but give a better understanding of how different bodies occupy different spaces.

Chapter 8: The Human Scale

The scale of the human body informs almost every aspect of architectural design. The dimensions in this chapter represent an average range (the lower number denotes the 2.5th percentile, while the upper number denotes the 97.5th percentile).

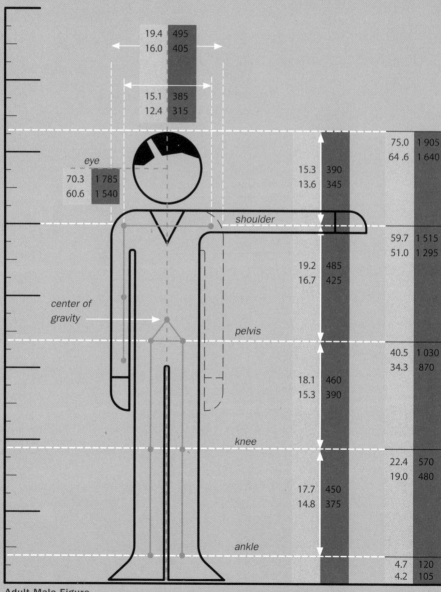

Adult Male Figure

On the drawings below, the gray bars indicate inches and the blue bars indicate millimeters.

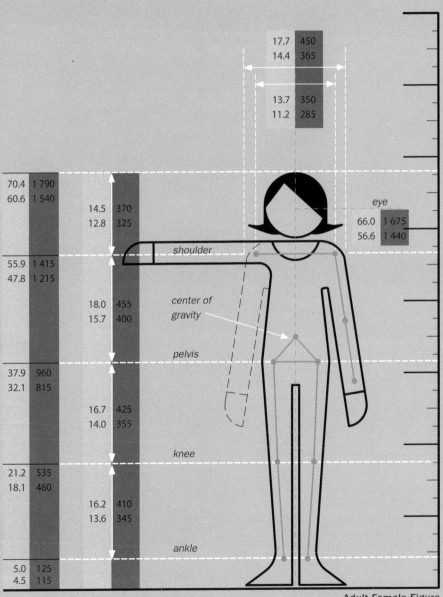

17.7	450
14.4	365

13.7	350
11.2	285

70.4	1 790
60.6	1 540

14.5	370
12.8	325

eye

66.0	1 675
56.6	1 440

shoulder

55.9	1 415
47.8	1 215

18.0	455
15.7	400

center of gravity

pelvis

37.9	960
32.1	815

16.7	425
14.0	355

knee

21.2	535
18.1	460

16.2	410
13.6	345

ankle

5.0	125
4.5	115

Adult Female Figure

ACCESSIBLE DESIGN DIMENSIONS

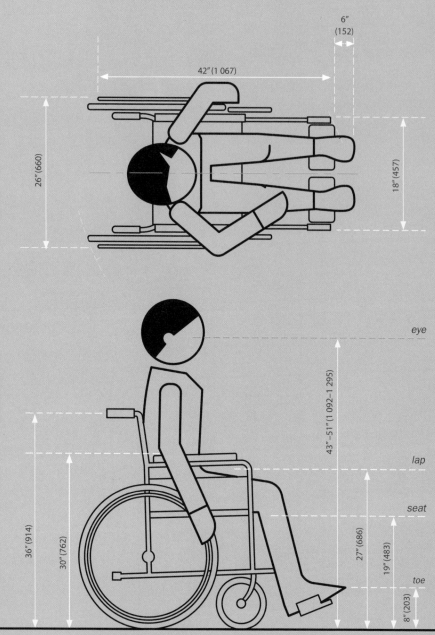

Overall Dimensions for Adult Wheelchairs

Architects must equally be familiar with the dimensions of those with special needs, specifically the constraints posed by wheelchair use. Design to accommodate wheelchairs and other special needs is increasingly the rule rather than the exception, particularly as the concept of universal design gains more prominence. Universal design suggests making all elements and spaces accessible to and usable by all people to the greatest extent possible—a goal that, through thoughtful planning and design, need not add to the cost of production.

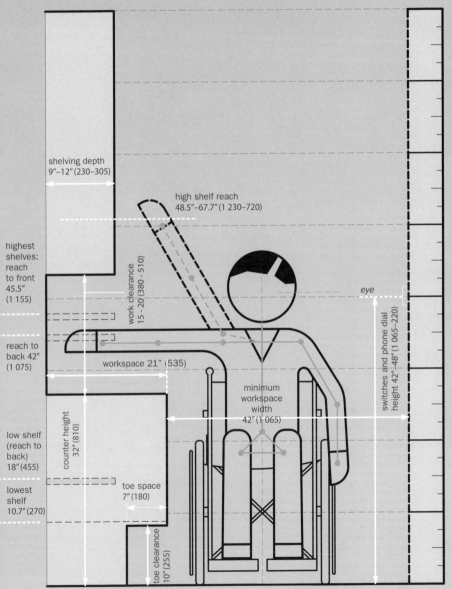

shelving depth
9″–12″ (230–305)

high shelf reach
48.5″–67.7″ (1 230–720)

highest shelves:
reach to front
45.5″ (1 155)

work clearance
15–20 (380–510)

reach to back 42″ (1 075)

workspace 21″ (535)

eye

switches and phone dial
height 42″–48″ (1 065–220)

minimum workspace width
42″ (1 065)

counter height
32″ (810)

low shelf
(reach to back)
18″ (455)

lowest shelf
10.7″ (270)

toe space
7″ (180)

toe clearance
10″ (255)

CH. 13 CH. 14

Side Approach Work Station Clearances

SEATED DIMENSIONS

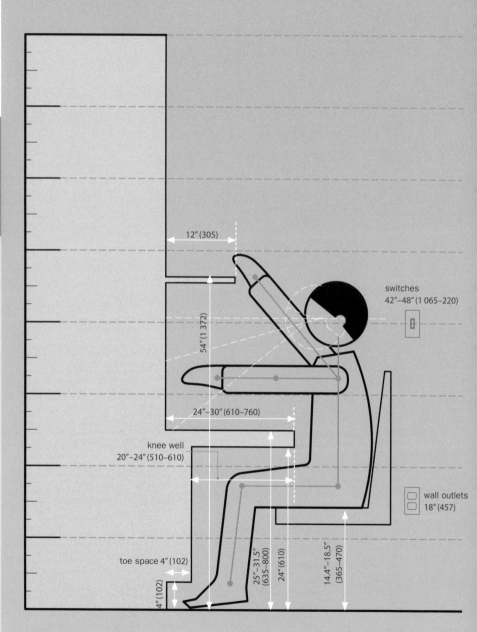

12" (305)

54" (1 372)

switches
42"–48" (1 065–220)

24"–30" (610–760)

knee well
20"–24" (510–610)

wall outlets
18" (457)

toe space 4" (102)

25"–31.5"
(635–800)

24" (610)

14.4"–18.5"
(365–470)

4" (102)

Work Station Clearances

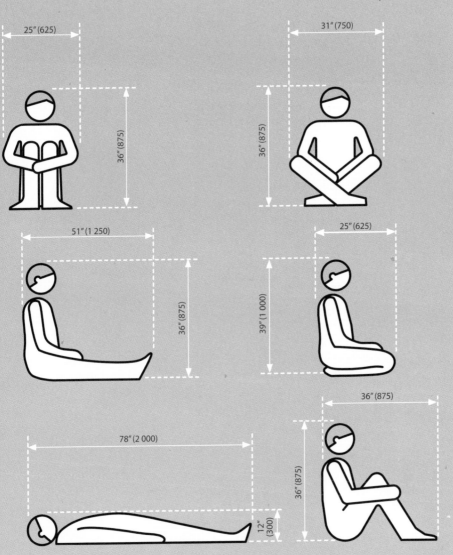

Lounging Position General Space Needs

Chapter 9: Form and Organization

PRIMARY ELEMENTS

The primary elements of form are points, lines, planes, and volumes, each growing from the other. A point is a position in space and the prime generator of form. A line is a point extended; its properties are length, position, and direction. A plane is a line extended; its properties are width and length, shape, surface, orientation, and position. A volume is a plane extended; its properties are length, width, and depth, form and space, surface, orientation, and position.

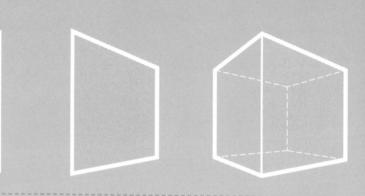

PRIMARY SHAPES

Square

Triangle

Circle

PLATONIC SOLIDS

Cube

Pyramid

Cone

Cylinder

Sphere

POLYHEDRA

Icosahedron (20-sided Solid)

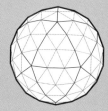

Geodesic Sphere

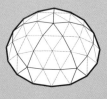

Geodesic Dome

A geometric polyhedron is a three-dimensional solid made up of a collection of polygons, usually joined at the edges.

Geodesic spheres and domes are designed by filling each face of a solid, such as an icosahedron, with a regular pattern of triangles, bulged out so that their vertices are not coplanar but are in the surface of the sphere instead. As a structural concept, the subpattern of triangles form geodesics that distribute stresses across the structure.

BOOLEAN OPERATIONS

Joining together or subtracting of one solid from one or more sets of solids.

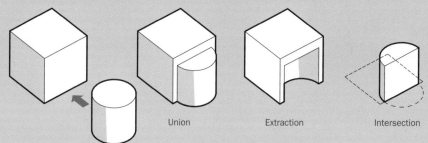

Union

Extraction

Intersection

RULED SURFACES

A ruled surface, which is the surface generated by connecting line segments between corresponding points, can take many forms.

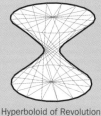

Hyperboloid of Revolution

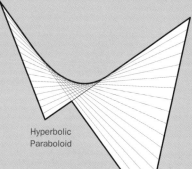

Hyperbolic Paraboloid

Conoid

A hyperbolic paraboloid is a doubly ruled surface generated by two meshes of lines that are skewed from each other but appear parallel when viewed in plan. The saddle point is found at its center.

CH. 27 CH. 28

ORGANIZING PRINCIPLES

Axis

A line defined by two points in space and about which elements, spaces, and forms are arranged.

Symmetry

A composition that is identical on opposite sides of a dividing line or central axis, creating a formal balance.

Types of Axes

Rotational Symmetry

Symmetry about a Center Point

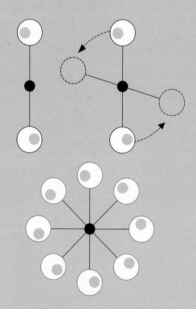

Symmetry of Order 4
(object matches itself four times in rotation)

RHYTHM AND REPETITION

Rhythm uses a regular or ordered repetition of dominant and subordinate elements or units to create an organizing series of like forms or spaces. Repetitive or recurring compositions may be used to create order and alignment or seeming disorder in an organized manner. Repetition of elements may be used for decorative purposes, elevational ordering, plan arrangements for building types with many like elements, and especially for structural grids and framing.

PROPORTIONING SYSTEMS

Though proportions and ratios are often thought to be the same thing, ratios, in fact, indicate a relationship of quantity or size between or among more than one thing; proportions establish a balanced relationship of parts to each other or to a greater whole. In architecture, proportion provides visual and spatial order as well as structural stability.

Proportional systems begin with a base module from which sizes and relationships grow. Architects have long used such ordering systems. In the classical orders, for example, the diameter of the column set the dimensions for all other elements, including the pedestal, capital, column height, and space between columns. The ancient Greeks applied the musical scale to building as an embodiment of universal harmony; during the Renaissance, architecture was believed to be a spatial manifestation of mathematics and the seven ideal plan shapes for rooms were the circle, square, $1:\sqrt{2}$, 1:2, 2:3, 3:4, and 3:5.

THE GOLDEN SECTION

The properties of proportion of the golden section have been employed by architects, artists, mathematicians, and musicians since the ancient Greeks recognized its proportional ordering in the human body. Even today many believe it to contain mystical qualities, whose unique mathematical and geometrical relationships create a harmonic condition that is nature's aesthetically "perfect" balance between symmetry and asymmetry.

Constructing a Golden Rectangle

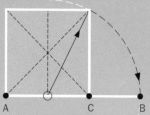

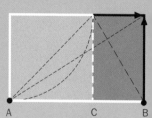

1. Create a square and locate the midpoint of one side.

2. Draw a line from the midpoint to a corner that does not share a line with the midpoint.

3. This is the radius of a circle with its center at the midpoint; the point where the circle and the line AC intersect becomes point B.

4. Line AB is the long leg of the golden rectangle.

5. A golden rectangle has been added to the original square, and together they also form a larger golden rectangle.

6. The process can be repeated infinitely, creating proportionally larger or smaller series of squares and rectangles.

In mathematics, the golden section is the ratio of the two divisions of a line such that the smaller is to the larger as the larger is to the sum of the two. In addition to its many uses in the arts and music, there are practical uses for the mathematical integrity of the golden section in its proportions as related to structure.

Calculating the Golden Mean

AC/CB = AB/AC (a unique characteristic)
If AB = 1, let AC = x

$$x=\frac{\sqrt{5}-1}{2} = 0.61803398 \ldots \text{(infinite)}.$$

Therefore: the ratio of AC to AB is approximately 61.8%;
the inverse (1/61.8) is 1.61803398 . . .

THE FIBONACCI SEQUENCE

The Fibonacci Sequence is a recursive series of numbers, where each number in the sequence is the sum of the two numbers preceding it. A simple sequence beginning with 0 follows:

0, 1, 1, 2, 3, 5, 8, 13, 21, 34, 55 ...

Any two adjacent numbers in the sequence may be divided, the lower number by the higher number (for example, 34/55), to achieve a very close approximation of the golden section (in this case, **0.618**1818 . . .). The higher the numbers, the more accurate the answer will be (for example: 377/610 = **0.6180**327 . . .).

REGULATING LINES

The guiding lines that indicate the pro-portional and alignment relationships in drawings, such as those depicting the golden rectangle, are known as regulating lines. They are used, for instance, both to determine and to illustrate proportional relationships in a design. Rectangles whose diagonals are either perpendicular or parallel to each other have similar proportions (even if they are not golden rect-angles), and the use of such lines is a common proportional ordering tool.

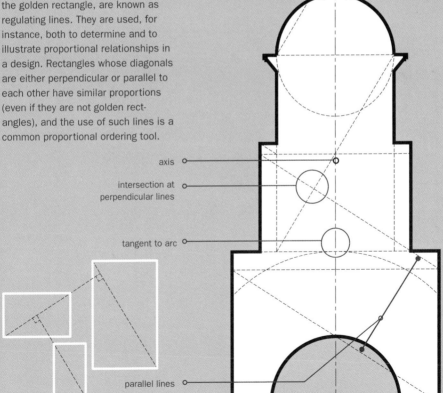

axis

intersection at perpendicular lines

tangent to arc

parallel lines

CH. 26 CH. 27

Chapter 10: Residential Spaces

KITCHENS

Typical Dimensions

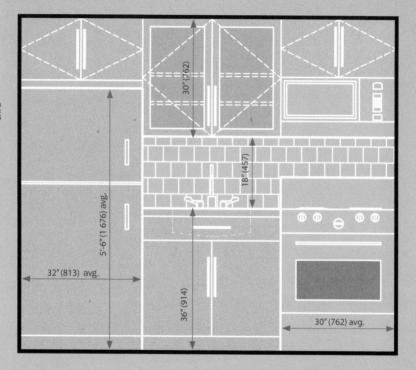

30" (762)

18" (457)

5'-6" (1 676) avg.

32" (813) avg.

36" (914)

30" (762) avg.

Typical Layout Types

Storage guidelines: minimum 18 sq. ft. (1.67 m²) basic storage, plus 6 sq. ft. (0.56 m²) per person served.

The total distance of all three sides of the work triangle should average between 23 lineal feet (7 010) and 26 lineal feet (7 925).

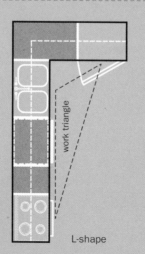

work triangle

L-shape

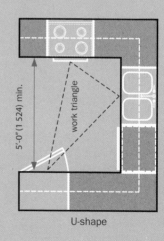

5'-0" (1 524) min.

work triangle

U-shape

Cabinetry Components

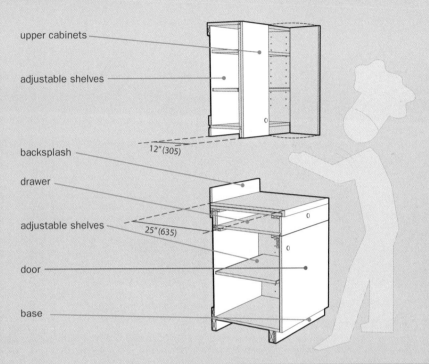

upper cabinets

adjustable shelves

12" (305)

backsplash

drawer

adjustable shelves

25" (635)

door

base

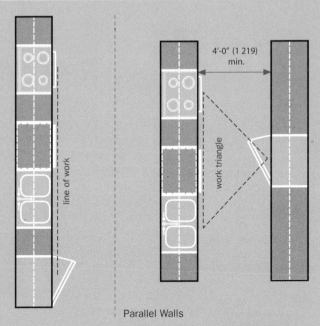

4'-0" (1 219) min.

work triangle

line of work

Single Wall

Parallel Walls

BATHROOMS

General Guidelines
(Subject to Local Codes)

Wall area above a tub or shower pan should be covered in a waterproof material to a height of not less than 72″ (1 829) AFF.

Minimum ceiling height = 6′-8″ (2 032)

Minimum ventilation should be a window of at least 3 sq. ft. (0.28 m²), of which 50 percent is operable, or a mechanical ventilation system of at least 50 cu. ft. per minute (cfm) ducted to the outside.

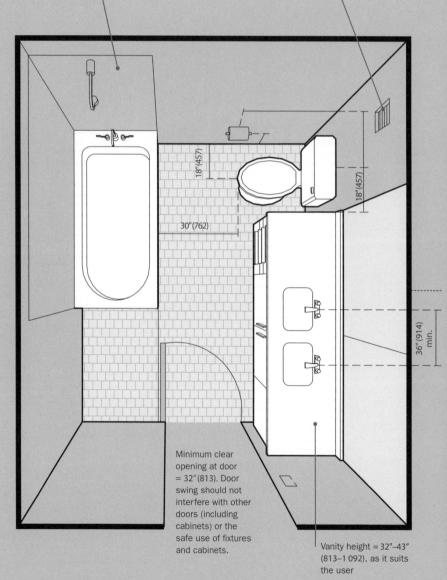

18″ (457)

30″ (762)

18″ (457)

36″ (914) min.

Minimum clear opening at door = 32″ (813). Door swing should not interfere with other doors (including cabinets) or the safe use of fixtures and cabinets.

Vanity height = 32″–43″ (813–1 092), as it suits the user

Glazing

Tempered glass or an approved equal should be used in the following conditions: shower doors or other glass in tub or shower enclosures; tub or shower surrounds with glass windows or walls that are less than 60" (1 524) above any standing surface; and any glazing such as windows or doors whose bottom edge is less than 18" (458) AFF.

Floors

Bathroom floors and tub and shower floors should have slip-resistant surfaces.

Electrical Outlets

All electrical receptacles should be protected by GFCI (ground-fault circuit interrupter) protectors, and at least one GFCI receptacle should be installed within 36" (914) of the outside edge of the lavatory. No receptacles of any kind should be installed in a shower or bathtub space, nor should switches be installed in wet locations in tub and shower spaces (unless installed as part of a UL-listed tub or shower assembly).

Lighting

In addition to general lighting, task lighting should be installed at each functional area of the bathroom, and at least one light must be provided that is controlled by a wall switch located at the entry. Any light fixture installed at a tub or shower must be marked as suitable for damp/wet locations.

Typical Arrangements

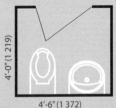

2'-6" (762)
6'-3" (1 905)

4'-0" (1 219)
4'-6" (1 372)

5'-0" (1 524)
7'-0" (2 134)

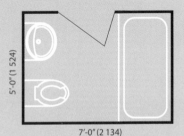

5'-0" (1 524)
7'-6" (2 286)

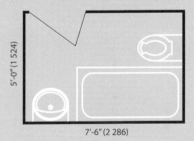

5'-0" (1 524)
8'-0" (2 438)

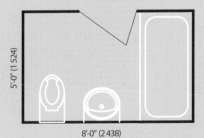

CH. 14

HABITABLE ROOMS

Beds (mattress sizes)

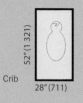

Crib
52" (1 321)
28" (711)

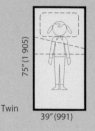

Twin
75" (1 905)
39" (991)

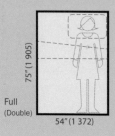

Full
(Double)
75" (1 905)
54" (1 372)

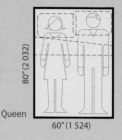

Queen
80" (2 032)
60" (1 524)

King
80" (2 032)
76" (1 930)

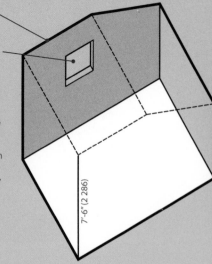

Ceiling height should not be less than 7'-6" (2 286) for at least 50 percent of the required area; 50 percent may be sloped to a minimum height of 5' (1 524).

In most residential projects, sleeping rooms should have at least one means of egress to the exterior, which can be in the form of an operable window of not less than 3.3 sq. ft. (0.307 m²), and with a minimum clear opening of 20" x 24" (508 x 610), with a sill height no higher than 44" (1 118).

7'-6" (2 286)

Seating

Table Size (in.)	Maximum Seats
24 x 48	4
30 x 48	4 (2 wch.)
30 x 60	6 (4 wch.)
36 x 72	6 (6 wch.)
36 x 84	8 (6 wch.)
30 x 30	2
36 x 36	4
42 x 42	4 (2 wch.)
48 x 48	8 (2 wch.)
54 x 54	8 (4 wch.)
30 dia.	2
36 dia.	4
42 dia.	4–5
48 dia.	6 (2 wch.)
54 dia.	6 (4 wch.)

wch. = wheelchair

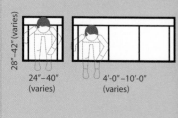

28"–42" (varies)
24"–40" (varies)
4'-0"–10'-0" (varies)

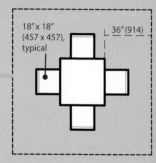

18" x 18" (457 x 457), typical
36" (914)

in.	24	30	36	42	48	54	60	72	84
mm	610	762	914	1067	1 219	1 372	1 524	1 829	2 134

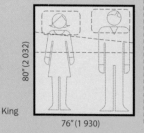

Each dwelling should have at least one room not less than 120 sq. ft. (11.15 m²).

Habitable rooms (except bathrooms and kitchens) should have an area greater than or equal to 70 sq. ft. (6.51 m²), with no less than 7'-0" (2 134) in any direction.

Kitchens may be a minimum of 50 sq. ft. (4.65 m²).

Closets

22"–30" (559–762) clear inside depth

48"–72" (1 219–829) of hanging space per person

12" (305) = 6 suits, 12 shirts, 8 dresses, or 6 pairs of pants

Garages

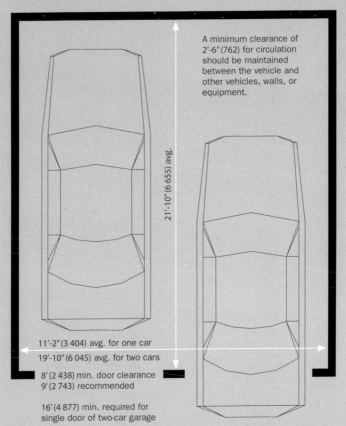

A minimum clearance of 2'-6" (762) for circulation should be maintained between the vehicle and other vehicles, walls, or equipment.

21'-10" (6 655) avg.

11'-2" (3 404) avg. for one car

19'-10" (6 045) avg. for two cars

8' (2 438) min. door clearance
9' (2 743) recommended

16' (4 877) min. required for single door of two-car garage

Chapter 11: Public Spaces

FIXED SEATING

Accessible spaces of 36" x 60" (914 x 1 524) should be open, on level ground, and provided as follows:

Total Seating	Wheelchair Spaces
4–25	1
26–50	2
51–300	4
301–500	6
500+	6 (+1 per each additional 100 seats)

Also, 1 percent of all fixed seats (but not less than one) must have removable or folding armrests on the aisle side and must be identified with appropriate signage.

Typical Chair Widths
Chair widths typically run 18"–24" (457–610); the ideal width is 21" (533).

Plumb Line Clearance
The distance between an unoccupied chair in the up position and the back of the chair in front of it. Local codes should be consulted for minimum clearances.

Row Spacing
Row spacing, like tread, runs 32"–40" (813–1 016) and higher.

Closer spacing may cause uncomfortable conditions for the seated person, as well as difficulty for anyone trying to pass in front of a seated person. Conversely, whereas wider spacing of rows provides more comfort while sitting and passing in front of seated persons, too wide a spacing may make the audience feel overly spread out. In addition, the wider spacing may encourage some people to try to squeeze through when exiting, causing a jam that could be dangerous in the event of an emergency.

An ideal spacing that accounts for all of these factors is 36" (914).

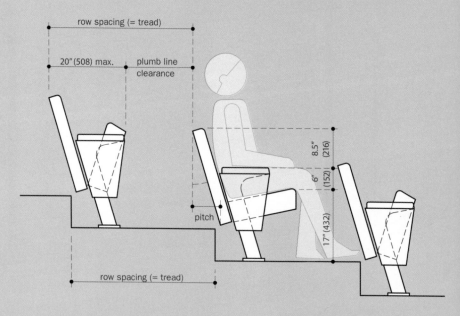

OFFICE WORK SPACES

Flexible Workspaces

Many companies produce flexible office furniture and workspace modules, in a wide variety of styles and finishes. These diagrams are for general layout purposes only and to illustrate a range of possibilities for office privacy, interaction, and space allocation.

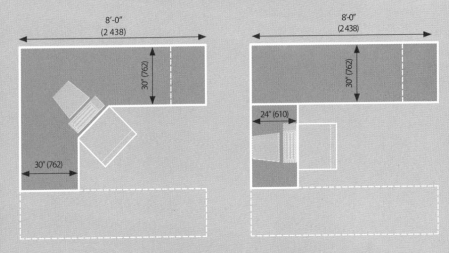

Various arrangements of four 8' x 8' (2 438 x 2 438) workspaces, allowing for a wide range of levels of interaction.

The primary advantage of flexible office furniture is precisely its ability to adjust to changing staff levels, changing personnel type, and even shifts in the nature of work being performed in the space.

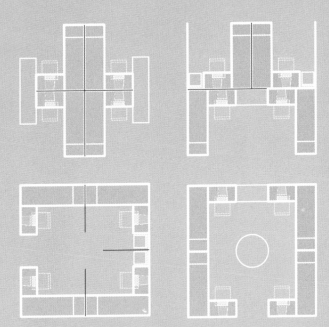

EATING ESTABLISHMENTS

Seating Types

Booths

Booth tables may be
2" (51) shorter than
bench seats, and with
rounded corners to
facilitate getting in and
out of the booth.

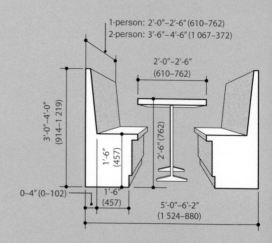

1-person: 2'-0"–2'-6" (610–762)
2-person: 3'-6"–4'-6" (1 067–372)

2'-0"–2'-6"
(610–762)

3'-0"–4'-0"
(914–1 219)

1'-6"
(457)

2'-6" (762)

0–4" (0–102)

1'-6"
(457)

5'-0"–6'-2"
(1 524–880)

Tables

Chair seat dimensions
average 1'-2"–1'-6"
(356–457).

Tables with widespread
bases (shown here) are
more practical for sitting
down and getting up than
four-legged tables.

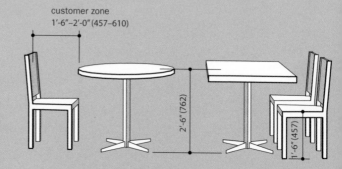

customer zone
1'-6"–2'-0" (457–610)

2'-6" (762)

1'-6' (457)

Bars and Counters

Counter stools should
average ten per server.

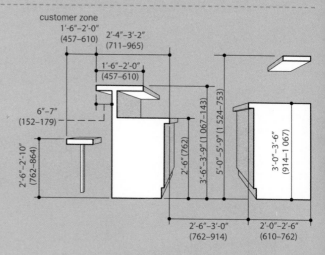

customer zone
1'-6"–2'-0"
(457–610)

2'-4"–3'-2"
(711–965)

1'-6"–2'-0"
(457–610)

6"–7"
(152–179)

2'-6"–2'-10"
(762–864)

2'-6" (762)

3'-6"–3'-9" (1 067–143)

5'-0"–5'-9" (1 524–753)

3'-0"–3'-6"
(914–1 067)

2'-6"–3'-0"
(762–914)

2'-0"–2'-6"
(610–762)

Seating Clearances

Clear floor area for wheelchairs is 30" x 48" (762 x 1 219), of which 19" (483) may be used for required under-table knee space. At least 5 percent (but not less than 1) of tables must be accessible.

19" (483)

36" (914) required for all accessible routes

service aisle

6" (152) no passage

18" (457) limited passage

30"–42" (762–1 067); 36" (914) minimum required for accessible aisle

service aisle

service aisle

service aisle

30" (762)

bar

General Guidelines

Restaurant Planning

Dining room = 60%
Kitchen, cooking, staging, preparation, and storage = 40%

Capacity per Person	Sq. ft. (m²)
Banquet seating	10–12 (0.93–1.11)
Table service (min.)	11–14 (1.02–1.30)
Cafeteria	12–15 (1.11–1.39)
Coffee shop	12–16 (1.11–1.48)
Cafe/general dining	15–18 (1.39–1.67)
Counter service	18–20 (1.67–1.86)
Formal dining	17–22 (1.60–2.04)

Note: These are minimum general dimensions for planning and layout. Always consult local building and fire codes; for example, the IBC requires minimum 15 sq. ft. (1.39 m²) per person for use group A-2 (loose-seating assembly areas serving food and drink). These areas take into account traffic aisles and wait stations.

Wait Stations

One small station of 6–10 sq. ft. (0.56–0.93 m²) per 20 diners

One large central station of 25–40 sq. ft. (2.32–3.72 m²) per 60 diners

Bar and Counter Seating

Allow 20"–22" (508–59) per standing person or 24" (610) per bar stool.

Bar stool height: 28"–30" (635–762)

Chapter 12: Parking

Almost everywhere, parking is often a person's first and last interface with a building and should be designed with this in mind. Primarily, parking should be safe, efficient, well-marked, and able to accommodate users of all kinds. Because vehicle sizes fluctuate, parking areas must be flexible enough to respond to future scenarios.

PARKING LOTS

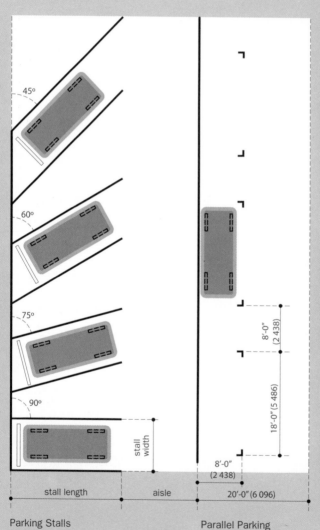

Parking Stalls

Parallel Parking

General Guidelines

Pavement striping should be 4" (102) wide, in white or yellow paint.

Parking area surfaces should have a minimum slope of 2 percent (a quarter-inch per foot or 6 mm per 305 mm) for drainage purposes.

Lots are laid out with modules. One complete module includes one access aisle and the parking it serves on either side.

The most common angle for parking is the 60° stall, which provides for ease of entering and exiting spaces while still allowing for an efficiently sized module. Stalls of 45° reduce the total number of parking spaces for a given area but do not require a wide access aisle. They are the only acceptable angle for a herringbone parking lot pattern. Stalls of 90° provide the most parking spaces for a given area, though they are unsuitable for in-and-out traffic, due to the higher degree of difficulty entering and exiting the stalls. They are ideal for all-day parking, such as for employees.

COMMON PARKING STALL LAYOUTS

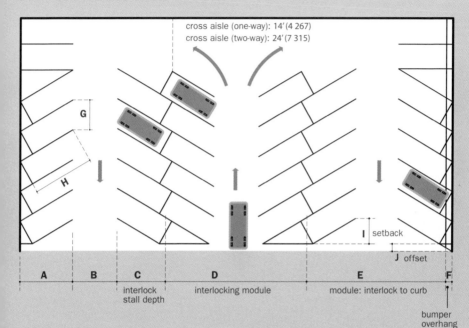

cross aisle (one-way): 14' (4 267)
cross aisle (two-way): 24' (7 315)

	A	B	C	D	E	F	G	H	I	J
45°	17.5'	12.0'	15.3'	42.6'	42.8'	2.0'	12.7'	25.0'	11.0'	6.3'
	(5 334)	(3 658)	(4 663)	(12 984)	(13 045)	(610)	(3 871)	(7 620)	(3 353)	(1 920)
60°	19.0'	16.0'	17.5'	51.0'	50.2'	2.3'	10.4'	22.0'	8.3'	2.7'
	(5 791)	(4 877)	(5 334)	(15 549)	(15 301)	(701)	(3 170)	(6 706)	(2 530)	(823)
75°	19.5'	23.0'	18.8'	61.0'	58.8'	2.5'	9.3'	20.0'	5.0'	0.5'
	(5 944)	(7 010)	(5 730)	(18 593)	(17 922)	(762)	(2 835)	(6 096)	(1 524)	(152)
90°	18.5'	26.0'	18.5'	63.0'	60.5'	2.5'	9.0'	18.5'	0.0	0.0
	(5 639)	(7 925)	(5 639)	(19 202)	(18 440)	(762)	(2 743)	(5 639)		

Recommended parking layouts and stall dimensions vary and are generally determined by local zoning provisions (which should always be consulted). Commonly accepted minimum stall sizes are 9' (2 743) x 18.5'–19.5' (5 639–944), though sizes and layouts should best accommodate their situation; for instance, stalls at hardware or grocery stores should be wide enough to accommodate easy loading and unloading of large packages, and may be up to 10' (3 048) wide. Compact car spaces may be as small as 7'-6" (2 286) x 15' (4 572) and should be well marked and logically grouped.

Parking Lot Flows

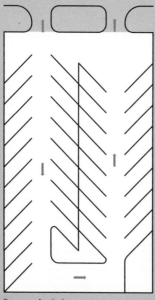

One-way Angled

Two-way 90 Degrees

Common Parking Space Allocations

Hospital	1.2 per bed
Auditorium/theater/stadium	0.3 per seat
Restaurant	0.3 per seat
Industrial	0.6 per employee
Church	0.3 per seat
Retail	4.0 per 1000' gross floor area
Office	3.3 per 1000' gross floor area
Shopping center	5.5 per 1000' gross leasable area
Hotels/motel	1.0 per room/0.5 per employee
Senior high schools	0.2 per student/1.0 per staff member
Elementary schools	1.0 per classroom

Typical Car Length Classifications

Pre-1975		Post-1975	
Subcompact	<100″ (2 540)	Small	<100″ (2 540)
Compact	101″–111″ (2 565–819)	Medium	100″–112″ (2 540–845)
Intermediate	112″–118″ (2 845–997)	Large	>112″ (2 845)
Standard	>119″ (3 025)		

PARKING GARAGES

Ramp Design

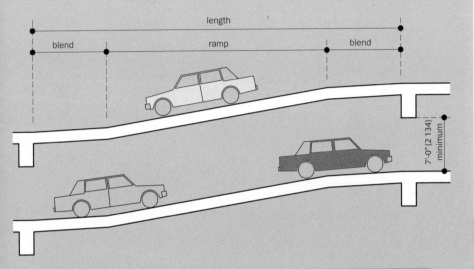

7'-0" (2 134) minimum

Straight Ramps

Length	< 65'-0" (19 812)	> 65'-0" (19 812)
Blend length	10'-0" (3 048)	8'-0" (2 438)
Blend slope	8%	6%
Ramp slope	16%	12%

Helical Ramps

width = 15'-0" (4 572)
for counterclockwise travel

width = 20'-0" (6 096)
for clockwise travel

slope = 12% maximum
(4% in transverse direction)

General Considerations

Parking garage stalls should be well-marked and use clear signage to direct drivers, especially in one-way traffic situations.

Express helical exit ramps are recommended to avoid congestion inside garage.

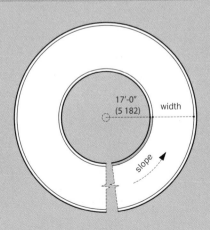

17'-0" (5 182) width

slope

CODES AND GUIDELINES **3.**

Codes, laws, and regulations can carry with them a certain off-putting suggestion of bureaucratic obfuscation. To run afoul of them would never be recommended, but attempts to understand them can be frustrating. Certainly, there exist standards that appear senseless or unnecessarily restrictive, but as the world changes and populations expand, the built environment is subject to an increasing number of forces that dictate its use and forms.

As we open doors, turn on lights, and navigate stairs, we all experience firsthand standards within design practice. Ideally, codes and standards allow us to use buildings safely. Constraints brought by code restrictions may also provide an opportunity to let good design solve difficult problems.

As the very real design needs of people with disabilities receive official and widespread acknowledgment and the concept of accessibility becomes more naturally integrated with architecture—for younger designers this is the norm—it can be difficult to imagine how recently it was viewed as an impediment to good design. Acceptance of the aesthetic possibilities of sustainable design is even more recent. In fact, new standards that accommodate all types of users and a growing recognition of architecture's responsibility to the environment and its future can provide fresh takes on old forms and strong incentives to try new processes.

Chapter 13: Building Codes

The fundamental purpose of building codes is to protect the health, safety, and welfare of all people through the construction of safe buildings and environments. Building practices have long been regulated in various ways, and regulations have existed in America since the early colonies, but it was the 1871 Chicago fire that emphasized the need for effective and enforceable building codes. In the early years since, most building codes in the United States were written and administered by local city, county, or state jurisdictions, eventually producing three major model codes: the National Codes of the Building Officials and Code Administrators International (BOCA), the Uniform Codes of the International Conference of Building Officials (ICBO), and Standard Codes of the Southern Building Code Congress International (SBCCI). With a few exceptions, each of the fifty states has adopted one of these models for its primary building code, in addition to supplemental codes for fire, mechanical, electrical, plumbing, and residential.

INTERNATIONAL BUILDING CODE

In 1997 the International Code Council (ICC) enlisted representatives from BOCA, ICBO, and SBCCI (the three founding arms of the ICC) to create a comprehensive and internationally available model construction code that would combine the considerable scope of the existing model codes. The first International Building Code (IBC) was established in 2000, and with it, the development of the National Codes, Uniform Codes, and Standard Codes was discontinued.

Currently, most U.S. states have adopted or are making efforts to adopt the IBC as their primary building code, though the process continues to differ for each state. Some have adopted the IBC but have not yet made it effective, others have adopted it on a statewide level, and still others have let their local city and county governments decide. The same has been true for the supplemental codes. The current status of the applicable codes for any given state or local jurisdiction should be verified with local building departments or by visiting the ICC website at www.iccsafe.org. Any code information cited in this book is from the IBC, unless stated otherwise.

> **NOTE OF DISCLAIMER**
> The code information contained in this chapter is for general information only and is here to provide the reader with an introductory overview of the purposes and organization of building codes. It is not intended to replace any codes discussed, to present interpretations or analyses of said codes, or to address any specific project. It also does not try to address all aspects of any one code in such a small number of pages; rather, the information touches on topics of general interest to most users of this book. All attempts have been made to present information as accurately as possible, with the understanding that code content may change after the book's publication.

To address a changing world, the IBC codes are evolving through continual review by almost any party that comes in contact with them, including code enforcing officials, various code development committees, and design professionals. Changes occur, for instance, to address new materials, emerging technologies, and shifts in use types. They even occur to clarify interpretations of language and the intent of the codes as written. As a result, the IBC has been designed to be updated every three years. The 2003 edition, for example, exhibits the 2000 code with ICC-approved changes included.

For any project, the applicable codes must be interpreted by the appropriate Authority Having Juris-diction (AHJ), which could include, among others, local building and fire officials. The use and inter-pretation of codes can be daunting, and differences of interpretation may occur among designers and building officials. For this reason, it is beneficial to a project to establish contact with the local building department early enough in the design process to address any questions of interpretation.

Numerous publications offer explanations and interpretations of many aspects of code use, though they should always be used in conjunction with the code itself, and not as a substitute. In addition, licensed code consultants can provide further clarification of codes or offer a general review of projects, especially large and complex ones, with an eye to code compliance.

Even with the help of consultants and the interpretations of others, architects must make every effort to familiarize themselves with pertinent codes, which puts them in a position of greater authority when issues of interpretation do arise. It is never recommended to memorize passages of the code, however, because these will change over time and memory may fail. What is important is to have a thorough working knowledge of the table of contents and to be able to navigate the code with a confi-dent efficiency that, like all aspects of the practice of architecture, comes with experience.

OTHER CODES

Within any one jurisdiction, a complex variety of codes may still be in use, even if the IBC has been adopted as the primary code. Local building departments must always be consulted for a complete breakdown of what codes are to be addressed for any given project. In addition, federal laws such as the Americans with Disabilities Act and the Federal Fair Housing Act must be followed.

All codes are structured around protection of human life and of property, including both prevention and reaction. Code analysis is performed based on the following sets of data:

Occupancy Type
Construction Type
Building or Floor Area
Building Height
Exits and Egress
Building Separations and Shafts
Fire Protection
Fire Extinguishing Systems
Engineering Requirements

CH. 14

CH. 30

2003 International Building Code Table of Contents

2003 International Building Code Table of Contents

OCCUPANCY TYPE AND USE GROUPS

A building's use and occupancy are primary criteria for determining many aspects of how codes will affect a building, including the height, area, and type of construction allowed. Within each occupancy use group are further subdivisions. It is not unusual for a building to fall under more than one category of occupancy type, which is known as a mixed-use occupancy. It may then be handled either as a "separated use," by providing complete fire separation between occupancies, or as a "nonseparated use," by subjecting each occupancy type to the most stringent requirements for its respective use group.

Occupancy Use Groups

A Assembly
B Business
E Educational
F Factory and Industrial
H High Hazard
I Institutional
M Mercantile
R Residential
S Storage
U Utility and Miscellaneous

In addition, other building types exist which do not fall into the above categories, and/or contain elements requiring additional code requirements, and may include: covered mall buildings, high-rise buildings, atriums, motor-vehicle related occupancies, special amusement buildings, and stages and platforms, among others.

Group A: Assembly
(50 or more occupants)

A-1: Assembly areas usually with fixed seats, usually for viewing movies or performances (may or may not have a stage)

A-2: Assembly areas involving serving and consumption of food and drink (may include alcohol), as in a restaurant or bar. Loose seating and possible patron alcohol impairment are key factors in this group.

A-3: Other assembly groups that don't fit A-1 or A-2. May include houses of worship.

A-4: Assembly areas for indoor sporting events.

A-5: Assembly areas for outdoor sporting events.

Group B: Business

Most office buildings fall into this category, including their storage areas (unless they exceed the amount of hazardous materials allowable, in which case they become Use Group H).

Also included are educational facilities after grade 12 (colleges and universities), outpatient clinics and doctors' offices, and research laboratories.

Any assembly area, including a lecture hall, may fall into Group A and should be treated as such.

Group E: Educational

E-1: More than 6 people, for classes up to the 12th grade

E-2: Daycare for five or more children over $2^1/2$ (daycare for fewer than 5 people is classified as R-3)

Group F: Factory and Industrial

F-1: Moderate-hazard industrial occupancy that has established that the relative hazards of operations do not put them in Group H (Hazardous) or in category F-2.

F-2: Low-hazard industrial occupancy where the materials of manufacture are considered to be noncombustible.

For both categories, the occupancies are not public.

Group H: High-Hazard

A range in high-hazard occupancies from H-1 to H-5, addressing the quantities and nature of use of the hazardous materials.

Group I: Institutional

I-1: More than 16 people in a 24-hour residential environment and under supervised conditions. May include group homes, assisted-living facilities, and halfway houses whose residents require little or no assistance from staff members.

I-2: More than 5 people in a 24-hour residential environment and under supervised conditions and custodial care. May include hospitals and nursing homes whose residents are unable to respond to emergency situations without the aid of staff members.

I-3: More than 5 people in a 24-hour supervised environment under full-time restraint and security. Because of security measures, occupants cannot respond to emergencies without the aid of a staff member. May include prisons, detention centers, and mental hospitals, which may be further subdivided into five categories based on the amount of freedom of movement of residents inside the facility.

I-4: More than 5 people under supervised conditions or custodial care for less than 24 hours a day. May include care facilities for adults and children under the age of two, who are unable to respond to emergency situations without assistance from a staff member.

Group M: Mercantile

Department stores, drug stores, markets, gas stations, sales rooms, and retail or wholesale stores.

Group R: Residential

R-1: Transient occupants who sleep in their rooms for less than 30 days. May include hotels and boarding houses.

R-2: Permanent dwellings (sleeping in units for more than 30 days) with more than two units. May include apartments, dormitories, and longer term boarding houses.

R-3: Permanent single-family or duplex residences. May also include daycare facilities for 5 or fewer people who do not use the facility for 24 hours.

R-4: Between 5 and 16 occupants of a residential care or assisted-living facility. Because it is for 16 or fewer occupants, R-4 is used instead of I-1.

Group S: Storage

S-1: Moderate-hazard storage occupancy for materials not considered hazardous enough for Group H but that do not qualify as S-2.

S-2: Low-hazard storage occupancy for materials considered to be noncombustible.

For either occupancy, as with Group H, the hazard rating and amount of hazardous material must be carefully evaluated.

Group U: Utility and Miscellaneous

Used for incidental buildings and non-buildings (such as fences or retaining walls) that are generally not occupied for long periods of time and may serve a secondary function to other occupancies. This occupancy is seldom used and is not to be used for any building that is difficult to categorize.

CONSTRUCTION TYPES AND FIRE RESISTANCE

Construction types are categorized by their material content and the resistance to fire of the structural system. The IBC assigns five broad categories to all buildings, based on the predominant materials in the building's construction. These categories are I, II, III, IV, and V, with Type I being most fire resistive and Type V being least fire resistive. The five types are divided into A and B categories, reflecting the level of fire-resistance rating for each.

Noncombustible materials, which are defined as being materials "of which no part will ignite and burn when subjected to fire," typically include masonry and steel. Combustible materials, which may be assumed to be materials that fail to meet noncombustibility requirements, include wood and plastic.

Types of Construction

Noncombustible				Noncombustible/Combustible				Combustible	
IA	IB	IIA	IIB	IIIA	IIIB	IV (Heavy Timber = HT)		VA	VB
All building elements as listed in IBC Table 601 (structural frame, interior and exterior bearing walls, interior and exterior nonbearing walls, floor construction, and roof construction) are of noncombustible materials.		All building elements as listed in IBC Table 601 (structural frame, interior and exterior bearing walls, interior and exterior nonbearing walls, floor construction, and roof construction) are of noncombustible materials. Type IIB construction is not required to be fire-resistance rated.		Exterior walls must be of noncombustible materials and interior building elements may be of any material permitted by the code. Fire retardant–treated wood framing may be allowed in exterior wall assemblies of less than 2-hour rating, as long as they comply with IBC Section 2303.2.		Exterior walls must be of noncombustible materials and interior building elements may be of solid or laminated wood without concealed spaces. Fire retardant–treated wood framing may be allowed in exterior wall assemblies of less than 2-hour rating, as long as they comply with IBC Section 2303.2.		All building elements as defined by IBC Table 601 are of any materials permitted by the code.	

Fire-Resistance Ratings

Fire-resistance ratings are measured in hours or fractions of an hour and reflect the amount of time that a material or assembly of materials will resist fire exposure, as set forth in ASTM E119 (American Society for Testing and Materials Standard for Fire Tests of Building Constructions). When beginning design of a building, the initial code analysis must consider the desired occupancy and the desired height and area to determine the minimum allowable construction type for fire ratings.

Fire Protection Systems

Limitations on building area and height may be lessened when fire-protection systems such as automatic sprinklers are in place. Active fire-protection systems are defined by IBC 902 as "approved devices, equipment and systems or combinations of systems used to detect a fire, activate an alarm, extinguish or control a fire, control or manage smoke and products of a fire, or any combination thereof." They are meant to work in conjunction with the building's passive systems (fire-resistive construction) to provide necessary protection for the occupants of any building type. Higher levels of stringency in one system might mean lessened requirements in the other, though neither should be compromised for the sake of cost or convenience.

The IBC requires active systems for buildings above certain sizes and occupant loads, regardless of the type of construction. IBC Section 903 establishes these requirements based on use groups and fire areas ("the aggregate floor area enclosed and bounded by fire walls, fire barriers, exterior walls, or fire-resistance-rated horizontal assemblies of a building").

Alternative fire-extinguishing systems may be used when necessary, in compliance with IBC 904. Examples of reasons to use alternative systems might include libraries and museums or telecommunications facilities, whose contents would sustain water damage from standard water sprinkler systems. Until recently, Halon 1301 gas was widely preferred as a fire-suppression option; however, it has proven to be harmful to the ozone layer and is being replaced by other options.

I-CODES

In addition to the International Building Code, the ICC publishes the following supplemental codes (I-Codes), all of which are compatible with each other:

ICC Electrical Code (EL)

ICC Performance Code (PC)

International Energy Conservation Code (E)

International Existing Building Code (EB)

International Fire Code (F)

International Fuel Gas Code (IFGC)

International Mechanical Code (M)

International Plumbing Code (P)

International Private Sewage Disposal Code (IPSDC)

International Property Maintenance Code (PM)

International Residential Code (IRC) (for one- and two-family dwellings)

International Urban-Wildland Interface Code (UW)

International Zoning Code (Z)

MEANS OF EGRESS

IBC 1002 defines a means of egress as "a continuous and unobstructed path of vertical and horizontal egress travel from any occupied portion of a building or structure to the public way." It consists of the exit access, the exit, and the exit discharge. Simply put, means of egress provide conditions for getting all occupants to a safe place (usually an outdoor public way) in the event of fire or other emergency.

Number of Means of Egress

Per IBC Table 1014.1, occupancy spaces that require more than one means of egress are:

A, B, E, F, M, and U, with occupant loads over 50

H-1, H-2, H-3, with occupant loads over 3

H-4, H-5, I-1, I-3, I-4, and R, with occupant loads over 10

S with occupant loads over 30

Any occupancy between 501 and 1,000 requires three exits, and occupancies over 1,000 requires four.

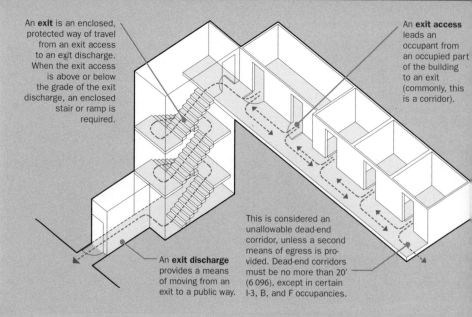

An **exit** is an enclosed, protected way of travel from an exit access to an exit discharge. When the exit access is above or below the grade of the exit discharge, an enclosed stair or ramp is required.

An **exit access** leads an occupant from an occupied part of the building to an exit (commonly, this is a corridor).

An **exit discharge** provides a means of moving from an exit to a public way.

This is considered an unallowable dead-end corridor, unless a second means of egress is provided. Dead-end corridors must be no more than 20′ (6 096), except in certain I-3, B, and F occupancies.

Required Egress Widths

Sizes are determined by coordinating IBC Table 1005.1 (summarized on the following page) with the requirements below, taking whichever number is higher.

Egress Doors

In areas with an egress load of more than fifty occupants, or any Group H occupancy, exit access doors should swing in the direction of travel. If they swing into a required egress path, they may not reduce the required width by more than one half while swinging open, and once opened 180°, the door may not project into the required width more than 7″(178).

Egress doors should be a minimum of 6′-8″ (2 032) high, with a clear opening width determined by IBC 1005.1, but no less than 32″(813), measured from the face of the door to the stop when open.

Maximum width of a swinging door leaf is 48″ (1 219).

Egress Corridors

Minimum corridor width is determined by IBC 1005.1 but must not be less than 44″(1 118), except for the following conditions:

Access to plumbing, electrical, or mechanical equipment: 24″(610)

Within a dwelling unit or in an occupancy of less than fifty: 36″(914)

Group E with a hundred or more capacity or Group I surgical health care centers: 72″(1 829)

Group I-2 areas with required bed movement: 96″ (2 438)

Egress Stairs

Minimum width is determined by IBC 1005.1 but must not be less than 44″ (1 118), except for passageways serving occupant loads of less than fifty, which must be no less than 36″ (914).

Ramps in an egress system should have a width no less than the corridors that serve them, typically 44″ (1 118).

Determining Occupancy Loads

The table at right may be used to establish occupant loads per area sizes, from which egress widths per occupant are calculated. Alternatively, occupant loads are determined by the actual number, if larger, of occupants for whom the space is designed or, in addition, for whom the space will serve as a means of egress.

Required Egress Widths in Inches Per Occupant

	Stairs	Other Egress Components
H-1, H-2, H-3, and H-4	0.7 (no sprinkler system)	0.4 (no sprinkler system)
	0.3 (with sprinkler system)	0.2 (with sprinkler system)
I-2 Institutional	0.3 (with sprinkler system)	0.2 (with sprinkler system)
All Other Occupancies	0.3 (no sprinkler system)	0.2 (no sprinkler system)
	0.2 (with sprinkler system)	0.15 (with sprinkler system)

Maximum Floor Areas per Occupant
(excerpted from IBC Table 1004.1.2)

Type of Occupancy	Floor Area per Occupant
Assembly with fixed seats	Occupant load for areas with fixed seats and aisles is determined by the number of seats, with one person for every 18″ (457) of seating length; or one person for every 24″ (610) in seating booths.
Assembly without fixed seats	chairs (concentrated): 7 sq. ft. (0.65 m²) net standing space: 5 sq. ft. (0.46 m²) net tables and chairs (unconcentrated): 15 sq. ft. (1.39 m²) net
Business areas	100 sq. ft. (9.29 m²) gross
Dormitories	50 sq. ft. (4.65 m²) gross
Educational–classrooms	20 sq. ft. (1.86 m²) net
Educational– shop and vocational areas	50 sq. ft. (4.65 m²) net
Commercial kitchens	200 sq. ft. (18.58 m²) gross
Library reading room	50 sq. ft. (4.65 m²) net
Library stacks	100 sq. ft. (9.29 m²) gross
Mercantile– basement or grade floor	30 sq. ft. (2.79 m²) gross
Mercantile–floors other than basement or grade floor	60 sq. ft. (5.57 m²) gross
Mercantile– storage, stock, and shipping	300 sq. ft. (27.87 m²) gross
Parking garage	200 sq. ft. (18.58 m²) gross
Residential	200 sq. ft. (18.58 m²) gross

Net area is generally considered to be the actual occupied area and does not include unoccupied areas such as corridors, walls, stairways, or toilets. Gross area includes floor area within the inside perimeter of the exterior walls, as well as corridors, stairways, closets, interior partitions, columns, and other fixed features.

Chapter 14: ADA and Accessibility

The Americans with Disabilities Act (ADA) was passed by Congress in 1990 to protect and honor the civil rights of people with disabilities, including conditions affecting mobility, sight, hearing, stamina, speech, and learning disorders. Modeled on earlier landmark laws prohibiting discrimination based on race and gender, the ADA provides equal access for all people to housing, public accommodations, employment, government services, transportation, and telecommunications.

KEY TERMS AS DEFINED BY ADA

Access aisle: Accessible pedestrian space between elements such as parking spaces, seating, or desks that provides clearances appropriate for use of the elements.

Accessible: Of a site, building, facility, or portion thereof, in compliance with ADA guidelines.

Accessible element: Element (telephone, controls, and the like) specified by ADA guidelines as in compliance.

Accessible route: Continuous unobstructed path connecting all accessible elements and spaces of a building or facility. Interior accessible routes may include corridors, floors, ramps, elevators, lifts, and clear floor space at fixtures. Exterior accessible routes may include parking access aisles, curb ramps, crosswalks at vehicular ways, walks, ramps, and lifts.

Accessible space: Space that complies with ADA guidelines.

Adaptability: Ability of certain building spaces and elements, such as kitchen counters, sinks, and grab bars, to be added or altered so as to accommodate the needs of individuals with or without disabilities or with different types or degrees of disability.

Addition: Expansion, extension, or increase in the gross floor area of a building or facility.

Administrative authority: Governmental agency that adopts or enforces regulations and guidelines for the design, construction, or alteration of buildings and facilities.

Alteration: Change to a building or facility made by, on behalf of, or for the use of, a public accommodation or commercial facility, which affects or could affect the usability of the building or facility or part thereof. Alterations include, but are not limited to, remodeling, renovation, rehabilitation, reconstruction, historic restoration, changes or rearrangement of the structural parts or elements, and changes or rearrangement in the plan configuration of the walls and full-height partitions. Normal maintenance, reroofing, painting or wallpapering, or changes to mechanical and electrical systems are not alterations unless they affect the usability of the building or facility.

Area of rescue assistance: Area that has direct access to an exit, where people who cannot use stairs may remain temporarily in safety to await further instructions or assistance during emergency evacuation.

Assembly area: Room or space accommodating a group of individuals for recreational, educational, political, social, or amusement purposes, or for the consumption of food and drink.

Automatic door: Door equipped with a power-operated mechanism and controls that open and close the door automatically on receipt of a momentary actuating signal. The switch that begins the automatic cycle may be a photoelectric device, floor mat, or manual switch. See power-assisted door.

Building: Any structure used and intended for supporting or sheltering any use or occupancy.

Circulation path: Exterior or interior way of passage from one place to another for pedestrians, including, but not limited to, walks, hallways, courtyards, stairways, and stair landings.

Clear: Unobstructed.

Clear floor space: Minimum unobstructed floor or ground space required to accommodate a single, stationary wheelchair and occupant.

Common use: Describes interior and exterior rooms, spaces, or elements that are made available for the use of a restricted group of people (for example, the occupants of a homeless shelter, the occupants of an office building, or the guests of such occupants).

Cross slope: Slope that is perpendicular to the direction of travel.

Curb ramp: Short ramp cutting through a curb or built up to it.

Detectable warning: Standardized surface feature built in or applied to a walking surface or other elements to warn visually impaired people of hazards on a circulation path.

Egress, means of: Continuous and unobstructed way of exit travel from any point in a building or facility to a public way. A means of egress comprises vertical and horizontal travel and may include intervening room spaces, doorways, hallways, corridors, passageways, balconies, ramps, stairs, enclosures, lobbies, horizontal exits, courts, and yards. An accessible means of egress is one that complies with ADA guidelines and does not include stairs, steps, or escalators. Areas of rescue assistance or evacuation elevators may be included as part of accessible means of egress.

Elements: Architectural or mechanical component of a building, facility, space, or site (for example, a telephone, curb ramp, door, drinking fountain, seating, or water closet).

Entrance: Any access point to a building or portion of a building or facility used for the purpose of entering. An entrance includes the approach walk, the vertical access leading to the entrance platform, the entrance platform itself, vestibules if provided, the entry door(s) or gate(s), and the hardware of the entry door(s) or gate(s).

Marked crossing: Crosswalk or other identified path intended for pedestrian use in crossing a vehicular way.

Operable part: Part of a piece of equipment or appliance used to insert or withdraw objects, or to activate, deactivate, or adjust the equipment or appliance (for example, a coin slot, push button, or handle).

Power-assisted door: Door used for human passage with a mechanism that helps to open the door, or relieves the opening resistance of a door, on the activation of a switch or a continued force applied to the door itself.

Public use: Describes interior or exterior rooms or spaces that are made available to the general public. Public use may be provided at a building or facility that is privately or publicly owned.

Ramp: Walking surface that has a running slope greater than 1:20.

Running slope: Slope that is parallel to the direction of travel.

Signage: Displayed verbal, symbolic, tactile, and pictorial information.

Space: Definable area (for example, a room, toilet room, hall, assembly area, entrance, storage room, alcove, courtyard, or lobby).

Tactile: Of an object, perceptible using the sense of touch.

Text telephone: Machinery or equipment that employs interactive graphic (that is, typed) communications through the transmission of coded signals across the standard telephone network. Text telephones can include devices known as TDDs (telecommunication display devices or telecommunication devices for deaf persons) or computers.

Walk: Exterior pathway with a prepared surface intended for pedestrian use, including general pedestrian areas such as plazas and courts.

CH. 8

CH. 13

SIGNAGE

Elevator Control Panel

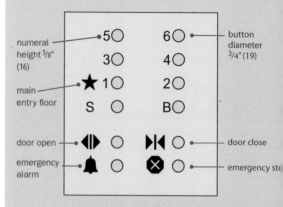

numeral height 5/8" (16)

main entry floor

door open

emergency alarm

button diameter 3/4" (19)

door close

emergency sto

Floor buttons should be no higher than 54" (1 372) AFF for a side approach and 48" (1 219) for a front approach. Emergency controls should be grouped at the bottom, with centerlines no less than 35" (889) AFF.

Directional or Informational Signs

Characters must have a width-to-height ratio of between 3:5 and 1:1, and a stroke width-to-height ratio of between 1:5 and 1:1.

Characters should be sized according to the viewing distance from which they are to be read.

Lowercase characters are permitted.

Characters and background must be eggshell, matte, or another nonglare finish and must contrast with background (either light on dark or dark on light).

Pictograms can be any size within any size field.

Room Signs

Characters should be raised $^1/_{32}$" (0.8) and in uppercase with sans serif or "simple serif."

Characters must be accompanied by Grade 2 Braille.

Raised characters must be a minimum of $^5/_8$" (16) and maximum of 2" (51) high based on an uppercase X.

Equivalent written descriptions (if any) must be placed directly below pictograms.

Pictograms can be any size within a minimum field of 6" (153) in height and may be raised $^1/_{32}$" (0.8) but are not required to be raised.

Characters and background must be eggshell, matte, or another nonglare finish and must contrast with background (either light on dark or dark on light).

Signage should be mounted on the wall adjacent to the latch side of the door (if at all possible), and so that a person can approach within 3" (76) and avoid door swing and protruding objects.

Mounting height must be 60" (1 524) from the floor to the centerline of sign.

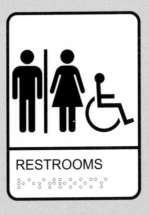

ACCESSIBLE MEANS OF EGRESS

Any space that is considered to be accessible must have at least one accessible means of egress.

Elevators that comply with ASME A17.1, Safety Code for Elevators and Escalators, may be allowed as part of an accessible egress route. Primarily, they must be equipped with standby power and emergency operation and signaling devices, and most must be accessed from an area of refuge.

Areas of refuge, where those unable to use stairways remain temporarily in an evacuation, should be in an egress stairway or have direct access to one, or to an elevator with emergency power. Two-way communications systems should be provided in the area of refuge, connecting it to a central control point.

One 30" x 48" (762 x 1 219) wheelchair space must be provided for every two hundred occupants of the space served. Generally these spaces are alcoves within an enclosed stair, because they must not reduce the egress width.

Except in sprinklered buildings, accessible egress stairways should be a minimum of 48" (1 219) wide clear between handrails. This provides a space wide enough for two people to carry a disabled person down or up to safety.

ACCESSIBLE PARKING SPACES

The length of accessible parking spaces must be in accordance with local building codes. Accessible spaces should be marked by high-contrast painted lines or other high-contrast delineation. Access aisles should be a part of an accessible route to the building or facility entrance. Two accessible parking spaces may share a common access aisle. Access aisles should be marked clearly by means of diagonal stripes.

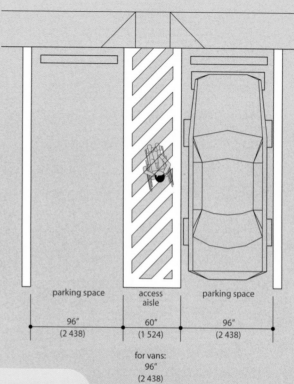

parking space	access aisle	parking space
96" (2 438)	60" (1 524)	96" (2 438)

for vans:
96"
(2 438)

Number of Accessible Spaces Required

Total Parking Spaces in Lot	Minimum Number of Accessible Spaces
1–25	1
26–50	2
51–75	3
76–100	4
101–150	5
151–200	6
201–300	7
301–400	8
401–500	9
501–1,000	2% of total
1,001 and over	20 plus 1 for each 100 over 1,000

Surface slopes should not exceed 1:50 (2%) in any direction on accessible parking spaces and access aisles.

Accessible parking spaces serving a particular building should be located on the shortest accessible route of travel from the adjacent parking to an accessible entrance.

In buildings with multiple accessible entrances with adjacent parking, accessible parking spaces should be dispersed and located closest to the accessible entrances.

WHEELCHAIR SPACE ALLOWANCES

Clear floor or ground space is defined as the minimum clear area required to accommodate a single, stationary wheelchair and occupant. This applies to both forward and parallel approaches to an element or object. Clear floor space may be part of the knee space required under objects such as sinks and counters.

Wheelchair Passage Widths

36" (914)

32" (813)

single wheelchair

60" (1 524)

two wheelchairs

30" x 48"
(762 x 1 219)
clear floor
space, typical

36" (914)

12"
(305)

12"
(305)

36" (914)

60" (1 524)

60" (1 524) dia. min.

60" (1 524) dia. min.

78" (1 981) preferred

Clear Floor Space at Alcoves

30" (762)

x ≤ 24"
(610)

48" (1 219)

48" (1 219)

x

30" (762)

x ≤ 15" (381)

30" (762)
or
36" (914) if x ≥ 24" (610)

x

48" (1 219)
or
60" (1 524) if x ≥ 15" (610)

x

DOORS

Clear Doorway Width and Depth

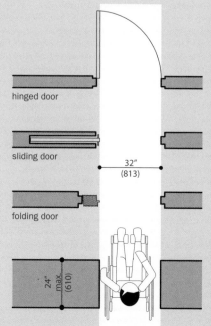

hinged door

sliding door

folding door

32"
(813)

24"
max.
(610)

Maneuvering Clearances at Doors

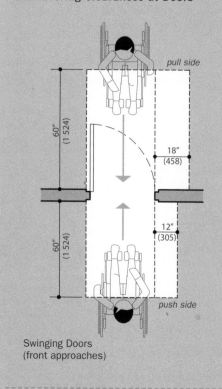

pull side

60"
(1 524)

18"
(458)

12"
(305)

60"
(1 524)

push side

Swinging Doors
(front approaches)

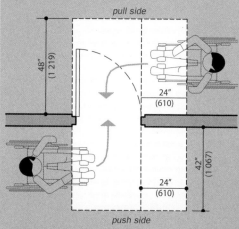

pull side

48"
(1 219)

24"
(610)

42"
(1 067)

24"
(610)

push side

Swinging Doors
(latch-side approaches)

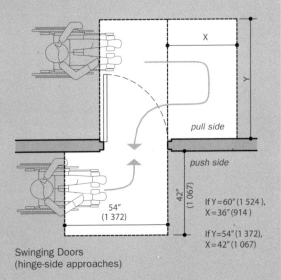

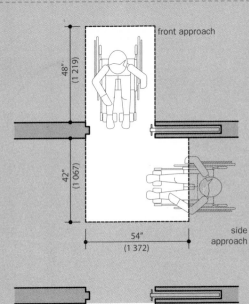

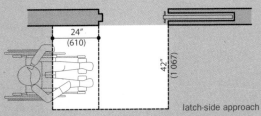

X

Y

pull side

push side

54"
(1 372)

42"
(1 067)

If Y=60" (1 524),
X=36" (914)

If Y=54" (1 372),
X=42" (1 067)

Swinging Doors
(hinge-side approaches)

front approach

48"
(1 219)

42"
(1 067)

54"
(1 372)

side
approach

24"
(610)

42"
(1 067)

latch-side approach

Sliding and Folding Doors

Two Hinged Doors in a Series

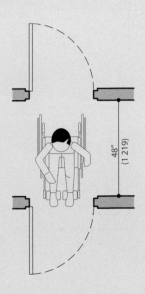

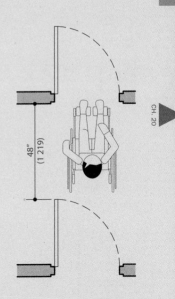

48"
(1 219)

48"
(1 219)

48"
(1 219)

CH. 20

TOILETS AND BATHROOMS

Clear Floor Space at Water Closets

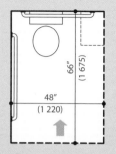
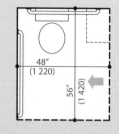
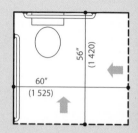

CH. 8

Toilet Stalls

CH. 10

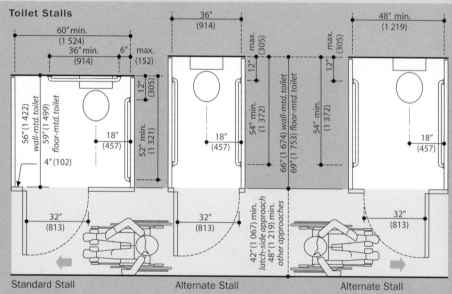

Standard Stall

Alternate Stall

Alternate Stall

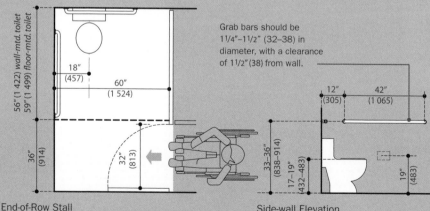

End-of-Row Stall

Side-wall Elevation

Grab bars should be 1¹/₄″–1¹/₂″ (32–38) in diameter, with a clearance of 1¹/₂″(38) from wall.

Lavatories

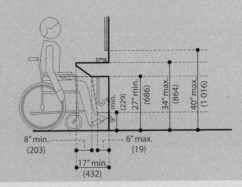

30" x 48"
(762 x
1 219) min.
clear floor
space

17" min.
(432)

19" max.
(483)

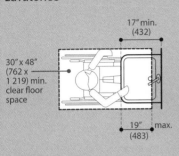

8" min.
(203)

6" max.
(19)

17" min.
(432)

9" min.
(229)

27" min.
(686)

34" max.
(864)

40" max.
(1 016)

Showers

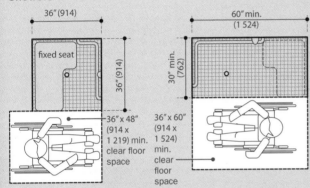

36" (914)

fixed seat

36" (914)

36" x 48"
(914 x
1 219) min.
clear floor
space

60" min.
(1 524)

30" min.
(762)

36" x 60"
(914 x
1 524)
min.
clear
floor
space

A seat must be provided in
shower stalls 36" x 36"
(914 x 914), mounted 17"–19"
(432–83) from the bathroom
floor and extending the full
depth of the stall.

Fixed seats in 30" x 60"
(762 x 1 524) shower stalls
should be of a folding type
mounted on the wall adjacent
to the controls.

Bathtubs

15" (381)

foot

seat

head

seat

30" x 60" (762 x 1 524)
min. clear floor space

48" x 60" (1 219 x 1 524)
min. clear floor space

30" x 75" (762 x 1 905) min.
clear floor space

12" max. 24" min.
(305) (610)

12" max. 48" min.
(305) (1 219)

9"
(229)

33-36"
(838-914)

ELEVATORS

Hall lantern fixtures at each hoistway entrance must indicate visibly and audibly which car is answering a call.

Door jambs should have raised and Braille floor designation markings.

Call buttons must be a minimum 3/4"(19) in the smallest direction.

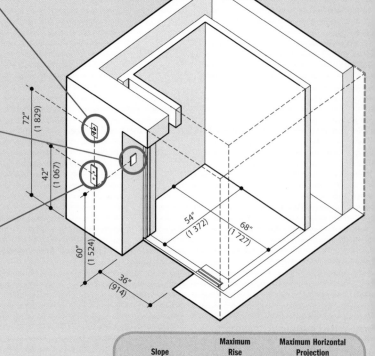

72" (1 829)

42" (1 067)

60" (1 524)

36" (914)

54" (1 372)

68" (1 727)

RAMPS

The minimum clear width of a ramp should be 36" (914), inside handrails. If a ramp has a rise greater than 6"(150) or a horizontal projection greater than 72"(1 830), then it should have handrails on both sides. Maximum slope is 1:12.

Slope	Maximum Rise	Maximum Horizontal Projection
1:12 to < 1:16	30"(760)	30'(9 000)
1:16 to < 1:20	30"(760)	40'(12 000)

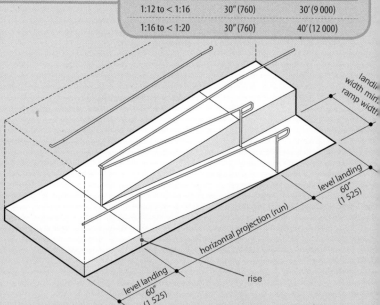

landing width min. ramp width

level landing 60" (1 525)

horizontal projection (run)

level landing 60" (1 525)

rise

STAIRS

Nosings

Risers should be sloped, or the underside of nosings should have an angle not less than 60° from the horizontal.

flush riser

angled nosing

rounded nosing

Handrail Extension at Bottom of Run

tread width

12" (305)

34"–38" (864–965)

27" max. (686)

Handrails

1¹/₄"–1¹/₂" (32–38) dia.

1¹/₂" (38) from wall

at wall: handrail returns to wall

at switchback: handrail is continuous

where no wall: handrail returns smoothly to the floor

handrail extension at top of run = 12" (305) minimum

min. landing width = width of stair

80" (2 032)

27" (686)

cane detection area

CH. 19

Chapter 15: Sustainable Design

The issue of sustainable design shines a brighter and brighter light on architecture's need to grow, learn, and adapt to a changing world. By nature, architecture is subject to inertia: Buildings take years to design and realize, and architects, engineers, and contractors take years to train. This process once ensured painstaking attention to detail and craftsmanship that resulted in a building that could last forever. Today architecture must too often bend to economic pressures to build quickly and inexpensively. Technological and engineering advances allow for such economy, though often at the risk of producing disposable buildings, ultimately unable to stand the test of time and frequently at odds with the well-being of the environment. Sustainable design proposes using systems that meet present needs without compromising those of future generations. Architects, for their part, are increasingly compelled to understand and implement such new systems and methods as they envision ways in which buildings may work with the environment and the living world. The result is a built world that enhances instead of diminishes its surroundings and resources.

LEED DESIGN

The LEED (Leadership in Energy and Environmental Design) Green Building Rating System is a voluntary, nationally recognized standard for developing high-performance, sustainable buildings. LEED was developed by the U.S. Green Building Council (US-GBC), comprising members from all walks of the building community. LEED's progressive levels of certification—Certified, Silver, Gold, and Platinum—reflect various levels of building performance and sustainability. Projects wishing for certification must register and submit documentation for review by LEED.

Among LEED's primary goals is to establish a common standard of measuring sustainability and to promote integrated design practices while raising awareness of the benefits of "green building." A green building is one that uses energy in an efficient and ecologically aware way and that minimizes negative impact on the health of its users.

DECLARATION OF INTERDEPENDENCE

In 1993 the Union Internationale des Architectes (UIA) and the AIA signed a "Declaration of Interdependence for a Sustainable Future," which made commitment to environmental and social sustainability a core issue of practice and professional responsibility. In addition to bringing the existing built environment up to established sustainability standards, the declaration also stresses the importance of developing and refining practices, procedures, products, services, and standards to enable implementation of sustainable design, as well as educating all members of the building community, clients, and the general public about the benefits of and need for sustainable approaches to design.

Similarly, a coalition of architects, landscape architects, and engineers formed the Interprofessional Council on Environmental Design (ICED) as a multidisciplinary partnership committed to the common goal of sustainability.

TERMINOLOGY

Adaptive reuse: Changing a building's function in response to the changing needs of its users.

Black water: Waste water from toilets, kitchen sinks, and dishwashers.

Brownfields: Abandoned or underused industrial and commercial sites where environmental contamination hampers redevelopment.

Chlorofluorocarbons (CFCs): Chemical compounds used as refrigerants and in aerosol and believed to be responsible for depleting the ozone layer.

Conservative disassembly: Counterproposal to destructive demolition of buildings (where most of the building's material is crushed into waste) that promotes varying levels of salvaging materials from a building before it is demolished.

Embodied energy: All of the energy consumed by all of the processes associated with the production of a building, including transportation.

Gray water: Wastewater from baths, showers, washers, and lavatories, which might be appropriate for irrigation or other uses not requiring clean water.

Hydrochlorofluorocarbons (HCFC): Alternative to CFCs, with shorter atmospheric lifetimes that deliver less reactive chlorine to the ozone layer, though alternatives to both are still being sought.

Hydronic heating: In-floor hot-water heating system where hot water is pumped through a thermal mass floor that absorbs the heat, evenly radiating it over time.

Life cycle analysis (LCA): Quantifiable assessment of all stages in the life cycle of a product system (resource extraction, manufacturing, on-site construction, occupancy/maintenance, demolition, and recycling/reuse/disposal) used to determine the impact of the material or system via four phases: initiation, inventory analysis, impact assessment, and improvement assessment.

Passive solar: Technology of heating and cooling a building naturally, through the use of energy-efficient materials and proper site placement.

Photovoltaics: Solar panels used to harness the sun's energy into electricity that can be stored in batteries and used to power an electrical system.

Renewable: Resource that comes into being through a relatively quick natural process, such as rain.

Upstream/downstream: Cause-and-effect example that what one does upstream affects what happens downstream.

Volatile organic compound (VOC): Highly evaporative, carbon-based chemical substance producing noxious fumes and found in many paints, caulks, stains, and adhesives.

GUIDELINES

Design for energy efficiency through the use of high levels of insulation and high-performance windows.

Design buildings with renewable energy sources such as passive solar heating, daylighting, and natural cooling, whenever possible.

Design for standard sizes to minimize material waste.

Avoid materials containing CFCs and HCFCs.

Use salvaged or recycled building materials such as heavy timbers, millwork, and plumbing fixtures.

When possible, use locally produced materials to cut down on transportation costs and pollution.

Use materials with low embodied energy. Rules of thumb: lumber, brick, concrete, and fiberglass have relatively low embodied energies, whereas timber, ceramics, and steel are higher, and glass, plastic and aluminum are very high. Often a higher embodied energy level can be justified if it contributes to lower operating energy, such as when large amounts of thermal mass can significantly reduce heating and cooling needs in well-insulated passive solar buildings.

Avoid off-gassing materials with high levels of VOCs.

Reduce energy and water consumption.

Minimize external pollution and environmental impact.

Reduce resource depletion.

Minimize internal pollution and negative effects on health.

SYSTEMS AND COMPONENTS 4.

A single person rarely designs all aspects of a building. Numerous teams of professionals are needed to create the systems that make a building stand and function well. Coordination of these systems begins early and may continue even after the building is occupied. During design, the building is an ever-changing organism, growing and shrinking to accommodate more systems as they are shaped and sized, designed and refined, requiring continual communication between the architect and the consulting trades.

Many decisions cannot be made until specific systems are in place. For example, the materials, structure, occupancy, and layout of a building must be known before a preliminary code analysis can be attempted. This analysis may yield new information, such as the need for wider egress stairs, more exit corridors, or further provisions for sprinkler systems. The accommodation of larger stairs and more corridors will affect the arrangement of spaces—or it may generate an overall change to the size of the building, which could, in turn, require less expensive cladding materials—and more sprinklers might entail more plumbing requirements. This give-and-take process continues throughout design, resulting in a (usually) happy coexistence of systems, spaces, and materials.

Chapter 16: Structural Systems

Structural elements of a building—its walls, frame, and foundation—hold it up (or keep it down) by resisting gravity (vertical forces) and lateral (horizontal) loads such as winds and earthquakes. The primary components of a building's structural system are its foundation system and framing system. The type selected for either is contingent on many factors, including the building's use, desired height, soil conditions of the site, local building codes, and available materials. Elements of a building's structure cannot be removed without compromising its strength and stability.

Loads

All stresses acting on a building's structure, no matter how complex, can be reduced to either tension or compression. In basic terms, a building's structure must press up with the same force that the weight of the building is pressing down, which includes all fixed dead loads and varying live loads.

Tension is a pulling and stretching force.

Compression is a pressing, pushing, or squeezing force.

Dead loads: Fixed, static loads made up of the building's own structure, skin, equipment, and other fixed elements.

Live loads: Moving or transient loads such as occupants, furnishings, snow, ice, and rain.

Wind loads: Pressure from wind that affects lateral loads as well as possible uplift forces on roofs or downward pressure.

Other loads: Impact loads, shock waves, vibrations, and seismic loads.

STRUCTURAL TERMINOLOGY

Arch: Structural device that supports vertical loads by translating them into axial forces.

Axial force: System of internal forces whose outcome is a force acting along the longitudinal axis of a structural member or assembly.

Beam: Horizontal linear element that spans an opening and is supported at both ends by walls or columns.

Buttress: Vertical mass built against a wall to strengthen it and to resist the outward pressure of a vault.

Cantilever: Horizontal beam or slab that extends beyond its last point of support.

Column: Upright structural member acting in compression.

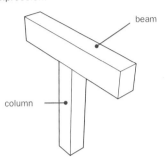

beam

column

Dome: Arch rotated in plan to produce an inverted bowl-shaped form.

Girder: Horizontal beam, which is usually very large, that supports other beams.

Lintel: Beam used to span the opening in a wall left for a window or a doorway. The lintel supports and distributes the load of the wall above the opening.

Prestressing: Applying a compressive stress to a concrete structural member, either by pre-tensioning (pouring concrete around stretched steel strands, then releasing the external tensioning force on the strands once the concrete has cured) or post-tensioning (tensioning high-strength steel tendons against a concrete structural member after the concrete has cured).

Retaining wall: Wall used to mediate abrupt changes in ground elevation and to resist lateral soil pressures.

Shear: System of internal forces whose outcome is a force acting perpendicular to the longitudinal axis of a structural member or assembly.

Shoring: Temporary vertical or sloping supports.

Slump test: Test in which wet concrete or plaster is placed in a metal cone-shaped mold of specific dimensions and allowed to slump under its own weight after the cone is removed. The index of the material's working consistency is determined by the distance between the height of the mold and the height of the slumped mixture.

Strain: Intensity of deformation at a point in an object.

Stress: Intensity of internal force acting at a point in an object.

Vault: Extruded arch.

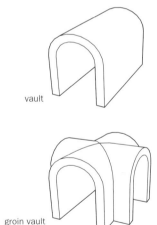

vault

groin vault

> ### Materials
> Structural framing elements may be made of wood, heavy timbers, concrete, masonry, steel, or a combination of these.

FOUNDATION SYSTEMS

The selection of a foundation system depends on many factors, including the building size and height, the quality of the subsurface soil and groundwater conditions, construction methods, and environmental concerns.

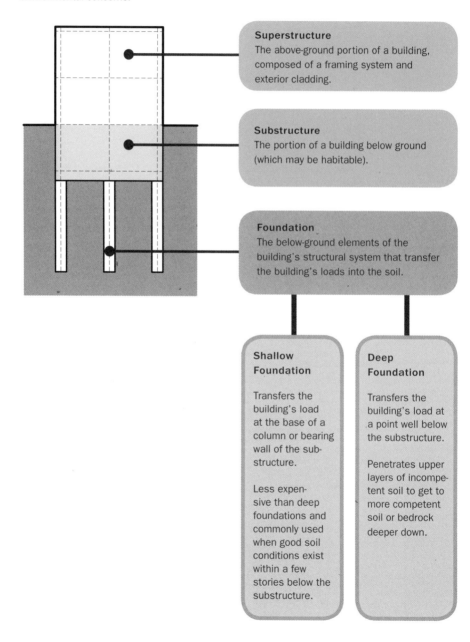

Superstructure
The above-ground portion of a building, composed of a framing system and exterior cladding.

Substructure
The portion of a building below ground (which may be habitable).

Foundation
The below-ground elements of the building's structural system that transfer the building's loads into the soil.

Shallow Foundation

Transfers the building's load at the base of a column or bearing wall of the substructure.

Less expensive than deep foundations and commonly used when good soil conditions exist within a few stories below the substructure.

Deep Foundation

Transfers the building's load at a point well below the substructure.

Penetrates upper layers of incompetent soil to get to more competent soil or bedrock deeper down.

SHALLOW SYSTEMS

Footings

Concrete footings may be in the form of a column pad, for distributing the load of a column, or a strip footing, which does the same for a bearing wall.

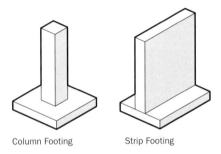

Column Footing Strip Footing

Slab on Grade

Used for one- and two-story structures, this inexpensive foundation has thickened edges and rests as a continuous slab on the surface of the ground.

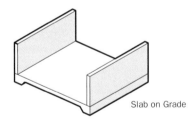

Slab on Grade

Mat Foundation

In this foundation system (also known as raft foundation), the whole building rests on a large continuous footing. It is often used to resolve special soil or design conditions. "Floating" or "compensated" mat foundations are sometimes employed in situations with weak soil. The floating foundation is placed beneath the building to a point that the amount of soil removed is equal to the total weight of the building.

DEEP SYSTEMS

Caissons

To construct a caisson (also referred to as a "drilled pier"), a hole is drilled or dug (a process known as augering) through unsatisfactory soil beneath a building's substructure, until rock, dense gravel, or firm clay is reached. If the caisson will rest on soil at the bottom, the hole is sometimes belled out to achieve a bearing area similar to a footing and the hole is then filled with concrete. Caissons may range from 18″ (457) to 6′ (1 829) in diameter.

Piles

Piles are similar to caissons, but are driven into place, not drilled or poured. They may be made from concrete, steel, or timber, or a combination of these materials. Piles are driven closely together in clusters and then cut off and capped in groups of two to twenty-five. The building's columns rest on top of the pile caps. Load-bearing walls, where used, rest on reinforced-concrete grade beams that span between pile caps, transmitting the walls' loads to the piles.

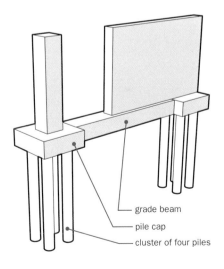

grade beam
pile cap
cluster of four piles

WOOD LIGHT-FRAMING

Wood light-frame construction uses a system of wood wall studs, floor joists, rafters, columns, and beams to create both structure and framework for applied interior and exterior finished surfaces. As a building material, wood is relatively inexpensive, versatile, and quick to erect. Typical spacing for studs and floor joists is 12″(305), 16″(406), or 24″(610) on center. These dimensions are compatible with typical wall, floor, and ceiling material unit dimensions, such as gypsum wallboard and plywood sheets. When complete SI conversion occurs in the United States, these building materials will undergo a change in unit size, and framing dimensions will shift to the metric planning grid used elsewhere in the world.

Exterior wall sheathing is typically plywood, which acts as a base for stucco, siding, or even brick and stone façades; insulation is placed between the studs. The most common framing method is platform framing, in which, in multistory buildings, the levels are built one at a time, so that each floor acts as a platform on which the walls above can rest. In balloon framing, wall studs are continuous from sill to roof; the intermediate floor joists tie into a ribbon occurring at the floor line and attached to the studs. Balloon framing is more prevalent in older houses and is seldom used today.

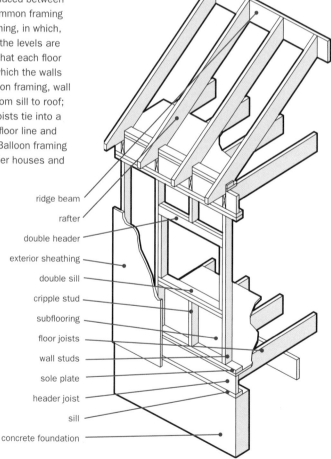

ridge beam
rafter
double header
exterior sheathing
double sill
cripple stud
subflooring
floor joists
wall studs
sole plate
header joist
sill
concrete foundation

HEAVY TIMBERS

Heavy-timber construction uses specifically engineered woods of minimum dimensions to achieve greater structural strength and fire resistance than is possible with wood light-frame construction, while also taking advantage of the aesthetic benefits of exposed wood. To achieve high levels of fire resistance, construction details, fastenings, and wood treatment are closely regulated in heavy-timber construction.

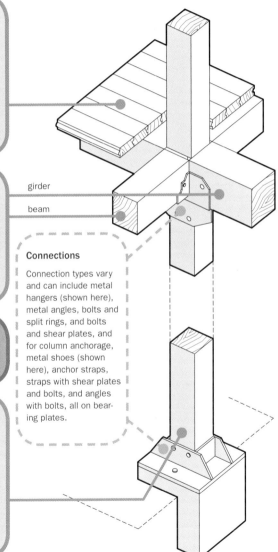

Decking

Floor deck planking spans between floor beams; finished floor material is placed above the planking, running perpendicular to it. Planks should be a minimum 3" nominal (76) thick if splined or tongue-and-grooved together, or a minimum 4" nominal (102) if set on edge and spiked together. Flooring should be 1/2"–1" (13–25) thick.

Floors

Beams and girders may be sawn or glue-laminated.

They should not be less than 6" wide x 10" deep nominal (152 x 254).

Truss members must be a minimum 8"x 8" nominal (203 x 203).

girder

beam

Connections

Connection types vary and can include metal hangers (shown here), metal angles, bolts and split rings, and bolts and shear plates, and for column anchorage, metal shoes (shown here), anchor straps, straps with shear plates and bolts, and angles with bolts, all on bearing plates.

Decay

Structural members must be preservatively treated or be from the heartwood of a naturally durable wood.

Columns

Columns may be sawed or glue-laminated.

Supporting floor loads, must be a minimum 8" wide x 8" deep nominal (203 x 203).

Supporting roof and ceiling loads, must be a minimum 6" wide x 8" deep nominal (152 x 203).

CH. 22

SITECAST CONCRETE FRAMING

Sitecast concrete is concrete that is cast into forms on the building site. It can be cast into any shape for which a form can be made; however, the work and time involved in building formwork, reinforcing and pouring the concrete, waiting for the concrete to cure, and dismantling the form-work makes sitecast concrete slower to erect than precast concrete or structural steel.

Concrete Casting

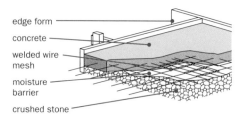

edge form
concrete
welded wire mesh
moisture barrier
crushed stone

Slab on Grade

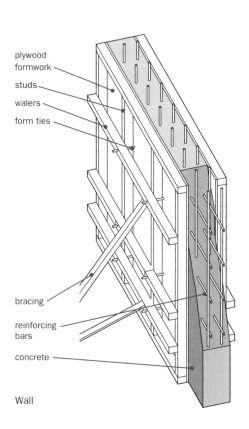

plywood formwork
studs
walers
form ties

bracing
reinforcing bars
concrete

Wall

Cast concrete uses welded wire mesh or reinforcing steel bars (rebar) to prevent cracking or uneven settling and to supply rigidity. Rebar commonly ranges in size from #3 to #18 (diameter in eighths of an inch), and its size, spacing, and number are determined by the sizes and natures of the columns, slabs, and beams.

Casting floor slabs, slabs on grade, plates, walls, columns, beams, and girders all involves the use of formwork, which is often plywood but can also be metal or fiberboard. Standardization of column and beam sizes within a project helps to mitigate the cost of the formwork, which can be reused.

To hold formwork together during pour and curing, form ties are inserted through holes in the formwork and secured in place with fasteners; the protruding ends are snapped off after formwork comes down.

Poured concrete must have regular control joints designed into walls and slabs, either as part of the form or tooled onto the surface before the concrete has cured. A control joint is a line of discontinuity acting as a plane of weakness where movement or cracking can occur in response to forces, relieving potential cracking elsewhere.

Concrete Floor and Roof Systems

Different systems, in order of increasing load capacity, spans, and cost, are one-way solid slab (spans across parallel lines of support), two-way flat plate (uses no beams, dropped plate, or column capitals, but rather, reinforcing of various stresses), two-way flat slab (uses column capitals and/or drop panels instead of beams), one-way joist, waffle slab, one-way beam and slab, and two-way beam and slab. Two-way systems tend to be square in proportion and are supported on four sides; one-way systems have a 1:>1.5 proportion and are supported on two sides.

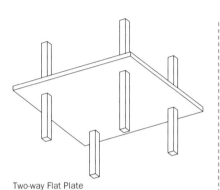

Two-way Flat Plate

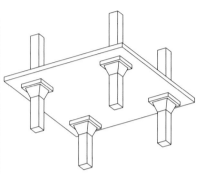

Two-way Flat Slab

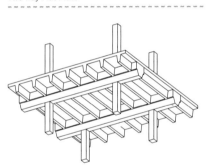

One-way Ribbed Slab (joist)

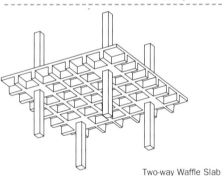

Two-way Waffle Slab

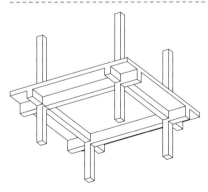

Flat Beam and Slab

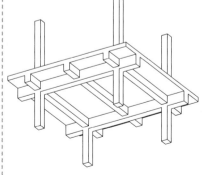

One-way Beam and Slab

CH. 24

PRECAST CONCRETE FRAMING

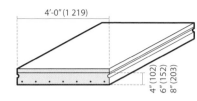

Solid Flat Slab

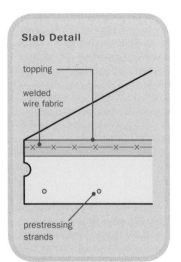

Slab Detail

topping

welded wire fabric

prestressing strands

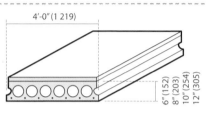

Hollow Core Slab

Hollow Core Slab Types

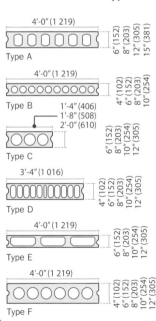

4'-0" (1 219)
Type A
6" (152) 8" (203) 12" (305) 15" (381)

4'-0" (1 219)
Type B
4" (102) 6" (152) 8" (203) 10" (254)

1'-4" (406) 1'-8" (508) 2'-0" (610)
Type C
6" (152) 8" (203) 10" (254) 12" (305)

3'-4" (1 016)
Type D
4" (102) 6" (152) 8" (203) 10" (254) 12" (305)

4'-0" (1 219)
Type E
6" (152) 8" (203) 10" (254) 12" (305)

4'-0" (1 219)
Type F
4" (102) 6" (152) 8" (203) 10" (254) 12" (305)

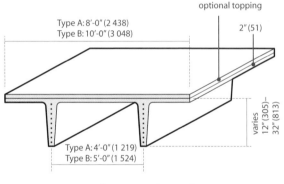

Type A: 8'-0" (2 438)
Type B: 10'-0" (3 048)

optional topping
2" (51)

Type A: 4'-0" (1 219)
Type B: 5'-0" (1 524)

varies 12" (305)– 32" (813)

Stemmed Deck, Double Tee (DT)

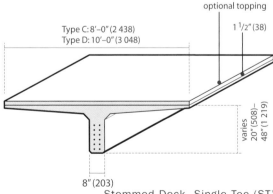

Type C: 8'-0" (2 438)
Type D: 10'-0" (3 048)

optional topping
1 1/2" (38)

varies 20" (508)– 48" (1 219)

8" (203)

Stemmed Deck, Single Tee (ST)

Rectangular Beam

Designation	No. of Strands	H	B
12RB24	10	24" (610)	12" (305)
12RB32	13	32" (813)	12" (305)
16RB24	13	24" (610)	16" (406)
16RB32	18	32" (813)	16" (406)
16RB40	22	40" (1 016)	16" (406)

L-shaped Beam

Designation	No. of Strands	H	H1/H2
18LB20	9	20" (508)	12"/8" (305/203)
18LB28	12	28" (711)	16"/12" (406/305)
18LB36	16	36" (914)	24"/12" (610/305)
18LB44	19	44" (1 118)	28"/16" (711/406)
18LB52	23	52" (1 321)	36"/16" (914/406)
18LB60	27	60" (1 524)	44"/16" (1 118/406)

Inverted Tee Beam

Designation	No. of Strands	H	H1/H2
24IT20	9	20" (508)	12"/8" (305/203)
24IT28	13	28" (711)	16"/12" (406/305)
24IT36	16	36" (914)	24"/12" (610/305)
24IT44	20	44" (1 118)	28"/16" (711/406)
24IT52	24	52" (1 321)	36"/16" (914/406)
24IT60	28	60" (1 524)	44"/16" (1 118/406)

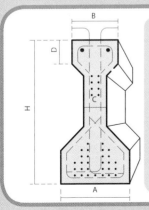

AASHTO* Girders

Designation	No. of Strands	H	A	B	C	D
Type II	14	36" (914)	18" (457)	12" (305)	6" (152)	6" (152)
Type III	22	45" (1 143)	22" (559)	16" (406)	7" (178)	7" (178)
Type IV	32	54" (1 372)	26" (660)	20" (508)	8" (203)	8" (203)

*American Association of State Highway Transportation Officials

Stemmed Deck DT Framing System

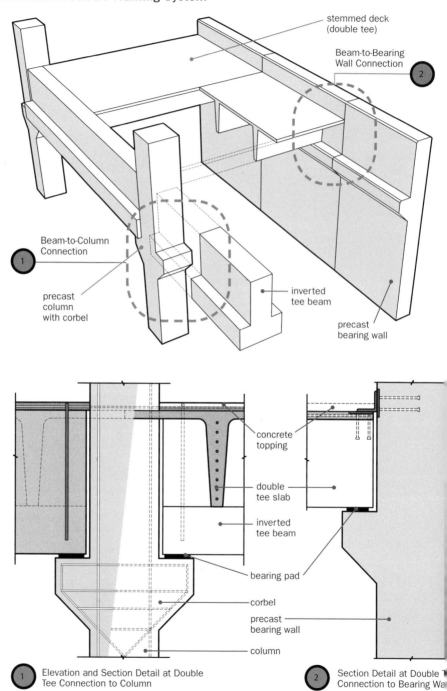

stemmed deck
(double tee)

Beam-to-Bearing
Wall Connection

2

Beam-to-Column
Connection

1

precast
column
with corbel

inverted
tee beam

precast
bearing wall

concrete
topping

double
tee slab

inverted
tee beam

bearing pad

corbel

precast
bearing wall

column

1 Elevation and Section Detail at Double
Tee Connection to Column

2 Section Detail at Double T
Connection to Bearing Wa

Hollow Slab Framing System

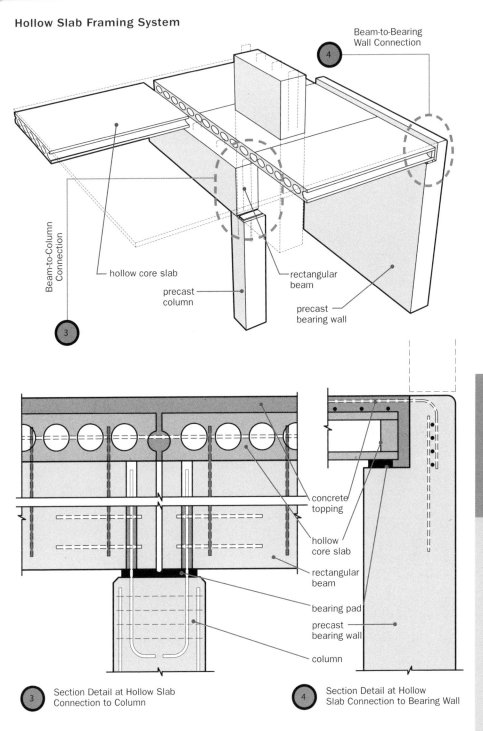

Beam-to-Bearing
Wall Connection

4

Beam-to-Column
Connection

3

hollow core slab

precast
column

rectangular
beam

precast
bearing wall

concrete
topping

hollow
core slab

rectangular
beam

bearing pad

precast
bearing wall

column

3 Section Detail at Hollow Slab
Connection to Column

4 Section Detail at Hollow
Slab Connection to Bearing Wall

STEEL FRAMING

Structural Steel Shape Designations

	Shape	Description
W	Wide-flange	hot-rolled, doubly symmetric wide-flange shapes used as beams and columns
HP	Wide-flange	hot-rolled, wide-flange shapes whose flanges and webs are of the same nominal thickness and whose depth and width are essentially the same; often used as bearing piles
S	American Standard beam	hot-rolled, doubly symmetric shapes produced in accordance with AASM* dimensional standards; generally being superseded by wide-flange beams, which are more structurally efficient
M	Miscellaneous	doubly symmetrical shapes that cannot be classified as W or HP shapes
L	Angle	equal leg and unequal leg angles
C	American Standard channel	hot-rolled channels produced in accordance with AASM dimensional standards
MC	Channel	hot-rolled channels from miscellaneous shape
WT	Structural tee	hot-rolled tees cut or split from W shapes
ST	Structural tee	hot-rolled tees cut or split from S shapes
MT	Structural tee	hot-rolled tees cut or split from M shapes
TU	Tube	hollow structural steel members shaped like a square or rectangle; used as beams or columns, or in bracing

*AASM: Association of American Steel Manufacturers

Steel Shape Examples

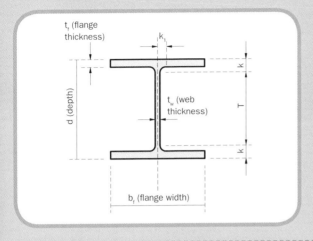

t_t (flange thickness)

k_1

d (depth)

t_w (web thickness)

T

k

k

b_f (flange width)

Wide-flange
W8X67

8 = nominal depth (in.);
67 = weight per foot of
length (lb.)

Wide-flange
HP12X84

12 = nominal depth (in.);
84 = weight per foot of length (lb.)

Angle
L6X4X⁷/₈

6 and 4 = nominal depths of
legs (in.); ⁷/₈ = nominal
thickness of legs (in.)

American Standard
S8X18.4

8 = nominal depth (in.);
18.4 = weight per foot of
length (lb.)

Channel
MC7X22.7

7 = nominal depth (in.); 22.7
= weight per foot of length (lb.)

Miscellaneous
M10X8

10 = nominal depth
(in.); 8 = weight per foot
of length
(lb.)

Structural Tees
WT25X95

ST15X3.75

Tube
TU2X2X¹/₈

CH. 25

Structural Systems **149**

Steel-Frame Connections

Steel is proportionally light in weight relative to its strength and can be erected quickly but precisely. Steel-frame construction uses a combination of structural steel shapes that act as columns, beams, girders, lintels, trusses, and numerous means of connection.

The integrity and strength of steel connections are just as important as the steel shapes themselves, because a failed connection results in a failed system. Steel-frame connections include angles, plates, and tees for transitioning between members being joined.

Connections that join only the web of the beam to the column are called framed connections; they can transmit all the vertical (shear) forces from the beam to the column. If the flanges of the beam are also connected to the column, it is then capable of transmitting bending moment from beam to column.

Framed Connection: Shear connection with beam web bolted to column flange using connecting angles.

Welded Moment Connection: Moment connection between beam and column using groove welds at beam web and flange.

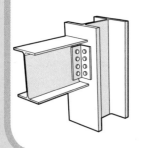
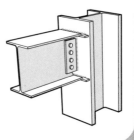

TRUSS DESIGN

Heel Conditions

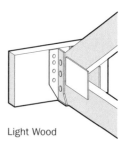

Light Wood

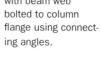

Heavy Wood

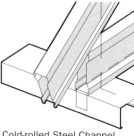

Cold-rolled Steel Channel

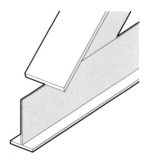

Welded Steel

A truss is a structural framework of triangular units for supporting loads over long spans. The framework of the structural members reduces nonaxial forces to a set of axial forces in the members themselves.

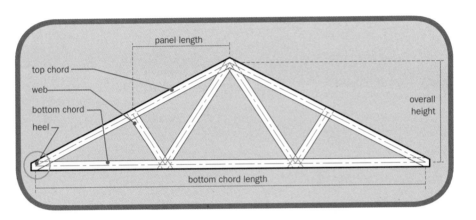

Truss Types

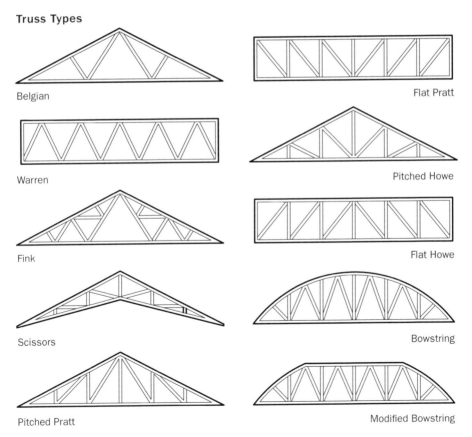

Belgian

Flat Pratt

Warren

Pitched Howe

Fink

Flat Howe

Scissors

Bowstring

Pitched Pratt

Modified Bowstring

Chapter 17: Mechanical Issues

A building's mechanical systems involve control of heat, ventilation, air-conditioning, refrigeration, plumbing, fire protection, and noise reduction, all of which must be integrated with the architectural, structural, and electrical design.

ENERGY DISTRIBUTION SYSTEMS

All-air Systems: Conditioned air is circulated to and from spaces by central fans that direct it through runs of ductwork.

Air and Water Systems: Conditioned air is ducted to each space, and chilled and heated water are piped to each space to modify the temperature of the air at each outlet.

All-water Systems: No ductwork is used, and air is circulated within each space, not from a central source. Chilled and heated water are furnished to each space. Because water piping is much smaller than ductwork for air, all-water systems are very compact.

Air duct: Pipe that carries warm and cold air to rooms and back to a furnace or air-conditioning system.

Air handling unit (AHU): Equipment including a fan or blower, heating and/or cooling coils, regulator controls, condensate drain pans, and air filters.

ASHRAE: American Society of Heating, Refrigerating, and Air-Conditioning Engineers.

Boiler: Tank where the heat produced from the combustion of fuels (natural gas, fuel oil, wood, or coal) generates hot water or steam for use in heating.

Cavity wall: Hollow wall formed with two layers of masonry, providing an insulating air space between.

Chase wall: Cavity wall containing electrical runs or plumbing pipes in its cavity.

Chiller: Heat exchanger (evaporator, condenser, and compressor system) that uses air, a refrigerant, water, and evaporation to transfer heat and produce air-conditioning.

Closed loop: Evaporator side of chiller system, closed to the atmosphere.

Cooling tower: Open recirculating system where heat exchange occurs by evaporation.

Dry bulb: Ambient outside temperature.

HVAC: Heating, ventilating, and air-conditioning.

Louver: Opening with horizontal slats that permit passage of air, but not rain, sunlight, or view, into a structure.

Plenum: Chamber that serves as a distribution area for heating or cooling systems, usually found between a false ceiling and the actual ceiling.

Open loop: Condenser/tower side of chiller system; open to the atmosphere.

Radiant heat: Heating system that uses coils of electricity, hot water, or steam pipes embedded in floors, ceilings, or walls to heat rooms.

Shaft: Enclosed vertical space (usually with fire-resistive walls) containing all vertical runs of pipes, ducts, and elevators.

Variable air volume (VAV): Air-handling system that conditions air to a constant temperature and varies airflow to ensure thermal comfort.

Wet bulb: Combination of outside air temperature and relative humidity; higher relative humidity makes it more difficult for a cooling tower to evaporate water into the atmosphere.

INSULATION

Sometimes called thermal resistance, R-value is the measure of the capacity of a material (or assembly of materials) to resist heat transfer. R-value is the reciprocal of the heat-transfer coefficient (U-value). The larger the R-value, the greater a material's insulating properties.

> **Measurement of R-value is**
>
> hr ft² °F/Btu in.
> (m °K/W)

Insulation Types

Type	Materials	R-value	Installation	Issues
Batt / blanket	glass wool and rock wool	3.3 (23)	between framing members	fairly good R-value, low in cost, and easy to install
Loose fill	glass wool and rock wool	2.5–3.5 (17–24)	blown into wall cavities and floors	good for existing construction
Loose fibers with binders	cellulose and glass wool	3.1–4.0 (22–27)	blown into cavities, binder is activated by spray of water	good R-value and low in cost
Foam-in-place	polyurethane foam	5–7 (27–49)	sprayed in place	ideal for difficult to insulate locations, though high in cost; possibly combustible and may emit toxic gases when burned
Rigid boards	types: polystyrene foam, polyure-thane foam, polyisocyanurate foam, phenolic foam, glass fiber, and cane fiber	3–8.3 (21–58)	boards applied over framing members, either as exterior sheathing or on the interior beneath finish material good	Good R-values, though higher cost; may be combustible and toxic when burned

ACOUSTICS

STC (Sound Transmission Class) is a number rating of airborne sound transmission loss as measured in an acoustical laboratory under carefully controlled test conditions. STC information is used during the building design phase to select a particular partition/window configuration to obtain the desired sound isolation performance. Higher STC numbers indicate less sound loss.

18	Hollow-metal door without seals
22	Solid wood door without seals
26	1/4″ plate glass
32	1/2″ plate glass
38	wood stud wall (1/2″ GWB both sides)
41	4″ painted CMU wall
42	metal stud wall (5/8″ GWB both sides)
46	8″ hollow CMU wall
48	12″ painted CMU wall
50	insulated metal stud wall (2 layers 5/8″ GWB both sides)
53	12″ poured solid concrete wall

Chapter 18: Lighting

Lighting has a tremendous effect on the manner in which a space will be experienced and perceived. Architects often work closely with lighting designers, who provide expertise on the technical aspects and effects of lighting and how they can best serve the design and function of a space. Lighting designers provide lighting specifications for the project and coordinate much of their design information with the electrical drawings and reflected ceiling plans.

LIGHTING TERMINOLOGY

Ambient lighting: General lighting for an entire space.

Ampere (amp): Unit of measuring electrical current, equal to one coulomb per second.

Baffle: Opaque or translucent element that controls the distribution of light at certain angles.

Ballast: Device that provides starting voltage for a fluorescent or HID lamp, then limits and regulates the current in the lamp during operation.

Bulb: Decorative glass or plastic housing that diffuses light distribution.

Candela: SI unit of the luminous intensity of a light source in a specific direction. Also called candle.

Candlepower (CP): Measure (in candelas) of the luminous intensity of a light source in a specific direction.

Coefficient of utilization (CU): Ratio of a luminaire's lumens on a surface to the lamp's production of lumens.

Color rendering index (CRI): Scale of 1 to 100 determining a light source's effect on the color appearance of an object, compared to the color appearance under a reference light source. A rating of 1 indicates maximum color shift and 100 indicates no color shift.

Color temperature: Specification of the color appearance of a light source, measured in Kelvins. Color temperatures below 3,200K may be considered warm and those above 4,000K may be considered cool.

Compact fluorescent: Small fluorescent lamp used as an alternative to incandescent light. Known also as twin-tube, PL, CFL, or BIAX.

Daylight compensation: Energy-saving photocell-controlled dimming system that reduces the output of lamps in the presence of daylight.

Diffuser: Translucent piece of plastic or glass that shields a fixture's light source, scattering and diffusing the transmitted light.

Direct glare: Glare resulting from direct view of light source.

Downlight: Ceiling fixture that can be fully recessed, semirecessed, or ceiling mounted, in which most of the light is directed downward. Variously called a can, high-hat, or recessed downlight.

Electroluminescent: Lighting technology that provides uniform brightness and long lamp life while consuming very little energy, making it ideal for use in exit signs.

Energy: Electric power unit, measured in kilowatt hours (kwh).

Fluorescent: Tube filled with argon, krypton, or another inert gas. An electrical current applied to the gas produces an arc of ultraviolet radiation that causes the phosphors inside the lamp wall to radiate visible light.

Foot-candle (FC): English unit of measuring the light level on a surface, equal to one lumen per square foot.

High-intensity discharge (HID): Mercury vapor, metal halide, high-pressure sodium, and low-pressure sodium light sources.

High output (HO): Lamp or ballast that operates at high currents and produces more light.

IALD: International Association of Lighting Designers.

IESNA: Illuminating Engineering Society of North America.

Illuminance: Luminous flux per unit area on a surface at any given point. Commonly called light level, it is expressed in foot-candles or lux.

Incandescent: Bulb that contains a conductive wire filament through which current flows. This is the most common type of light source.

Lamp: Light-producing component inside a bulb.

Lay-in troffer: Fluorescent fixture that lays into a ceiling grid.

Light-emitting diode (LED): Semiconductor diode that emits light when voltage is applied to it; used in electronic displays such as signage.

Lens: Transparent or translucent element that alters the directional characteristics of light as it passes through.

Lumen: Unit of measuring the total light output of a lamp.

Luminaire: Complete lighting unit (also called a fixture) consisting of lamp(s) and the parts required to distribute the light, hold the lamps, and connect them to a power source.

Luminance: Luminous intensity per unit area of a surface. It is expressed in candelas (metric) or footlamberts (customary).

Lux (LX): Metric unit of illuminance measure. One lux = 0.093 foot-candles; one foot-candle = 10.76 lux.

Nadir: Reference direction directly below (0 degrees) a luminaire.

Opaque: Of material, transmitting no visible light.

Optics: Components of a light fixture—reflectors, refractors, lenses, louvers, and so on; *or*, the light-emitting performance of a luminaire.

Reflectance: Ratio of light reflected from a surface to the light incident on the surface. (The reflectance of a dark carpet is 20 percent and that of a clean white wall is 50 to 60 percent.)

Reflector: Element of a luminaire that shrouds the lamps, redirecting some of the light they emit.

Refractor: Element of a luminaire that redirects light output by bending the waves of light.

Room cavity ratio (RCR): Ratio of room dimensions used to determine how light will interact with the room's surfaces.

T12 lamp: Industry standard designation for a fluorescent lamp that is $^{12}/_8''$ in diameter. T8 and T10 are similarly named.

Translucent: Of material, transmitting some visible light.

Transparent: Of material, transmitting most visible light incident on it.

Troffer: Recessed fluorescent fixture (from *trough* plus *coffer*).

Ultraviolet (UV): Invisible radiation of shorter wavelength and higher frequency than visible violet light.

Underwriters' Laboratories (UL): Independent organization that tests products for public safety.

LIGHT FIXTURES AND TYPES

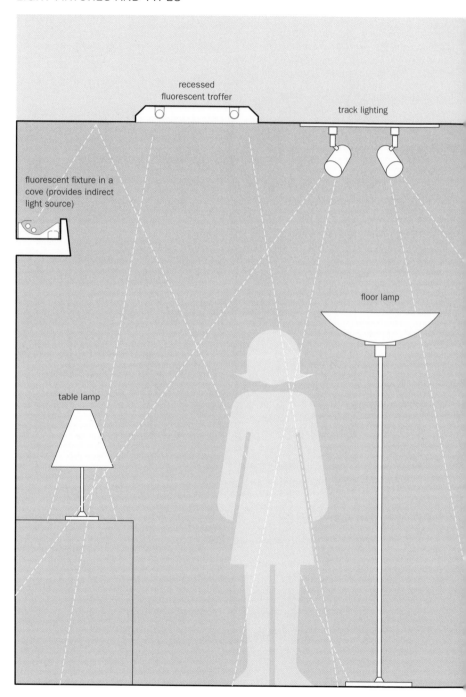

recessed
fluorescent troffer

track lighting

fluorescent fixture in a
cove (provides indirect
light source)

floor lamp

table lamp

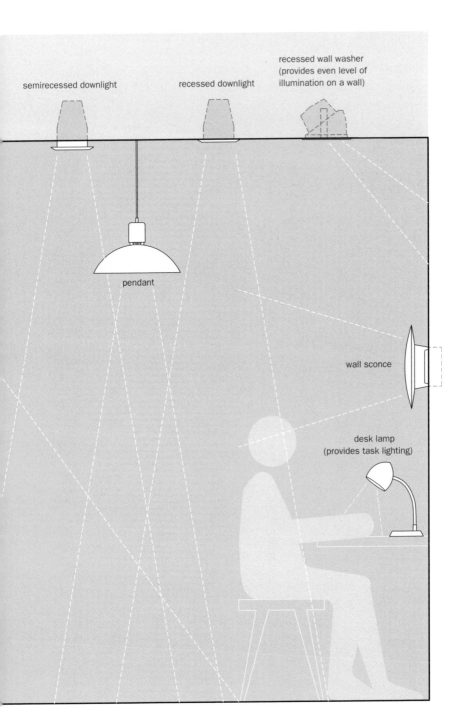

semirecessed downlight

recessed downlight

recessed wall washer
(provides even level of
illumination on a wall)

pendant

wall sconce

desk lamp
(provides task lighting)

Chapter 19: Stairs

Stairs are a primary method of vertical circulation in most private residences and even in public places where elevators or escalators are present. In elevatored buildings, building codes will require a minimum number of enclosed exit stairs. Stair construction is typically of wood, metal, or concrete, or a combination of all three.

STAIR TYPES

Straight Run Stair

Fire codes generally restrict the total rise of a straight stair to 12'-0" (3 658) before an intermediate landing is required. Landing depth should equal the stair width.

L-shaped Stair with Landing

L-shaped stairs may contain long or short legs, with a landing at any change in direction.

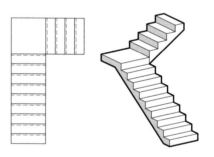

U-shaped Stair with Landing

U-shaped stairs, which switch back as they ascend, are useful in tight floor plans and as one component in a stacking multilevel circulation system (such as an egress stair core).

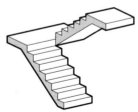

L-shaped Stair with Winders

Winders may help to compress the area needed for a stair by adding angled treads where a landing might go in a typical L-shaped stair. Most winders do not comply with local codes.

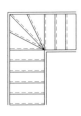

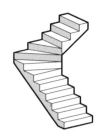

L-shaped Stair with Offset Winders

Offset winder treads are more generous in proportion and, therefore, may comply with applicable codes.

Spiral Stair

Spiral stairs occupy a minimum amount of plan space and are often used in private residences. Most spiral stairs are not acceptable as egress stairs, except in residences and in spaces of five or fewer occupants in 250 sq. ft. (23 m²) or less.

Curved Stair

Curved stairs follow the same layout principles of spiral stairs. Though with a sufficient open center diameter, the treads may be dimensioned to legal code standards for egress.

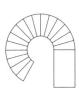

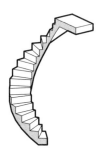

STAIR COMPONENTS

arrow indicates direction of stair (one plan might have stairs going down and up)

break line (entire run of stair cannot be seen in floor plan)

dashed lines indicate stair continues above break line

UP

total run of stair

ceiling clearance: 6'-8" (2 032) min.

guard rail height: 42" (1 067) min.

handrail height: 34–38" (864–965)

total rise of stair

max. opening may allow an 8" (203) dia. sphere to pass through

max. opening may allow a 4" (102) dia. sphere to pass through

max. opening may allow a 6" (152) dia. sphere to pass through

CH. 14 CH. 13

Plan and Elevation of Stair

TREADS AND RISERS

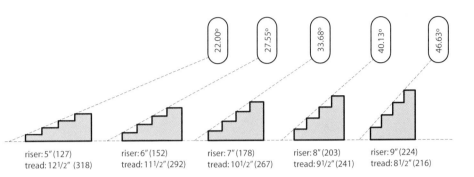

| 22.00° | 27.55° | 33.68° | 40.13° | 46.63° |

riser: 5″ (127)
tread: 12¹/2″ (318)

riser: 6″ (152)
tread: 11¹/2″ (292)

riser: 7″ (178)
tread: 10¹/2″ (267)

riser: 8″ (203)
tread: 9¹/2″ (241)

riser: 9″ (224)
tread: 8¹/2″ (216)

Riser and Tread Dimensions

Angle	Riser inches (mm)	Tread inches (mm)
22.00°	5 (127)	12 ¹/2 (318)
23.23°	5 ¹/4 (133)	12 ¹/4 (311)
24.63°	5 ¹/2 (140)	12 (305)
26.00°	5 ³/4 (146)	11 ³/4 (299)
27.55°	6 (152)	11 ¹/2 (292)
29.05°	6 ¹/4 (159)	11 ¹/4 (286)
30.58°	6 ¹/2 (165)	11 (279)
32.13°	6 ³/4 (172)	10 ³/4 (273)
33.68°	7 (178)	10 ¹/2 (267)
35.26°	7 ¹/4 (184)	10 ¹/4 (260)
36.87°	7 ¹/2 (191)	10 (254)
38.48°	7 ³/4 (197)	9 ³/4 (248)
40.13°	8 (203)	9 ¹/2 (241)
41.73°	8 ¹/4 (210)	9 ¹/4 (235)
43.36°	8 ¹/2 (216)	9 (229)
45.00°	8 ³/4 (222)	8 3/4 (222)
46.63°	9 (229)	8 ¹/2 (216)
48.27°	9 ¹/4 (235)	8 ¹/4 (210)
49.90°	9 ¹/2 (241)	8 (203)

*Blue band indicates preferred proportions
for comfort and safety.*

General Guidelines

The following are rules of thumb for calculating limits; always check appropriate local codes:

riser x run = 72″–75″ (1 829–905)

riser + run = 17″–17 ¹/2″ (432–45)

2(riser) + run = 24″–25″ (610–35)

exterior stairs: 2(riser) + run = 26″ (660)

Nonresidential:
minimum width = 44″ (1 120)
maximum riser = 7 ¹/2″ (191)
minimum tread = 11″ (279)

Residential:
minimum width = 36″ (915)
maximum riser = 8 ¹/4″ (210)
minimum tread = 9″ (229)

Chapter 20: Doors

Interior and exterior doors may be of many combinations of wood, metal, and glass, and mounted in wood or metal frames. Interior doors may require various levels of fire ratings; exterior doors must be well constructed and tightly weather-stripped to avoid excessive leakage of air and moisture.

Widths

2'-0"	2'-4"	2'-6"	2'-8"	2'-10"	3'-0"	3'-4"	3'-6"	3'-8"	3'-10"	4'-0"
(610)	(711)	(762)	(813)	(864)	(914)	(1 016)	(1 067)	(1 118)	(1 168)	(1 219)

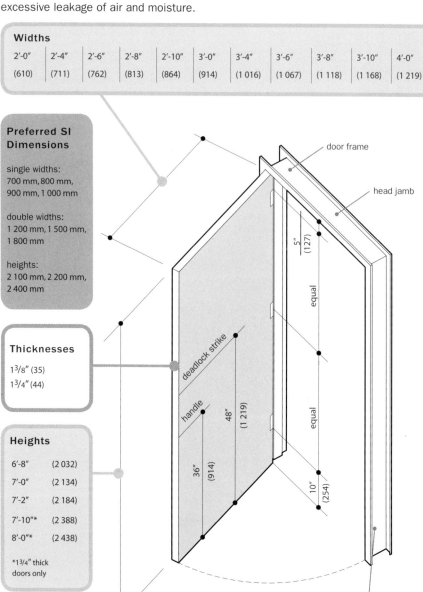

Preferred SI Dimensions

single widths:
700 mm, 800 mm,
900 mm, 1 000 mm

double widths:
1 200 mm, 1 500 mm,
1 800 mm

heights:
2 100 mm, 2 200 mm,
2 400 mm

Thicknesses

1³/₈" (35)
1³/₄" (44)

Heights

6'-8"	(2 032)
7'-0"	(2 134)
7'-2"	(2 184)
7'-10"*	(2 388)
8'-0"*	(2 438)

*1³/₄" thick
doors only

CH. 14 CH. 13

door frame

head jamb

5"
(127)

equal

deadlock strike

handle

48"
(1 219)

equal

36"
(914)

10"
(254)

side jamb

DOOR TYPES

| Flush | Vision Panel | Narrow Lite | Glass |

| Glass | Louvered | Louvered | Glass and Louvered |

Fire Doors

U.L. Label	Rating	Glazing Permitted: 1/4" (6.4) Wire Glass
A	3 hour	no glazing permitted
B	1 1/2 hour	100 sq. in. (64 516 mm²) per leaf
C	3/4 hour	1 296 sq. in. (836 179 mm²) per light; 54" (1 372) max. dimension
D	1 1/2 hour	no glazing permitted
E	3/4 hour	720 sq. in. (464 544 mm²) per light; 54" (1 372) max. dimension

Max. door size: 4' x 10' (1 219 x 3 048); door frame and hardware must have same rating as door; door must be self-latching and equipped with closers; louvers with fusible links are permitted for B and C label doors; no louver and glass light combinations are allowed.

WOOD DOORS

Flush Solid Core

Used primarily for exterior conditions and wherever increased fire resistance, sound insulation, and dimensional stability are required.

Flush Hollow Core

Lightweight and inexpensive, used primarily for interior applications, though may be used on the exterior if bonded with a waterproof adhesive. Low sound and heat insulation value.

Panel

Supporting framework of rails and stiles may hold panels of wood, glass, or louvers. Makeup of doors minimizes dimensional changes brought on by fluctuating moisture content of the wood.

Door Elevation

Door Elevation

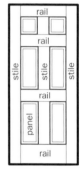

Door Elevation

Detail Section

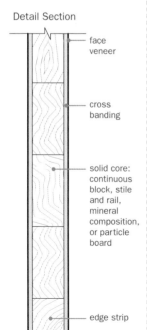

- face veneer
- cross banding
- solid core: continuous block, stile and rail, mineral composition, or particle board
- edge strip

Detail Section

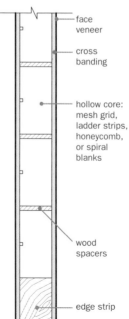

- face veneer
- cross banding
- hollow core: mesh grid, ladder strips, honeycomb, or spiral blanks
- wood spacers
- edge strip

Detail Section

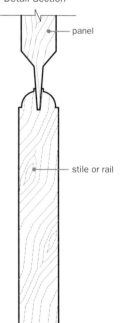

- panel
- stile or rail

Typical Wood Door Framing

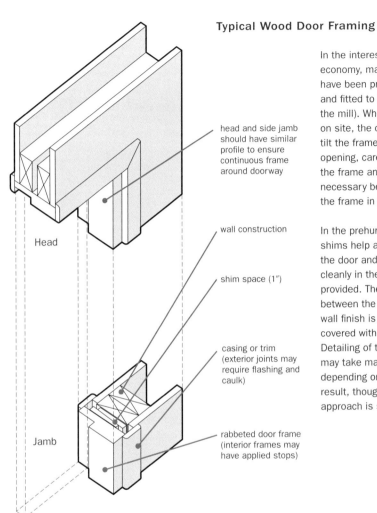

Head

head and side jamb
should have similar
profile to ensure
continuous frame
around doorway

wall construction

shim space (1")

casing or trim
(exterior joints may
require flashing and
caulk)

Jamb

rabbeted door frame
(interior frames may
have applied stops)

In the interest of speed and economy, many wood doors have been prehung (hinged and fitted to their frames at the mill). When they arrive on site, the carpenter may tilt the frame into the rough opening, carefully plumbing the frame and shimming as necessary before nailing the frame in place.

In the prehung method, shims help assure that the door and frame will fit cleanly in the rough opening provided. The resulting gap between the frame and the wall finish is generally covered with a casing. Detailing of this condition may take many forms, depending on the desired result, though a common approach is shown at left.

Ch. 22

Wood Face Veneer Types

Standard: 1/32"–1/16"
(0.08–1.6), bonded to
hardwood; crossband of
1/16"–1/10" (1.6–2.5).
Economical and widely
used; for all types of cores.
Difficult to refinish or repair
face damage.

Sawn veneers: 1/8" (3.2),
bonded to crossband. Easily
refinished and repaired.

Sawn veneers: 1/4" (6.4),
no crossband on stile and
rail. Face depth allows for
decorative grooves.

Wood Grades

Premium:
For natural, clear,
or stained finishes

Standard:
For opaque
(painted) finishes

HOLLOW METAL DOORS

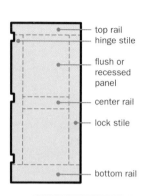

- top rail
- hinge stile
- flush or recessed panel
- center rail
- lock stile
- bottom rail

Meeting Stiles

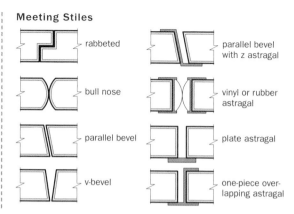

- rabbeted
- bull nose
- parallel bevel
- v-bevel
- parallel bevel with z astragal
- vinyl or rubber astragal
- plate astragal
- one-piece over-lapping astragal

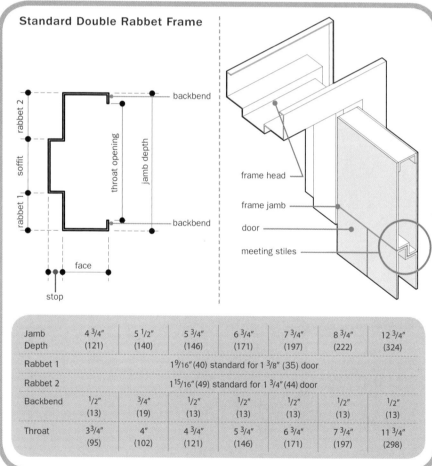

Standard Double Rabbet Frame

rabbet 2
rabbet 1
soffit
throat opening
jamb depth
face
stop
backbend
backbend

frame head
frame jamb
door
meeting stiles

Jamb Depth	4 3/4" (121)	5 1/2" (140)	5 3/4" (146)	6 3/4" (171)	7 3/4" (197)	8 3/4" (222)	12 3/4" (324)
Rabbet 1	1 9/16" (40) standard for 1 3/8" (35) door						
Rabbet 2	1 15/16" (49) standard for 1 3/4" (44) door						
Backbend	1/2" (13)	3/4" (19)	1/2" (13)	1/2" (13)	1/2" (13)	1/2" (13)	1/2" (13)
Throat	3 3/4" (95)	4" (102)	4 3/4" (121)	5 3/4" (146)	6 3/4" (171)	7 3/4" (197)	11 3/4" (298)

FRAME ANCHORS

Hollow Metal Door Gauges

GRADE	GAUGE
Residential	20 and lighter
Commercial	16 and 18
Institutional	12 and 14
High Security	steel plate

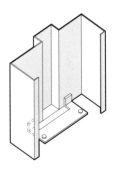

Standard Floor Knee
Jambs are attached to the floor with powder-driven fasteners.

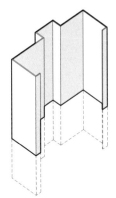

Extended Frame with Base Anchor
Floor-topping concrete is poured around the door frame.

Wood Stud Anchor
Jambs are anchored to wood studs by nailing through holes in jamb inserts.

Steel Channel Anchor
Jambs are anchored to steel studs; sheet metal zees are welded to jambs, and receive screws driven through studs.

Masonry T Anchor
Jambs are anchored to masonry walls: loose sheet metal tees are inserted into the frame and built into the mortar joints.

OTHER CORES

treated fibrous material formed into honeycomb

anhydrous mineral, foam, or fiber core

kiln-dried structural wood core

z-member or channel stiffeners (vertical, horizontal, or gridded)

CH. 25

Chapter 21: Windows and Glazing

TERMINOLOGY

Caulk: Sealant that fills a void.

Condensation: Process in which water vapor from the air, coming into contact with a cold surface like glass, condenses and forms a foggy effect.

Convection: Transfer of heat by air movement.

Desiccant: Porous crystalline substance used in the air space of insulating glass units to absorb moisture and solvent vapors from the air.

Dew point: Calculated temperature at which water vapor will condense.

Dual-sealed units: Sealed insulating glass units with a primary seal and a secondary outer seal.

Emissivity: Relative ability of a surface to absorb and emit energy in the form of radiation.

Gas-filled units: Insulating glass units with a gas instead of air in the air space, used to decrease the thermal conductivity U value.

Glaze: To fit a window frame with glass.

Grille: Decorative grid installed on or between glass lites, meant to look like a muntin bar, but without actually dividing the glass.

Light (or lite): Unit of glass in a window or door, enclosed by the sash or muntin bars. Sometimes spelled *lite* to avoid confusion with visible light; also called a pane.

Mullion: Horizontal or vertical member holding together two adjacent lites of glass or sash.

Muntin bar: Strip that separates panes of glass in a sash.

Passive solar gain: Solar heat that is captured naturally as it passes through a material.

R-value: Measure of the overall resistance to heat transmission due only to the difference in air temperature on either side of the material. See U-value.

Radiation: Process by which heat is emitted from a body through open space, as in sunlight.

Sash: Frame that holds glass lites and into which glass products are glazed.

Shading coefficient: Relative measurement of the total amount of solar energy that enters a building space through its glass, as the ratio of the solar heat gain through a specific glass product to the solar heat gain through a lite of $1/8''$ (3) clear glass. Glass of $1/8''$ (3) thickness is given a value of 1.0. The lower the shading coefficient number, the lower the amount of solar heat transmitted.

Tempered glass: Specially heat-treated high-strength safety glass.

Thermal performance: Ability of a glass unit to perform as a barrier to the transfer of heat.

Total solar energy: Total solar spectrum composed of UV, visible, and near infrared wavelengths.

U-value: Measure of thermal conductance; the reciprocal of R-value.

Ultraviolet (UV): Type of radiation in wavelengths shorter than those of visible light and longer than those of X rays.

Visible light: Portion of solar energy detected by the human eye as light.

WINDOW TYPES

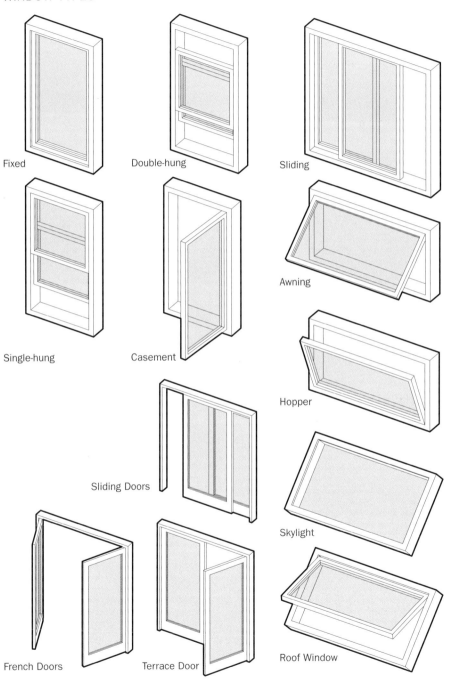

Fixed

Double-hung

Sliding

Single-hung

Casement

Awning

Hopper

Sliding Doors

Skylight

French Doors

Terrace Door

Roof Window

Window Sizing

A typical chart from a window manufacturer's catalog depicts stock sizes and types of windows (in feet and inches). Mas Opg (masonry opening) is the opening that must be provided for a brick, block, or stone wall; Rgh Opg (rough opening) is the opening required for typical stud walls; Sash Opg (sash opening) is the size of the window itself; and Glass Size is the size of the glass.

Mas Opg 2'-8 $^1/_2$"
Rgh Opg 2'-6 $^3/_8$"
Sash Opg 2'-4"
Glass Size 24"

3'-6 $^1/_2$"
3'-5 $^3/_4$"
3'-2"
16"

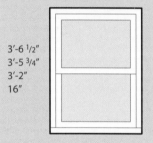

4'-2 $^1/_2$"
4'-1 $^3/_4$"
3'-10"
20"

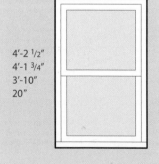

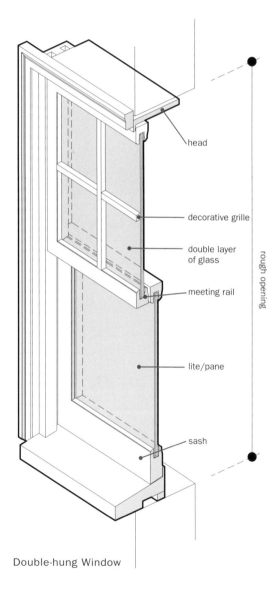

head

decorative grille

double layer of glass

meeting rail

lite/pane

sash

rough opening

Double-hung Window

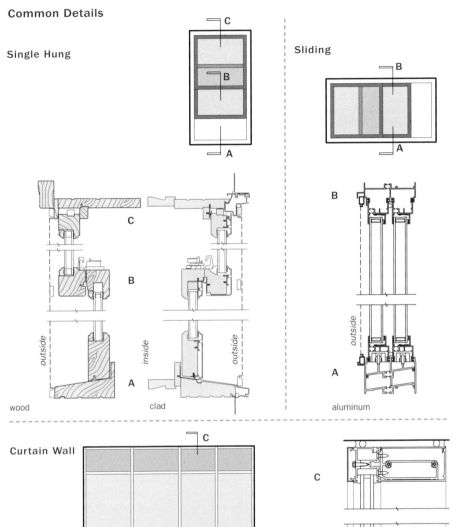

Common Details

Single Hung

C

B

A

wood — clad

outside · *inside* · *outside*

Sliding

B

A

outside

aluminum

Curtain Wall

C

B

A

outside

C

B

A

GLASS AND GLAZING

Most architectural glass comprises three major raw materials that are found naturally: silica, lime, and sodium carbonate. Secondary materials may be added to facilitate the glass-making process or to give the glass special properties, which can be broken into three basic categories. Soda-lime glass accounts for the majority of commercially produced glass. Used for bottles, glassware, and windows, its composition of silica, soda, and lime does not give it good resistance to sudden thermal changes, especially high temperatures, or to chemical corrosion. Lead glass contains about 20 percent lead oxide, and its soft surface makes it ideal for decorative cutting and engraving, though it does not withstand sudden temperature changes. Borosilicate glass, which refers to any silicate glass with a composition of at least 5 percent boric oxide, has greater resistance to thermal changes and chemical corrosion.

Glass Production

The most common flat glass is float glass, in which properly weighed and mixed soda lime glass, silica sand, calcium, oxide, soda and magnesium are melted in a 2,732°F (1,500°C) furnace. The highly viscous molten glass is floated across a bath of molten tin in a continuous ribbon. Because the tin is very fluid, the two materials do not mix, creating a perfectly flat surface between them. By the time the glass has left the molten tin, it has cooled enough to proceed to a lehr, where it is annealed, that is, cooled slowly under controlled conditions.

Glass may also be rolled, a process by which semimolten glass is squeezed between metal rollers to form a ribbon with predefined thicknesses and patterned surfaces. This process is used mostly for patterned and cast-glass production.

Glass Thickness

Sheet size, wind, and other loads determine the required glass thickness for any particular window.

Nominal Thickness	Actual Range
3/32″ single strength	0.085″–0.101″ (2.16–2.57)
laminate	0.102″–0.114″ (2.59–2.90)
1/8″ double strength	0.115″–0.134″ (2.92–3.40)
5/32″	0.149″–0.165″ (3.78–4.19)
3/16″	0.180″–0.199″ (4.57–5.05)
7/32″	0.200″–0.218″ (5.08–5.54)
1/4″	0.219″–0.244″ (5.56–6.20)
5/16″	0.292″–0.332″ (7.42–8.43)
3/8″	0.355″–0.406″ (9.02–10.31)
1/2″	0.469″–0.531″ (11.91–13.49)
5/8″	0.595″–0.656″ (15.09–16.66)
3/4″	0.719″–0.781″ (18.26–19.84)
1″	0.969″–1.031″ (24.61–26.19)
1 1/4″	1.125″–1.375″ (28.58–34.93)

GLASS FORMS

Glass Block: Glass blocks are considered to be masonry units. Typical units are made by fusing together two hollow halves, with a vacuum inside. Solid blocks, called glass bricks, are impact resistant but can be seen through. Solar control units may have coatings or inserts. Glass block walls are constructed in a similar fashion to other masonry walls, with mortar, metal anchors, and ties; they can be applied to interiors or exteriors.

Customary Sizes
4 1/2" x 4 1/2"
5 3/4" x 5 3/4" (nominal 6" x 6")
7 1/2" x 7 1/2"
7 3/4" x 7 3/4" (nominal 8" x 8")
9 1/2" x 9 1/2"
11 3/4" x 11 3/4" (nominal 12" x 12")
3 3/4" x 7 3/4" (nominal 4" x 8")
5 3/4" x 7 3/4" (nominal 6" x 8")
9 1/2" x 4 1/2"

thickness: 3"–4"

Preferred SI Sizes
115 x 115 mm
190 x 190 mm
240 x 240 mm
300 x 300 mm
240 x 115 mm

thickness: 80–100 mm

Cast or Channel Glass: U-shaped linear glass channels are self-supporting and contained within an extruded metal perimeter frame. One or two interlocking layers may be used, creating varying levels of strength, sound and thermal insulation, and translucence. Glass thicknesses are roughly 1/4" (6–7); channel widths range from 9" (230) to 19" (485), with heights varying depending on widths and wind loads. Cast glass can be employed vertically or horizontally, internally or externally, and as a curved surface. The glass itself can be made with wires, tints, and other qualities. Double layers of channels provide a natural air space that can be filled with aerogel, a lattice-work of glass strands with small pores, which results in an insulating substance that is 5 percent solid and 95 percent air.

GLASS TYPES

Insulating Glass: Two or more panes of glass enclose a hermetically sealed air space and are separated by a desiccant-filled spacer that absorbs the internal moisture of the air space. The multiple layers of glass and air space of these insulating glass units (IGUs) drastically reduce heat rates. Low-E or other coatings may be used on one or more of the glass surfaces to further improve thermal performance. Argon and sulfur hexafluoride gases may fill the space between glass sheets for even further efficiency as well as reduced sound transmission. Standard overall thickness for a double-glazed IGU is 1″ (25.4), with 1/4″ (6) thick glass and a 1/2″ (13) air space.

Numbers in bubbles represent glass surface numbers, beginning with 1 on the exterior face.

exterior interior

air space

spacer

Reflective Glass: Ordinary float glass (clear or tinted) is coated with metal or metal oxide to reduce solar heat. The coating also produces a one-way mirror effect, generally with the mirror on the exterior. Shading coefficients depend on the density of the metallic coating and range from about 0.31 to 0.70.

Low-E Glass: Low emissivity is clear float glass with a microscopically thin metal oxide coating that reduces U-value by suppressing radiative heat flow and blocking short wave radiation to impede heat gain. At the same time, it provides for light transmission, low reflection, and reduced heat transfer. Generally, Low-E glass can be cut, laminated, or tempered. It is produced in soft-coat (vacuum or sputter coated) or hard-coat (pyrolitic) versions.

Body-Tinted Glass: Chemical elements added to the molten glass mixture produce a variety of colors. The visible light transmitted depends on the color and ranges from about 14 percent for very dark colors to 75 percent for light colors. (Clear glass has about an 85 percent light transmission.) Shading coefficients range from 0.50 to 0.75, meaning that they transmit 50 to 75 percent of the solar energy that would be transmitted by double-strength clear glass.

Colorant	Glass Colors
Cadmium sulfide	yellow
Carbon and sulfur	brown, amber
Cerium	yellow
Chromium	green, pink, yellow
Cobalt	blue, green, pink
Copper	blue, green, red
Iron	blue, brown, green
Manganese	purple
Nickel	purple, yellow
Selenium	pink, red
Titanium	brown, purple
Vanadium	blue, gray, green

Safety Glass

Tempered Glass: Annealed glass is cut and edged before being reheated at about 1,200°F (650°C). If the glass is cooled rapidly, it is considered to be fully tempered; the glass can be up to four times as strong as annealed glass, and, when broken, it shatters into small, square-edged granules instead of into sharp shards. If cooled slowly, the glass is twice as strong as annealed glass, and the broken pieces are more linear but tend to stay in the frame. The slower process is also much less expensive. Tempered glass is ideal for floor-to-ceiling glass, glass doors, walls of squash courts, and walls exposed to heavy winds and intense temperatures.

Chemically Strengthened Glass: Glass is covered by a chemical solution that produces a higher mechanical resistance, giving the glass similar properties to thermal-strengthened (tempered) glass.

Laminated Glass: Interlayers of plastic or resin are sandwiched between two sheets of glass and the layers are bonded together under heat and pressure. When the glass breaks, the laminate interlayer holds the fragments together, making it ideal for use in overhead glazing, stair railings, and store fronts. Security glass (bulletproof) is made of multiple layers of glass and vinyl, in many thicknesses.

Wired Glass: A wire mesh is sandwiched between two ribbons of semimolten glass, which are squeezed together through a pair of metal rollers. When the glass breaks, the wire holds it in place. Wire glass is often acceptable for windows in fire doors and walls.

Specialty and Decorative Glasses

Photovoltaic Glass: Solar cells are embedded in special resin between panes of glass. Each cell is electrically connected to the other cells, converting solar energy into an electrical current.

X-ray Protection Glass: Used primarily in medical or other radiology rooms, X-ray glass has high levels of lead oxide that reduce ionizing radiation. X-ray glass can be laminated and used in single- or double-glazed units.

Electrically Heated Glass: Polyvinyl butyral (PVB) films are pressed between two or more sheets of glass. Electrically conductive wires heat the glass, making it useful in areas of high moisture content or with extreme differences between indoor and outdoor temperatures.

Self-cleaning Glass: Float glass is given a photocatalytic coating on the exterior that reacts to ultraviolet rays to break down organic dirt. Hydrophilic properties also cause rain to flow down the glass as a sheet, washing away the dirt.

Enameled/Screen-printed Glass: Special mineral pigments are deposited on one face of the glass surface before tempering or annealing. A variety of colors and patterns may be applied for decorative purposes. Enameled glass can also be used as a solar-ray conductor.

Sand-blasted Glass: A translucent surface is produced by spraying sand at high velocity over the surface of the glass, which may be done in decorative patterns or in varying depths and translucencies, depending on the force and type of sand.

Acid-etched Glass: One side of float glass is acid-etched, giving a smoother finish than achieved by sand-blasting.

Antireflective Glass: Float glass is given a coating that reflects very small amounts of light.

CHARACTERISTICS OF MATERIALS 5.

During the design process architects often use a foam board model as a quick way to realize and study a form or space. A foam board model (usually white) is neutral in texture and color, as it has neither. Frequently, the building's materials may not yet have been chosen or finalized, and there is a seductive simplicity to the foam (or wood or cardboard) model at this point: anything is still possible. Aside from the overarching impact of the project's budget, numerous factors influence the selection of materials for a building's structure, skin, and finishes. Some materials are more readily available in certain regions, or the local building trades may be more comfortable with specific construction practices. Other materials have very long lead times, and for some projects, time constraints may rule these out. Also, different climates have different material needs, and the building's program, size, and code requirements bear on the appropriateness of materials and methods of construction.

A basic sampling of common materials found in many buildings is presented here. Space limitations do not allow for discussion of other more innovative materials, but increasingly, for reasons of practicality, cost, or environmental concerns, architects are looking to less standard sources for building materials (textiles, plastics, and aerogels) or to unconventional uses for common products (concrete roof tiles, acrylic "glass blocks," and recycled cotton fabric insulation).

Chapter 22: Wood

Lightweight, strong, and durable, wood is an ideal construction material with many uses. The two major classifications—soft wood and hard wood—do not necessarily indicate relative hardness, softness, strength, or durability.

COMMON WOOD TERMS

Board foot: Unit of measurement for wood quantities, equivalent to 12″ x 12″ x 1″ (305 x 305 x 25.5).

Book-matched: Result of resawing thick lumber into thinner boards, opening the two halves like a book, and gluing the boards together along the edge to create a panel with a mirrored grain pattern.

Burl: Irregular grain pattern that results from an unusual growth on the tree.

Cathedral grain: V-shaped grain pattern running the length of the board.

Check: Separation of the wood fibers running with the grain that do not go through the whole cross section. Occurs as a result of tension and stress caused by wood movement during the drying process.

Dimensional stability: Ability of a section of wood to resist changes in volume at fluctuating moisture levels. Low dimensional stability produces expansion in humid environments and contraction in dry ones.

Early growth/Late growth: In regions of little climatic change, trees tend to grow at a fairly consistent rate and have little variation in texture. In regions of seasonal climatic change, however, trees grow at different rates, depending on the season. Variations in growth contribute to the color and texture of the growth rings in the tree.

Figure: Patterns on a wood surface produced by growth rings, rays, knots, and irregular grains. Descriptors include interlocked, curly, tiger, wavy, and fiddleback, among others.

fiddleback *swirl*

bird's-eye *crotch*

Grain: Size, alignment, and appearance of wood fibers in a piece of lumber.

CH. 16

Gum pocket: Excessive accumulation of resin or gum in certain areas of the wood.

Hardness: Ability of wood to resist indentation. See Janka hardness test.

Hardwood: Wood from deciduous trees (which lose their leaves in the winter months). Oak and walnut constitute 50 percent of all hardwood production.

Heartwood: Harder, nonliving innermost layers of a tree. It is generally darker, denser, more durable, and less permeable than the surrounding sapwood. Good all-heartwood lumber may be difficult to obtain, and, depending on the species, it is common to find boards with both heartwood and sapwood combined.

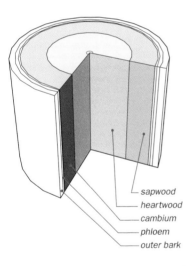

— sapwood
— heartwood
— cambium
— phloem
— outer bark

Janka hardness test: Test that measures the pounds of force required to drive a 0.444" (11 mm) -diameter steel ball to half its depth into a piece of wood.

Moisture content: Percentage that represents a board's ratio of water weight to the weight of oven-dried wood.

Movement in performance: See dimensional stability.

Plainsawn: Lumber cut with less than a 30-degree angle between the face of the board and the wood's growth ring.

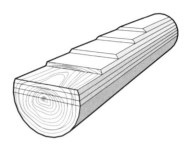

Plywood: Large sheet of wood made up of several layers of veneer that are glued together so that the grain of each layer lies perpendicular to the grain of the previous layer. There are always an odd number of layers, enabling the grain direction of both faces to run parallel to one another.

Pressure-treated lumber: Wood products that are treated with chemical preservatives to prevent decay brought on by fungi and to resist attack from insects and microorganisms. Under pressure, the preservatives are forced deep into the cellular structure of the wood.

Quartersawn: Lumber cut with a 60- to 90-degree angle between the face of the board and the wood's growth rings.

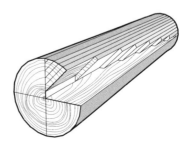

CH. 26

Riftsawn: Lumber cut with a 30- to 60-degree angle between the face of the board and the wood's growth rings.

Sapwood: Living outer layers of a tree, between the outer bark and the thin formative layers of the cambium and phloem, on the one side, and the heartwood, on the other. These layers contain the sap-conducting tubes. Generally lighter in color, less durable, less dense, and more permeable than heartwood, sapwood darkens with age and becomes heartwood. Sapwood and heartwood together make up the xylem of the tree.

Softwood: Wood from coniferous (evergreen) trees.

Split: Separation of wood fibers from one face through to the next. Occurs most often at the ends of boards.

Stain: Substance used to change the color of wood.

Straight grain: Wood fibers that run parallel to the axis of a piece of lumber.

Stud: 2″ x 4″ and 2″ x 6″ dimension lumber used for load-bearing and stud walls.

Texture: Describes the size and distribution of wood fibers: coarse, fine, or even.

Warp: Bowing, cupping, and twisting distortion in lumber that occurs after it has been planed, usually during the drying process.

SOFTWOOD LUMBER

Lumber Standards*

Rough Lumber
Sawed, trimmed, and edged lumber whose faces are rough and show marks.

Surfaced (Dressed) Lumber
Rough lumber that has been smoothed by a surfacing machine.

S1S: Surfaced one side
S1E: Surfaced one edge
S2S: Surfaced two sides
S2E: Surfaced two edges
S1S1E: Surfaced one side and one edge
S1S2E: Surfaced one side and two edges
S2S1E: Surfaced two sides and one edge
S4S: Surfaced four sides

Worked Lumber
Surfaced lumber that has been matched, patterned, shiplapped, or any combination of these.

Shop and Factory Lumber
Millwork lumber for use in door jambs, moldings, and window frames.

Yard (Structural) Lumber
Lumber used for house framing, concrete forms, and sheathing.

Boards: No more than 1″ (25) thick and 4″–12″ (102–305) wide

Planks: Over 1″ (25) thick and 6″ (152) wide

Timbers: Width and thickness both greater than 5″ (127)

*From U.S. Department of Commerce American Lumber Standards of Softwood Lumbers

Softwood Lumber Sizes

Nominal Size[1] inches	Actual Size, Dry[2] inches (mm)	Actual Size, Green[3] inches (mm)
1	$3/4$ (19)	$25/32$ (20)
$1^1/4$	1 (25)	$1^1/32$ (26)
$1^1/2$	$1^1/4$ (32)	$1^9/32$ (33)
2	$1^1/2$ (38)	$1^9/16$ (40)
$2^1/2$	2 (51)	$2^1/16$ (52)
3	$2^1/2$ (64)	$2^9/16$ (65)
$3^1/2$	3 (76)	$3^1/16$ (78)
4	$3^1/2$ (89)	$3^9/16$ (90)
$4^1/2$	4 (102)	$4^1/16$ (103)
5	$4^1/2$ (114)	$4^5/8$ (117)
6	$5^1/2$ (140)	$5^9/16$ (143)
7	$6^1/2$ (165)	$6^5/8$ (168)
8	$7^1/4$ (184)	$7^1/2$ (190)
9	$8^1/4$ (210)	$8^1/2$ (216)
10	$9^1/4$ (235)	$9^1/2$ (241)
11	$10^1/4$ (260)	$10^1/2$ (267)
12	$11^1/4$ (286)	$11^1/2$ (292)
14	$13^1/4$ (337)	$13^1/2$ (343)
16	$15^1/4$ (387)	$15^1/2$ (394)

[1]Nominal dimensions are approximate dimensions assigned to pieces of lumber and other materials as a convenience in referring to the piece.

[2]Dry lumber is defined as having a moisture content of less than 19 percent.

[3]Green (unseasoned) lumber is defined as having a moisture content of greater than 19 percent.

Softwood grading is based on the appearance, strength, and stiffness of the lumber. Numerous associations nationwide establish their own grading standards, though they must all conform to the U.S. Department of Commerce American Lumber Standards. Grading is often difficult to understand, and because it deals with both strength analysis and visual analysis, there is an allowable 5 percent variation below a given grade.

CH. 26

Board Feet

Most lumber is measured and sold in board feet (one board foot equals 144 cubic inches), calculated as follows:

$$\frac{\text{thickness} \times \text{face width} \times \text{length}}{144}$$

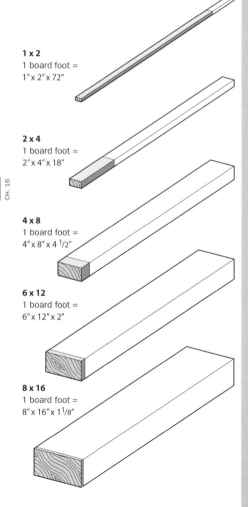

1 x 2
1 board foot =
1" x 2" x 72"

2 x 4
1 board foot =
2" x 4" x 18"

4 x 8
1 board foot =
4" x 8" x 4 1/2"

6 x 12
1 board foot =
6" x 12" x 2"

8 x 16
1 board foot =
8" x 16" x 1 1/8"

HARDWOOD

Hardwood Lumber Grades

First and Second (FAS): Best grade, normally required for a natural or stained finish. Boards must be at least 6" wide, 8'–16' long, and 83.3 percent clear on the worst face.

Select, No. 1 Common: Boards must be a minimum 3" wide, 4'–16' long, and 66.66 percent clear on the worst face.

Select, No. 2 Common

Select, No. 3 Common

Hardwood Lumber Thicknesses

Quarter*	Rough Dimension	Surfaced 1 Side (S1S)	Surfaced 2 Sides (S2S)
	3/8" (10)	1/4" (6)	3/16" (5)
	1/2" (13)	3/8" (10)	5/16" (8)
	5/8" (16)	1/2" (13)	7/16" (11)
	3/4" (19)	5/8" (16)	9/16" (14)
4/4	1" (25)	7/8" (22)	13/16" (21)
5/4	1 1/4" (32)	1 1/8" (29)	1 1/16" (27)
6/4	1 1/2" (38)	1 3/8" (35)	1 5/16" (33)
8/4	2" (51)	1 13/16" (46)	1 3/4" (44)
12/4	3" (76)	2 13/16" (71)	2 3/4" (70)
16/4	4" (102)	3 13/16" (97)	3 3/4" (95)

*Hardwood thickness is often referred to in "quarters:" 4/4 equals 1" (25), 6/4 is 1 1/2" (38), and so on.

LAMINATED TIMBERS

Laminated timbers, also called glue-lams, are engineered, stress-rated structural members built up of several layers of wood bonded by high-strength adhesives. Several grades of lumber are used, with the highest grades in areas of high stress and the lowest in areas of less stress. Because laminated timbers are factory made and engineered, they are more dimensionally stable than solid timbers.

Floor Beam Spans

Span		Spacing		Beam Size	
feet	mm	feet	mm	inches	mm
12	3 658	6	1 829	3 $^1/_8$ x 9	79 x 229
		8	2 438	3 $^1/_8$ x 10 $^1/_2$	79 x 267
		10	3 048	3 $^1/_8$ x 10 $^1/_2$	79 x 267
		12	3 658	3 $^1/_8$ x 12	79 x 305
16	4 877	8	2 438	3 $^1/_8$ x 13 $^1/_2$	79 x 343
		12	3 658	3 $^1/_8$ x 15	79 x 381
		14	4 267	3 $^1/_8$ x 15	79 x 381
		16	4 877	3 $^1/_8$ x 15	79 x 381
20	6 096	8	2 438	3 $^1/_8$ x 16 $^1/_2$	79 x 419
		12	3 658	5 $^1/_8$ x 15	130 x 381
		16	4 877	5 $^1/_8$ x 18	130 x 457
		20	6 096	5 $^1/_8$ x 18	130 x 457
24	7 315	8	2 438	5 $^1/_8$ x 19 $^1/_2$	130 x 495
		12	3 658	5 $^1/_8$ x 21	130 x 533
		16	4 877	5 $^1/_8$ x 24	130 x 610
		20	6 096	5 $^1/_8$ x 25 $^1/_2$	130 x 648
28	8 534	8	2 438	5 $^1/_8$ x 19 $^1/_2$	130 x 495
		12	3 658	5 $^1/_8$ x 21	130 x 533
		16	4 877	5 $^1/_8$ x 24	130 x 610
		20	6 096	5 $^1/_8$ x 25 $^1/_2$	130 x 648
32	9 754	8	2 438	5 $^1/_8$ x 21	130 x 533
		12	3 658	5 $^1/_8$ x 24	130 x 610
		16	4 877	5 $^1/_8$ x 27	130 x 686
		20	6 096	6 $^3/_4$ x 27	171 x 686
40	12 192	12	3 658	6 $^3/_4$ x 28 $^1/_2$	171 x 724
		16	4 877	6 $^3/_4$ x 31 $^1/_2$	171 x 800
		20	6 096	6 $^3/_4$ x 33	171 x 838
		24	7 315	6 $^3/_4$ x 36	171 x 914

Load capacity equals 50 lbs. per sq. ft.

PLYWOOD

Plywood quality is rated by the American Plywood Association (APA) and is generally graded by the quality of the veneer on both front and back sides of the panel (A-B, C-D, and so on). Veneer grades describe appearance according to natural unrepaired growth characteristics and the size and number of repairs allowed during manufacture.

Veneer Grades

N — Premium grade available by special order. Select, all heartwood or all sapwood with a smooth surface and free of open defects. No more than six repairs, wood only, matched for grain and color, and parallel to the grain, allowed per 4′ x 8′ panel. Best for natural finish.

A — Smooth and paintable. Permits no more than eighteen neatly made repairs of boat, sled, or router type, and parallel to the grain. Used for natural finish in less demanding applications.

B — Solid surface that allows shims, circular repair plugs, and tight knots limited to 1″ across grain, with minor splits permitted.

C Plugged — Improved C veneer with splits up to $1/8$″ width and knotholes and borer holes up to $1/4$″ x $1/2$″. Some broken grain is permitted, and synthetic repairs are allowed.

C — Tight knots and knotholes up to $1^1/2$″ permitted if total width of knots and knotholes is within specified limits. Synthetic or wood repairs allowed. Discoloration and sanding defects that do not impair strength, limited splits, and stitching all permitted. Lowest exterior use grade.

D — Knots and knotholes up to to $2^1/2$″ across grain and $1/2$″ larger within specified limits permitted. Limited splits and stitching also permitted. Use restricted to Interior, Exposure 1, and Exposure 2 panels.

Typical Plywood Construction

3-layer (3 ply)

3-layer (4 ply)

5-layer (5 ply)

5-layer (6 ply)

Classification of Plywood Species

Under Voluntary Product Standard PS 1-95, plywood species are divided into five categories based on an elastic modulus in bending and stiffness. Group numbers that appear on the APA trademark reflect the classification of the species of wood on the front and back veneers (inner veneers may be of a different group). The higher group number is generally used if the two faces are of different grades.

Stiffest **Least stiff**

Group 1	Group 2	Group 3	Group 4	Group 5
Apitong	Cedar (Port Orford)	Alder (red)	Aspen (bigtooth, Quaking)	Basswood
Beech (American)	Cypress	Birch (paper)	Cativo	Poplar (balsam)
Birch (sweet)	Douglas Fir-2	Cedar (Alaska)	Cedar (incense, western red)	
Birch (yellow)	Fir (balsam, California red, grand, noble, Pacific silver, white)	Fir (subalpine)	Cottonwood (eastern)	
Douglas Fir-1		Hemlock (eastern)	Cottonwood (black western poplar)	
Kapur		Maple (bigleaf)	Pine (eastern white, sugar)	
Keruing	Hemlock (western)	Pine (jack, lodgepole, ponderosa, spruce)		
Larch (western)	Lauan (Almon, Bagtikan, Mayapis, red, Tangile, white)	Redwood		
Maple (sugar)	Maple (black)	Spruce (Engelmann, white)		
Pine (Caribbean)	Mengkulang			
Pine, southern (loblolly, longleaf, shortleaf, slash)	Meranti (red)			
Tanoak	Mersawa			
	Pine (pond, red, Virginia, western white)			
	Poplar (yellow)			
	Spruce (black, red, Sitka)			
	Sweetgum			
	Tamarack			

Exposure Durability

Exterior: Fully waterproof glue and minimum C-grade veneers make it suitable for applications permanently exposed to the weather.

Exposure 1: Fully waterproof glue and minimum D-grade veneers make it suitable for applications with some exposure to weather.

Exposure 2: Glue of intermediate moisture resistance makes it suitable for applications of intermittent high humidity.

Interior: Used for protected indoor applications only.

WOOD TYPES AND CHARACTERISTICS

Species	Hard-ness	Principal Finish Carpentry Uses	Color	Finishes Painted	Finishes Transp.	Maximum Practical Sizes Thick	Maximum Practical Sizes Wide	Maximum Practical Sizes Long
ASH, white	H	trim, cabinetry	creamy white to light brown	n/a	excellent	1 1/2″ (38 mm)	7 1/2″ (191 mm)	12′ (3 658 mm)
BASSWOOD	S	decorative moldings, carvings	creamy white	excellent	excellent	1 1/2″ (38 mm)	7 1/2″ (191 mm)	10′ (3 048 mm)
BEECH	H	semi-exposed cabinet parts	white to reddish brown	excellent	good	1 1/2″ (38 mm)	7 1/2″ (191 mm)	12′ (3 658 mm)
BIRCH, yellow, natural	H	trim, paneling, cabinetry	white to dark red	excellent	good	1 1/2″ (38 mm)	7 1/2″ (191 mm)	12′ (3 658 mm)
BIRCH, yellow, select red	H	trim, paneling, cabinetry	dark red	n/a	excellent	1 1/2″ (38 mm)	5 1/2″ (140 mm)	11′ (3 353 mm)
BUTTERNUT	M	trim, paneling, cabinetry	pale brown	n/a	excellent	1 1/2″ (38 mm)	5 1/2″ (140 mm)	8′ (2 438 mm)
CEDAR, western red	S	trim, exterior and interior paneling	reddish brown nearly white	n/a	good	3 1/4″ (83 mm)	11″ (280 mm)	16′ (4 877 mm)
CHERRY, American black	H	trim, paneling, cabinetry	reddish brown	n/a	excellent	1 1/2″ (38 mm)	5 1/2″ (140 mm)	7′ (2 134 mm)
CHESTNUT, wormy	M	trim, paneling	grayish brown	n/a	excellent	3/4″ (19 mm)	7 1/2″ (191 mm)	10′ (3 048 mm)
CYPRESS, yellow	M	trim, frames, special siding	yellowish brown	good	good	2 1/2″ (64 mm)	8 1/2″ (241 mm)	16′ (4 877 mm)
FIR, Douglas, flat grain	M	trim, frames, paneling	reddish tan	fair	fair	3 1/4″ (83 mm)	11″ (280 mm)	16′ (4 877 mm)
FIR, Douglas, vertical grain	M	trim, frames, paneling	reddish tan	good	good	1 1/2″ (38 mm)	11″ (280 mm)	16′ (4 877 mm)
MAHOGANY, African, quartersawn	M	trim, frames, paneling, cabinetry	reddish brown	n/a	excellent	2 1/2″ (64 mm)	7 1/2″ (191 mm)	15′ (4 572 mm)
MAHOGANY, Honduras	M	trim, frames, paneling, cabinetry	rich golden brown	n/a	excellent	2 1/2″ (64 mm)	11″ (280 mm)	15′ (4 572 mm)
MAPLE, hard-natural	VH	trim, paneling, cabinetry	white to reddish brown	excellent	good	3 1/2″ (89 mm)	9 1/2″ (241 mm)	12′ (3 658 mm)
MAPLE, soft-natural	M	trim, semi-exposed cabinet parts	white to reddish brown	excellent	n/a	3 1/4″ (83 mm)	3 1/2″ (241 mm)	12′ (3 658 mm)
OAK, English brown	H	veneered paneling, cabinetry	leathery brown	n/a	excellent	1 1/2″ (38 mm)	5 1/2″ (140 mm)	8′ (2 438 mm)
OAK, red, plainsawn	H	trim, paneling, cabinetry	reddish tan to brown	n/a	excellent	1 1/2″ (38 mm)	7 1/4″ (184 mm)	12′ (3 658 mm)

Species	Hard-ness	Principal Finish Carpentry Uses	Color	Finishes		Maximum Practical Sizes		
				Painted	Transp.	Thick	Wide	Long
OAK, red, riftsawn	H	trim, paneling, cabinetry	reddish tan to brown	n/a	excellent	1 1/16" (27 mm)	5 1/2" (140 mm)	10' (3 048 mm)
OAK, white, plainsawn	H	trim, paneling, cabinetry	grayish tan	n/a	excellent	1 1/2" (38 mm)	5 1/2" (140 mm)	10' (3 048 mm)
OAK, white, riftsawn	H	trim, paneling, cabinetry	grayish tan	n/a	excellent	3/4" (19 mm)	4 1/2" (114 mm)	10' (3 048 mm)
OAK, white, quartersawn	H	trim, paneling, cabinetry	grayish tan	n/a	excellent	3/4" (19 mm)	4 1/2" (114 mm)	10' (3 048 mm)
PECAN	H	trim, paneling, cabinetry	reddish brown w/brown stripes	n/a	good	1 1/2" (38 mm)	5 1/2" (140 mm)	12' (3 658 mm)
PINE, eastern	S	trim, frames, paneling, cabinetry	creamy white to pink	good	good	1 1/2" (38 mm)	9 1/2" (241 mm)	14' (4 267 mm)
PINE, sugar	S	trim, frames, paneling, cabinetry	creamy white	good	good	1 1/2" (38 mm)	9 1/2" (241 mm)	14' (4 267 mm)
PINE, Ponderosa	S	trim, frames, paneling, cabinetry	white to pale yellow	good	good	1 1/2" (38 mm)	9 1/2" (241 mm)	16' (4 877 mm)
PINE, southern yellow, shortleaf	S	trim, frames, paneling, cabinetry	white to pale yellow	fair	good	1 1/2" (38 mm)	7 1/2" (191 mm)	16' (4 877 mm)
POPLAR, yellow	M	trim, paneling, cabinetry	white to brown w/green cast	excellent	good	2 1/2" (64 mm)	7 1/2" (191 mm)	12' (3 658 mm)
REDWOOD, flat grain	S	trim, frames, paneling	deep red	good	good	2 1/2" (64 mm)	11" (280 mm)	16' (4 877 mm)
REDWOOD, vertical grain	S	trim, frames, paneling	deep red	excellent	excellent	2 1/2" (64 mm)	11" (280 mm)	16' (4 877 mm)
ROSEWOOD, Brazilian	VH	veneered paneling, cabinetry	mixed red/ brown/black	n/a	excellent	-	-	-
SPRUCE, Sitka	S	trim, frames	light yellowish tan	fair	fair	3 1/4" (83 mm)	9 1/2" (241 mm)	16' (4 877 mm)
TEAK	H	trim, paneling, cabinetry	tawny yellow to dark brown	n/a	excellent	1 1/2" (38 mm)	7 1/2" (191 mm)	10' (3 048 mm)
WALNUT, American black	H	trim, paneling, cabinetry	chocolate brown	n/a	excellent	1 1/2" (38 mm)	4 1/2" (114 mm)	6' (1 829 mm)
ZEBRAWOOD, African, quartersawn	H	trim, paneling, cabinetry	gold streaks on dark brown	n/a	excellent	1 1/2" (38 mm)	9" (229 mm)	16' (4 877 mm)

S=soft; M=medium; H=hard; VH=very hard; n/a=not normally used
Finishes: Painted and Transparent

CH. 26

WOOD SAMPLES

ASH white *Fraxinus Americana*

BIRCH *Betula alleghaniensis*

BUTTERNUT *Juglans cinerea*

CEDAR western red *Thuja plicata*

CHESTNUT *Castanea dentate*

MAHOGANY Honduras *Sweitenia macrophylla*

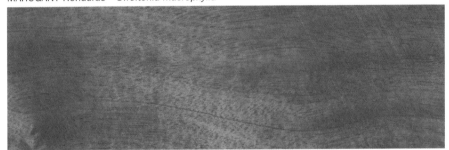

MAPLE *Acer saccharum*

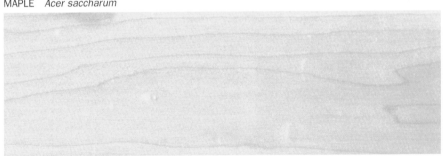

OAK English brown *Quercus robur*

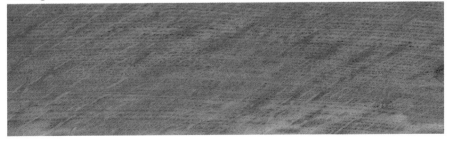

OAK red *Quercus rubra*

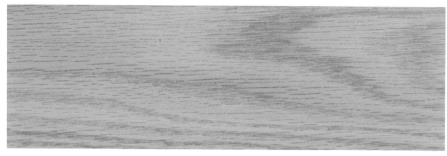

OAK white *Quercus alba*

PECAN *Carya species*

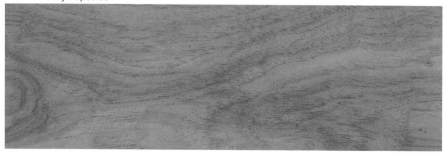

PINE eastern or northern white *Pinus strobes*

ROSEWOOD *Dalbergia nigra*

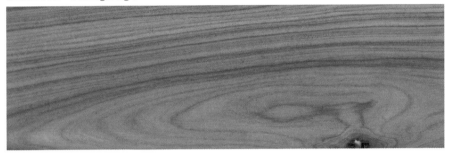

TEAK *Tectona grandis*

WALNUT *Juglans*

ZEBRAWOOD *Brachystegea fleuryana*

WOOD JOINERY

Edge Joints

Simple Butt Joint

Back Batten

Batten

Shiplap

Tongue and Groove

Fillet

End Joints

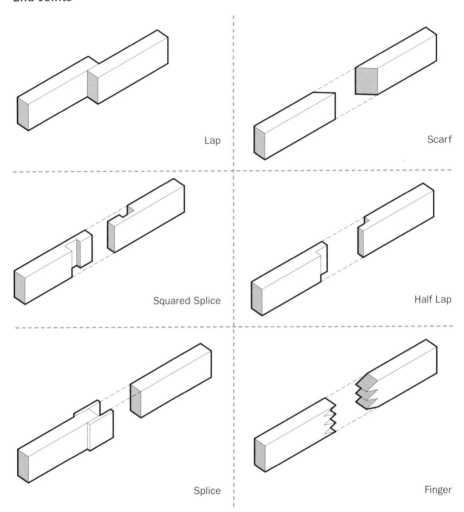

Lap

Scarf

Squared Splice

Half Lap

Splice

Finger

Right-Angle Joints (Miters)

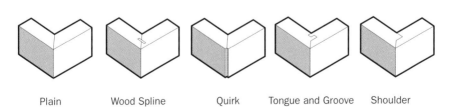

Plain

Wood Spline

Quirk

Tongue and Groove

Shoulder

Right-Angle Joints

Butt Joint

Right-Angle Joints (Dovetail)

Rabbet

Dado

Dovetail Dado

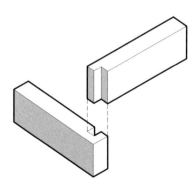

Dado and Rabbet

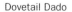

Right-Angle Joints (Mortise and Tenon)

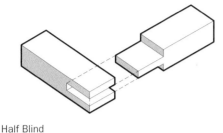

Half Blind

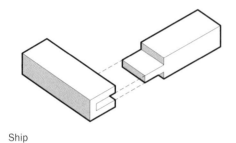

Ship

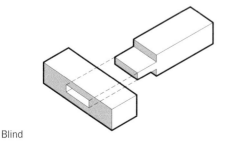

Blind

Right-Angle Joints (Lap)

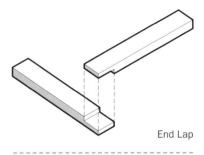

End Lap

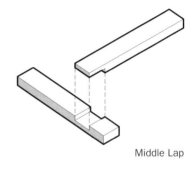

Middle Lap

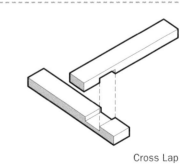

Cross Lap

Miter Half Lap

Chapter 23: Masonry

Masonry building has become quicker, stronger, and more efficient than in the past, but the basic principles of construction have changed very little since ancient times. Masonry units include bricks, stones, and concrete blocks, and because they all come from the earth, they are suitable for use as foundations, pavers, and walls embedded in the earth. The strength and durability of most masonry makes it ideal to resist fire and decay from water and air.

BRICKS

The small scale of a single brick makes it a flexible material for use in walls, floors, and even ceilings. Brick production, in which the clay is fired at very high temperatures, gives brick excellent fire-resistive qualities.

Brick Grades (Building and Facing)

SW: Severe weathering (where water may collect)

MW: Moderate weathering

NW: Negligible weathering

Brick Types (Facing)

FBS: General use in exposed exterior and interior walls; most common type and default choice if architect does not specify

FBX: Special use in exposed exterior and interior walls, where a higher degree of mechanical perfection, narrower color range, and minimal variation in size are required

FBA: Special use in exposed exterior and interior walls, where non-uniformity in size, color, and texture are desired

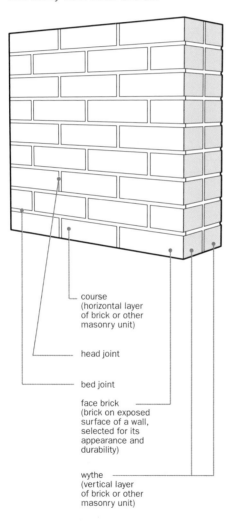

course
(horizontal layer of brick or other masonry unit)

head joint

bed joint

face brick
(brick on exposed surface of a wall, selected for its appearance and durability)

wythe
(vertical layer of brick or other masonry unit)

Masonry Elements

Brick Manufacturing

Winning and storage: Clays are mined and enough raw material is stored for several days' use to allow continuous operation in any weather. The three principal types of clay are surface clays, shales, and fire clays.

Preparation: Clay is crushed and pulverized.

Forming Processes

Stiff mud process (extrusion process): Clay is mixed with minimal amounts of water and then "pugged" (thoroughly mixed). Air pockets are removed from the clay as it is passed through a vacuum. Then it is extruded through a rectangular die and pushed across a cutting table where it is sliced into bricks by cutter wires.

Soft mud process (molding process): Moist clay is pressed into rectangular molds. Water-struck bricks have a smooth surface, produced when the molds have been dipped into water before being filled; sand-struck, or sand-mold, bricks have a matte-textured surface, produced by dusting the molds with sand before forming the brick.

Dry-press process: Clay is mixed with a minimum of water and machine-pressed into steel molds. This process is used for clays with low plasticity.

Drying Process

Molded bricks are placed in a low-temperature kiln and dried for one to two days.

Firing Process

In periodic kilns, bricks are loaded, fired, cooled, and unloaded. In continuous tunnel kilns, bricks ride through a tunnel on railcars, where they are fired the entire time at various temperatures and emerge at the end fully burned. Firing can take from 40 to 150 hours.

Water-smoking and dehydration: Remaining water is removed from the clay.

Oxidation and vitrification: Temperatures reach up to 1,800° F (982°C) and 2,400°F (1,316°C), for these respective processes

Flashing: Fire is regulated to produce color variations in the brick.

Higher firing temperatures produce darker and generally smaller bricks, though overall color depends on the chemical composition of the clay. Bricks may also be glazed, either during the initial firing or in a special additional firing.

BRICK UNITS

Comparative Proportions

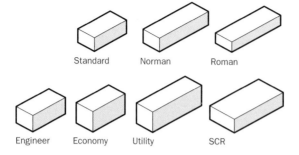

Standard Norman Roman

Engineer Economy Utility SCR

Nominal brick dimensions are derived from combining actual brick dimensions (length, thickness, and height) with their respective mortar joints. Typical mortar joints are $3/8''$ (10) and $1/2''$ (13).

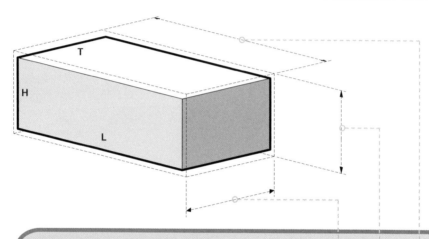

Standard Sizes

Unit Type	Joint Thickness in. (mm)	Brick Thickness = T in. (mm)	Brick Height = H in. (mm)	Brick Length = L in. (mm)	Vertical Coursing = (C) in. (mm)	Nominal T in. (mm)	Nominal H in. (mm)	Nominal L in. (mm)
Standard Modular	$3/8$ (10)	$3\,5/8$ (92)	$2\,1/4$ (57)	$7\,5/8$ (194)	3C = 8 (203)	4 (102)	$2\,2/3$ (68)	8 (203)
	$1/2$ (13)	$3\,1/2$ (89)	$2\,3/16$ (56)	$7\,1/2$ (191)				
Norman	$3/8$ (9.5)	$3\,5/8$ (92)	$2\,1/4$ (57)	$11\,5/8$ (295)	3C = 8 (203)	4 (102)	$2\,2/3$ (68)	12 (305)
	$1/2$ (12.7)	$3\,1/2$ (89)	$2\,3/16$ (56)	$11\,1/2$ (292)				
Roman	$3/8$ (9.5)	$3\,5/8$ (92)	$1\,5/8$ (41)	$11\,5/8$ (295)	2C = 4 (102)	4 (102)	2 (51)	12 (305)
	$1/2$ (12.7)	$3\,1/2$ (89)	$1\,1/2$ (38)	$11\,1/2$ (292)				
Engineer Modular	$3/8$ (9.5)	$3\,5/8$ (92)	$2\,13/16$ (71)	$7\,5/8$ (194)	5C = 16 (406)	4 (102)	$3\,1/5$ (81)	8 (203)
	$1/2$ (12.7)	$3\,1/2$ (89)	$2\,11/16$ (68)	$7\,1/2$ (191)				
Economy	$3/8$ (9.5)	$3\,5/8$ (92)	$3\,5/8$ (92)	$7\,5/8$ (194)	1C = 4 (102)	4 (102)	4 (102)	8 (203)
	$1/2$ (12.7)	$3\,1/2$ (89)	$3\,1/2$ (89)	$7\,1/2$ (191				
Utility	$3/8$ (9.5)	$3\,5/8$ (92)	$3\,5/8$ (92)	$11\,5/8$ (295)	1C = 4 (102)	4 (102)	4 (102)	12 (305)
	$1/2$ (12.7)	$3\,1/2$ (89)	$3\,1/2$ (89)	$11\,1/2$ (292)				
SCR	$1/2$ (12.7)	$5\,1/2$ (140)	$2\,1/8$ (54)	$11\,1/2$ (292)	3C = 8 (203)	6 (152)	$2\,2/3$ (68)	12 (305)

Preferred SI Dimensions for Masonry

Nominal Height (H) x Length (L)	Vertical Coursing (C)
50 x 300 mm	[2C = 100]
67 x 200 mm 67 x 300 mm	[3C = 200]
75 x 200 mm 75 x 300 mm	[4C = 300]
80 x 200 mm 80 x 300 mm	[5C = 400]
100 x 200 mm 100 x 300 mm 100 x 400 mm	[1C = 100]
133 x 200 mm 133 x 300 mm 133 x 400 mm	[3C = 400]
150 x 300 mm 150 x 400 mm	[2C = 300]
200 x 200 mm 200 x 300 mm 200 x 400 mm	[1C = 200]
300 x 300 mm	[1C = 300]

Acceptable Length Substitutions for Flexibility

200 mm	(100 mm)
300 mm	(100 mm, 150 mm, 200 mm, 250 mm)
400 mm	(100 mm, 200 mm, 300 mm)

Orientations

Rowlock

Header

Sailor

Soldier

Stretcher

Shiner

Bond Types

Running Bond

Flemish Monk Bond

1/3 Running Bond

Stack Bond

Common Bond

Flemish Bond

Standard Brick Coursing

no. of courses		no. of courses	
	9'-4" (2 845)		18'-8" (5 690)
42		84	
41		83	
40	8'-8" (2 642)	82	18'-0" (5 486)
39		81	
38		80	
37	8'-0" (2 438)	79	17'-4" (5 283)
36		78	
35		77	
34	7'-4" (2 235)	76	16'-8" (5 080)
33		75	
32		74	
31	6'-8" (2 032)	73	16'-0" (4 877)
30		72	
29		71	
28	6'-0" (1 829)	70	15'-4" (4 674)
27		69	
26		68	
25	5'-4" (1 626)	67	14'-8" (4 470)
24		66	
23		65	
22	4'-8" (1 422)	64	14'-0" (4 267)
21		63	
20		62	
19	4'-0" (1 219)	61	13'-4" (4 064)
18		60	
17		59	
16	3'-4" (1 016)	58	12'-8" (3 861)
15		57	
14		56	
13	2'-8" (813)	55	12'-0" (3 658)
12		54	
11		53	
10	2'-0" (610)	52	11'-4" (3 454)
9		51	
8		50	
7	1'-4" (406)	49	10'-8" (3 251)
6		48	
5		47	
4	8" (203)	46	10'-0" (3 048)
3		45	
2		44	
1		43	9'-4" (2 845)

Mortar

Mortar adheres masonry units together, cushions them while mediating their surface irregularities, and provides a watertight seal. Composed of portland cement, hydrated lime, an inert aggregate (generally sand), and water, there are four basic types of mortar:

M: High strength (masonry below grade, or subjected to severe frost or to high lateral or compressive loads)

S: Medium-high strength (masonry subjected to normal compressive loads, but requiring high flexural bond strength)

N: Medium strength (masonry above grade, for general use)

O: Medium-low strength (masonry in non-load-bearing interior walls and partitions)

Mortar Joints

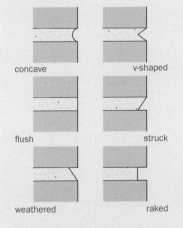

concave v-shaped

flush struck

weathered raked

Colors

Bricks come in numerous textures and patterns, and both bricks and mortar are available in almost endless varieties of color (especially if either is custom produced). Coordination of brick and mortar colors can be an effective way to achieve different qualities within one brick type and color. Matching mortar to brick color, for example, produces a more monolithic look for the wall. Similarly, darker mortars can make a wall feel darker overall, and lighter mortars can make it feel lighter. Full-scale mockups are helpful for testing color combinations.

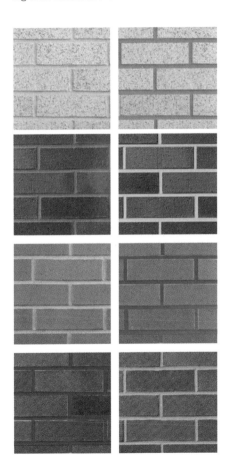

CONCRETE MASONRY UNITS

CMUs (also called concrete blocks) are available as bricks, large hollow stretcher units, and large solid units. The cores of hollow units can receive grout and reinforcing steel, making them a common element in masonry bearing-wall construction, either alone or as a backup for other cladding material. Like bricks, CMUs have nominal dimensions and accommodate mortar joints; 8″ (203) nominal block heights correspond to three brick courses.

Typical Standard Sizes (W x H x L)

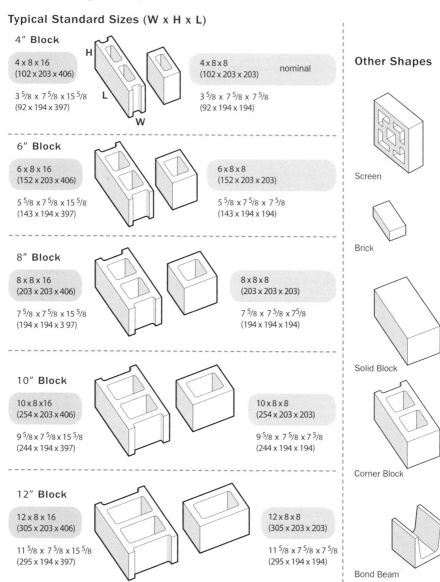

4″ Block

4 x 8 x 16
(102 x 203 x 406)

3 5/8 x 7 5/8 x 15 5/8
(92 x 194 x 397)

4 x 8 x 8
(102 x 203 x 203) nominal

3 5/8 x 7 5/8 x 7 5/8
(92 x 194 x 194)

6″ Block

6 x 8 x 16
(152 x 203 x 406)

5 5/8 x 7 5/8 x 15 5/8
(143 x 194 x 397)

6 x 8 x 8
(152 x 203 x 203)

5 5/8 x 7 5/8 x 7 5/8
(143 x 194 x 194)

8″ Block

8 x 8 x 16
(203 x 203 x 406)

7 5/8 x 7 5/8 x 15 5/8
(194 x 194 x 3 97)

8 x 8 x 8
(203 x 203 x 203)

7 5/8 x 7 5/8 x 7 5/8
(194 x 194 x 194)

10″ Block

10 x 8 x16
(254 x 203 x 406)

9 5/8 x 7 5/8 x 15 5/8
(244 x 194 x 397)

10 x 8 x 8
(254 x 203 x 203)

9 5/8 x 7 5/8 x 7 5/8
(244 x 194 x 194)

12″ Block

12 x 8 x 16
(305 x 203 x 406)

11 5/8 x 7 5/8 x 15 5/8
(295 x 194 x 397)

12 x 8 x 8
(305 x 203 x 203)

11 5/8 x 7 5/8 x 7 5/8
(295 x 194 x 194)

Other Shapes

Screen

Brick

Solid Block

Corner Block

Bond Beam

All sizes may also be 4″ (102) high and 8″ (203), 12″ (305), or 24″ (610) long.

CMU Production

To produce CMUs, a stiff concrete mixture is placed into molds and vibrated. The wet blocks are then removed from the molds and steam cured.

Fire-resistance ratings for CMUs vary depending on the aggregate type used in the concrete and the size of the block.

CMU Grades

N: General use above and below grade

S: Use above grade only; good where wall is not exposed to weather; if used on exterior, wall must have weather-protective coating

CMU Types

I: Moisture-controlled, for use where shrinkage of units would cause cracking

II: Not moisture-controlled

CMU Weights

Normal: Made from concrete weighing more than 125 lb. per cu. ft. (pcf) (2 000 kg/m³)

Medium: Made from concrete weighing 105–25 pcf (1 680–2 000 kg/m³)

Light: Made from concrete weighing 105 pcf (1 680 kg/m³) or less

Decorative CMUs

Concrete blocks are easily produced in many different shapes, surface textures, and colors, allowing for a variety of wall surfaces. Numerous standard decorative units exist and units may be custom designed.

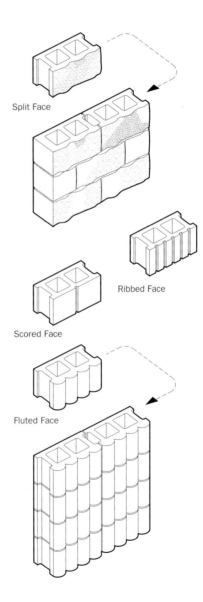

Split Face

Ribbed Face

Scored Face

Fluted Face

STONE

As a building material, stone may be used in two different manners: as a masonry unit laid with mortar, similar to brick or concrete blocks, or as a thin, non-load-bearing veneer facing attached to a backup wall and structural frame. Stone colors, textures, and patterns are highly varied, as are the design and detailing of unit masonry and cladding systems.

limestone

SEDIMENTARY ROCK
(rock deposited as a result of natural action or wind)

Limestone: Colors limited mostly to white, buff, and gray. Very porous and wet when quarried, though after air seasoning, quarry sap evaporates and stone becomes harder. Suitable for wall and floor surfaces, but does not accept a polish.

sandstone

Sandstone: Colors range from buff to chocolate brown to red. Suitable for most building applications, but also does not accept a high polish.

Stone masonry includes rubble stone (irregular quarried fragments), dimension stone (quarried and cut into rectangular forms called cut stone when large and ashlar when small), and flagstone (thin slabs of paving stone, irregular or cut).

Masonry Patterns

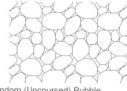

Random (Uncoursed) Rubble

Coursed Rubble

granite

IGNEOUS ROCK
(rock deposited in a molten state)

Granite: Wide range of grains and colors including gray, black, brown, red, pink, buff, and green. Nonporous and very hard. Suitable for use in the ground and with exposure to weather. Comes in many textures and may be highly polished.

Random (Uncoursed) Ashlar

slate

METAMORPHIC ROCK
(sedimentary or igneous rock transformed into another rock type by heat or pressure)

Slate: Colors range from red and brown to grayish-green to purple and black. Sheetlike nature makes it ideal for paving, roofing, and veneer panels.

marble

Marble: Highly varied in both color and streaking patterns. Color range includes white, black, blue, green, red, and pink, and all tones between. Suitable for use as a building stone but is most often highly polished and used as a veneer panel.

Coursed Ashlar

MASONRY BEARING WALLS

Brick, concrete block, and stone walls built as load-bearing walls will have many different characteristics, depending on whether or not they are reinforced, use more than one masonry unit type (composite wall), or are solid or cavity walls.

Reinforcing
Reinforcing masonry allows the entire wall system to be thinner and taller.

Composite Walls
Composite masonry walls employ a concrete block backup with brick or stone veneer on the exterior wythe, with the two layers bonded with steel horizontal reinforcing. Masonry ties join wythes of masonry together or to supporting wood, concrete, or steel backup structures. Anchors connect masonry units to the supporting structure.

Cavity Walls
Cavity walls have an inner and outer wythe of masonry units, separated by an air space of a minimum 2" (51). Masonry ties hold the two wythes together. If rain penetrates the outer wythe, it runs down the inner surface of the outer wythe and is collected at the base with flashing materials that divert it back to the outside through weep holes.

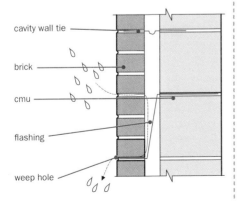

cavity wall tie

brick

cmu

flashing

weep hole

Common Wall Configurations

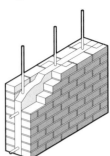

Double-wythe brick wall with concrete and steel reinforcing between

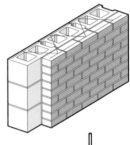

Brick wall on CMU backup (CMUs may or may not be reinforced), tied together with Z-ties

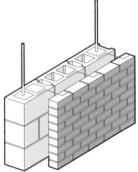

Brick and CMU cavity wall (CMU wall is reinforced)

Stone veneer on CMU backup, tied together with adjustable stone ties

Chapter 24: Concrete

Concrete comprises a mixture of aggregate (sand and gravel), portland cement, and water. Because these elements are found almost everywhere, concrete is employed as a construction material throughout the world. When combined correctly with steel reinforcing, concrete becomes virtually indestructible structurally and is generally not susceptible to burning or rotting. It can be shaped into almost any form.

COMPOSITION

Aggregate: Mixture of sand and gravel. Gravel sizes can range from dust to $2^1/_2$" but should not exceed one-quarter of the thickness of the unit being poured (that is, for a 4" slab, gravel should not be greater than 1"). Rounded fragments are preferred. Larger gravel yields more cost-effective concrete and fewer problems from shrinkage.

Portland cement: Chemical combination of lime, silicon, aluminum, iron, small amounts of other ingredients, and gypsum, which is added in the final grinding process. Exact ingredients vary by region, based on local availability.

There are five basic types of portland cement.

Water: Clean and impurity free.

Air: Millions of tiny air bubbles in the mixture make up a fourth component of some mixes of concrete. Air makes the concrete lighter and more able to withstand the effects of freezing and thawing, thus useful in cold climates.

Types of Portland Cement

There is no universal international standard for portland cement. The United States uses the ASTM C-150 Standard Specification for Portland Cement, as do a number of other countries.

Type I: Normal; for general use

Type IA: Normal, air-entraining

Type II: Moderately sulfate resistant; ideal for use in bridges and pilings; also used when heat build-up is an issue

Type IIA: Moderately sulfate resistant, air-entraining

Type III: Quick hardening with high early strength; used mostly in winter and for rush jobs

Type IIIA: High early strength, air-entraining

Type IV: Slow hardening and low heat producing; used when the amount and rate of heat generation must be minimized

Type V: Highly sulfate resistant; used in high water and soils with high alkali content

Sample Aggregate Composition Ratios

Cement	Sand	Gravel	Application
1	3	6	normal static loads without rebar; unexposed
1	2.5	5	normal foundations and walls; exposed
1	2.5	4	basement walls
1	2.5	3.5	waterproof basement walls
1	2.5	3	light-duty floors and driveways
1	2.25	3	steps, driveways, and sidewalks
1	2	4	lintels, reinforced roads, buildings, and walls; exposed
1	2	3.5	retaining walls and driveways
1	2	3	swimming pools
1	1.75	4	light-duty floors
1	1.5	3	columns and watertight tanks
1	1	2	high-strength columns, girders, and floors

Water-to-Cement Ratio

Ratios of the component materials of concrete depend on the desired compressive strength, application, geographic location, and watertightness of the cured concrete, among many other factors. Guidelines for mixing concrete of a high quality are the same for any application, however, and advocate the use of clean ingredients, proper mixing and proportions, careful handling of wet concrete, and controlled curing.

The water-to-cement ratio is of distinct importance to the strength of the cured concrete. A rule of thumb is to keep ratios to below 0.60 (the weight of water in the mix should be no more than 60 percent the weight of the cement). More water makes the wet concrete easier to pour but jeopardizes the strength of the cured concrete with air bubbles. Conversely, mixtures with low water-to-cement ratios must often be treated with workability admixtures to ensure large air voids do not occur as a result of less fluidity.

CH. 26

PLACING AND CURING

As concrete is poured and placed, care must be taken to ensure that it is not subjected to excessive vibration or sudden vertical drops, which could cause segregation of the materials (course aggregate to the bottom, water and cement to the top). For this reason, vertical transportation should be done with drop chutes. If the concrete must travel excessive distances from the mixer to the formwork, it should be pumped through hoses, not transported in the formwork.

Concrete cures by hydration, as a binding chemical combination of the cement and water; it must be kept moist during this period, generally twenty-eight days, before it is adequately cured. Surfaces may be kept moist by spraying them with water or a curing compound or by covering them with moisture-resistant sheets.

CH. 16

Admixtures

Other ingredients may be added to concrete for various desired effects.

Accelerating admixtures: Promote faster curing (may be used in cold weather, when curing is slowed down).

Air-entraining admixtures: Increase workability of wet concrete, aid in reducing freeze-thaw damage, and may produce lightweight, thermal-insulated concrete.

Blast furnace slag: Similar to fly ash in effect.

Coloring agents: Dyes and pigments.

Corrosion inhibitors: Reduce corrosion of reinforcing steel.

Fibrous admixtures: Short glass, steel, or polypropylene fibers that act as reinforcing.

Fly ash: Improves workability of wet concrete while also increasing strength and sulfate resistance, and decreases permeability, temperature rises, and needed water.

Pozzolans: Improve workability, reduce internal temperatures while curing, and reduce reactivity caused by sulfates.

Retarding admixtures: Promote slower curing and allow more time for working with wet concrete.

Silica fume: Produces extremely high strength concrete with very low permeability.

Super-plasticizers: High-range water-reducing admixtures that turn stiff concrete into flowing liquid for placing in difficult sites.

Water-reducing admixtures: Allow for more workability with less water in the mix.

Reinforcing Steel

Without reinforcing, concrete would have few or no structural uses. Fortunately, steel and concrete are chemically compatible and have a similar rate of dimensional change due to temperature.

FINISHES

Concrete can be finished in a variety of ways, allowing it to be used on virtually any surface in almost any kind of space.

As cast: Concrete remains as it is after removal of forms and often bears the imprint of wood grain from the plywood.

Blasted: Various degrees of sandblasting smooth the surface while exposing successive levels of cement, sand, and aggregate.

Chemically retarded: Chemicals are applied to the surface to expose the aggregate.

Mechanically fractured: Tooling, hammering, jackhammering, and scaling produce varied aggregate-exposing effects.

Polished: Heavy-duty polishing machines polish the surface to a high gloss, with or without polishing compounds.

Sealed: Acrylic resin helps protect concrete from spalling (chipping or flaking caused by improper drainage or venting and freeze/thaw damage), dusting, efflorescence (whitening caused by water leeching soluble salts out of concrete and depositing them on the surface), stains, deicing salts, and abrasion.

Color

Colored concrete provides numerous design opportunities, It is generally achieved in one of two ways:

Integral coloring: Color is added to the wet concrete or mixed in at the jobsite—in either case, the color is distributed throughout the concrete. Because so much concrete is involved, colors are limited to earth tones and pastels. Once cured, the surface is sealed, which provides protection and a sheen that enhances the color.

Dry-shake color hardeners: Color hardeners are broadcast onto freshly placed concrete and troweled into the surface. The hardeners produce a dense and durable surface. Because the color is concentrated on top of the concrete, more vibrant and intense tones are possible. Sealers applied after curing further accentuate the richness of the color.

As in all natural materials, variations in color outcome will occur. The base color of the cement determines the ranges possible.

Reinforcing bars: Bars come in the following sizes: 3, 4, 5, 6, 7, 8, 9, 10, 11, 14, 18. Nominal diameters of #8 and lower are the bar number in eighths of an inch; that is, #3 is 3/8" (9.52). Nominal diameters of #9 and higher are slightly larger.

Welded wire fabric: Reinforcing steel is formed into a grid of wires or round bars 2"–12" (51–305) on center. Lighter styles are used in slabs on grade and some precast elements; heavier styles may be used in walls and structural slabs.

Chapter 25: Metals

Metals play an enormous role in almost every component of many projects and building types, from structural steel to sheet-metal ductwork, from drywall partition studs to oxides used as paint pigments. Metals of most varieties occur in nature as oxide ores, which can be mined and worked to extract and refine the metals, separating them from other elements and impurities. Metals fall under two broad categories: ferrous (containing iron) and nonferrous. Ferrous metals are generally stronger, more abundant, and easier to refine, but they have a tendency to rust. Nonferrous metals tend to be easier to work and most form their own thin oxide layers that protect them from corrosion.

MODIFYING METAL PROPERTIES

Most metals in their chemically pure and natural form are not very strong. To be suitable for construction and other functions, their properties must be altered, which can be done in several ways, often dependent on the proposed use of the metal.

Alloys

Metals are mixed with other elements, usually other metals, to create an alloy. For example, iron mixed with small amounts of carbon produces steel. Generally, the alloy is stronger than its primary metal ingredient. In addition to improved strength and workability, alloys provide self-protecting oxide layers.

Heat-Treated Metals

Tempering: Steel is heated at a moderate rate and slowly cooled, producing a harder and stronger metal.

Annealing: Steel and sometimes aluminum alloys are heated to very high temperatures and cooled slowly, softening the metal so that it is easier to work.

Cold-Worked Metals

At room temperature, metals are rolled thin, beaten, or drawn, making them stronger but more brittle by altering their crystalline structures. Cold-worked metals may be reversed by annealing.

Cold rolling: Metal is squeezed between rollers.

Drawing: Drawing metal through increasingly smaller orifices produces the wires and cables used to prestress concrete, which have five times the structural strength of steel.

Coated Metals

Anodizing: A thin oxide layer of controlled color and consistency is electrolytically added to aluminum to improve its surface appearance.

Electroplating: Chromium and cadmium are coated onto steel to protect it from oxidation and improve its appearance.

Galvanizing: Steel is coated with zinc to protect it against corrosion.

Other coatings: Coatings can include paints, lacquers, powders, fluoropolymers, and porcelain enamel.

GALVANIC ACTION

Galvanic action is corrosion that occurs between metals under the following conditions: There exist two electro-chemically dissimilar metals, an electrically conductive path between the two metals, and a conductive path for metal ions to move from the less noble metal to the more noble one. A good understanding of the mate-rial compatibilities in the galvanic series will minimize corrosion in design. The galvanic series lists metals from least noble (anodic, or most reactive to corrosion) to most noble (cathodic, or least reactive to corrosion). Generally, the farther apart two metals are on the list, the greater the corrosion of the less noble one. Therefore, combinations of metals that will be in electri-cal contact should be selected from groups as close together in the series as possible.

Note that the ranking of metals may differ, based on variations in alloy composition and nonuniform condi-tions. When specifying and detailing metals, always consult the manufacturer of the metal product.

General Guidelines

Electrically insulate metals from different groups whenever possible; otherwise, paint metals or use plastic coatings at joints.

Do not join dissimilar materials by threaded connec-tions, which will deteriorate. Instead, use brazed or thermal joints, with a brazing alloy more noble than at least one of the metals being joined.

Avoid combinations that involve small areas of the less noble metal, relative to larger areas of the more noble metal.

Apply paints and coatings judiciously. If the less noble metal is painted, so should the more noble one, to avoid corrosive attacks in areas of imperfec-tion. Coatings should be well maintained.

Avoid putting metals in contact with chemically active materials and moisture (aluminum with con-crete or mortar, steel with certain treated woods, for example), which may cause deterioration.

Galvanic Series

Anode (+)

| Magnesium, magnesium alloys |
| Zinc, zinc alloys and plates |
| Zinc (hot-dipped), galvanized steel |
| Aluminum (non-silicon cast alloys), cadmium |
| Aluminum (wrought alloys, silicon cast) |
| Iron (wrought, malleable), plain carbon and low-alloy steel |
| Aluminum (wrought alloys —2000 series) |
| Lead (solid, plated), lead alloys |
| Tin plate, tin-lead solder |
| Chromium plate |
| High brasses and bronzes |
| Brasses and bronzes |
| Copper, low brasses and bronzes, silver solder, copper-nickel alloys |
| Nickel, titanium alloys, monel |
| Silver |
| Gold, platinum |

Cathode (–)

The series listed here is for general information only and does not con-sider the anodic index of any metals. The anodic index (V) of each metal determines more precisely its compatibility thresholds with other metals.

Accurate anodic index numbers should be obtained from the specific metal manufacturer.

METAL TYPES

Ferrous

Cast iron: Very brittle with high compressive strength and ability to absorb vibrations; ideal for gratings and stair components but too brittle for structural work.

Malleable iron: Produced by casting, reheating, and slowly cooling to improve workability; similar to cast iron in use.

Mild steel: Ordinary structural steel with a low carbon content.

Stainless steel: Produced by alloying with other metals, primarily chromium or nickel for corrosion resistance and molybdenum when maximum resistance is required (in sea water, for example). Though harder to form and machine than mild steel, its uses are many, including flashing, coping, fasteners, anchors, hardware, and finishes that can range from matte to mirror polish.

Steel: Iron with low amounts of carbon (carbon increases strength, but decreases ductility and welding capabilities); used for structural components, studs, joists, and fasteners, and in decorative work.

Wrought iron: Soft and easily worked, with high corrosion resistance, making it ideal for use below grade. Most often cast or worked into bars, pipes, or sheets, and fashioned for ornamental purposes. Other metals like steel have virtually replaced it today.

Steel Alloys

Aluminum: Hardens surfaces

Chromium and cadmium: Resists corrosion

Copper: Resists atmospheric corrosion

Manganese: Increases hardness and helps to resist wear

Molybdenum: Often combined with other alloys, increases corrosion resistance and raises tensile strength

Nickel: Increases tensile strength and resists corrosion

Silicon: Increases strength and resists oxidation

Sulfur: Allows for free machining of mild steels

Titanium: Prevents intergranular corrosion in stainless steel

Tungsten: With vanadium and cobalt, increases hardness and resists abrasions

Aluminum Alloy Series

Wrought		Cast	
Series	**Alloying Element**	**Series**	**Alloying Element**
1000	pure aluminum	100.0	pure aluminum
2000	copper	200.0	copper
3000	manganese	300.0	silicon plus copper and/ or magnesium
4000	silicon	400.0	silicon
5000	magnesium	500.0	magnesium
6000	magnesium and silicon	600.0	unused series
7000	zinc	700.0	zinc
8000	other elements	800.0	tin
		900.0	other elements

1st digit is series no.; 2nd is modification of alloy; 3rd/4th are arbitrary identifiers

1st digit is series no.; 2nd/ 3rd are arbitrary identifiers; no. after decimal is casting if 0, ingot if 1 or 2

Nonferrous

Aluminum: When pure, it resists corrosion well, but is soft and lacks strength; with alloys, it can achieve various levels of strength and stiffness, at one-third the density of steel, and can be hot- or cold-rolled, cast, drawn, extruded, forged, or stamped. Sheets or foil, when polished to a mirror finish, have extremely high levels of light and heat reflectivity. Its uses include curtain wall components, ductwork, flashing, roofing, window and door frames, grills, siding, hardware, wiring, and coatings for other metals. Aluminum powder may be added to metallic paints and its oxide acts as an abrasive in sandpaper.

Brass: Alloy of copper, zinc, and other metals; can be polished to a high luster and is mostly used for weather stripping, ornamental work, and finish hardware.

Bronze: Alloy of copper and tin that resists corrosion; used for weather stripping, hardware, and ornamental work.

Cadmium: Similar to zinc; usually electroplated onto steel.

Chromium: Very hard and will not corrode in air; like nickel, often used as an alloy to achieve a bright polish and is excellent for plating.

Copper: Ductile and corrosion-, impact-, and fatigue-resistant; it has high thermal and electrical conductivity, and can be cast, drawn, extruded, hot-, or cold-rolled. Widely employed as an alloy with other metals, it can also be used for electrical wiring, flashing, roofing, and piping.

Lead: Extremely dense, corrosion resistant, limp, soft, and easy to work; most often combined with alloys to improve hardness and strength. Foil or sheets are ideal for waterproofing, blocking sound and vibrations, and shielding against radiation. Can also be used as roofing and flashing, or to coat copper sheets (lead-coated copper) for roofing and flashing. High toxicity of vapors and dust have made its use less common.

Magnesium: Strong and lightweight; as an alloy, serves to increase strength and corrosion resistance in aluminum. Often used in aircraft, but too expensive for most construction.

Tin: Soft and ductile; used in terneplate (80 percent lead, 20 percent tin) for plating steel.

Titanium: Low density and high strength; used in numerous alloys and its oxide has replaced lead in many paints.

Zinc: Corrosion resistant in water and air, but very brittle and low in strength. Primarily used in galvanizing steel to keep it from rusting; also electroplated onto other metals as an alloy. Other functions include flashing, roofing, hardware, and die-casting.

CH. 26

FABRICATION TECHNIQUES

Casting: Molten metal is poured into a shaped mold. The metal produced is weak but can be made into many shapes, such as faucets or hardware.

Drawing: Wires are produced by pulling metal through increasingly smaller holes.

Extrusion: Heated (but not molten) metal is squeezed through a die, producing a long metal piece with a shaped profile.

Forging: Metal is heated until flexible and then bent into a desired shape. This process improves structural performance by imparting a grain orientation onto the metal.

Grinding: Machines grind and polish metal to create flat, finished surfaces.

Machining: Material is cut away to achieve a desired shape. Processes include drilling, milling (with a rotating wheel), lathing (for cylindrical shapes), sawing, shearing, and punching. Sheet metal is cut with shears and folded on brakes.

Rolling: Metal is squeezed between rollers. Hot rolling, unlike cold, does not increase the strength of metal.

Stamping: Sheet metal is squeezed between matching dies to give it shape and texture.

Joining Metals

Welding: In this high-temperature fusion, a gas flame or electric arc melts two metals and allows the point of connection to flow together with additional molten metal from a welding rod. Welded connections are as strong as the metals they join and can be used for structural work.

Brazing and soldering: In these lower-temperature processes, the two metals are not themselves melted but joined with the solder of a metal with a lower melting point: Brass or bronze are used in brazing, lead-tin alloy is used in soldering. Too weak for structural connections, brazing and soldering are used for plumbing pipes and roofing.

Mechanical methods: Metals can also be drilled or punched with holes, through which screws, bolts, or rivets are inserted.

Interlocking and folding: Sheet metal can be joined by such connections.

GAUGES AND MILS

Sheet metal thicknesses have long been expressed in terms of gauge (ga.), an antiquated term based on weight (originally for reasons of taxation) and not a reference to the precise thickness of a sheet. Thus, a sheet of mild steel and one of galvanized steel may have the same gauge but different thicknesses. As the gauge number increases, the sheet becomes thinner; sheets thicker than $1/4''$ (6), or about 3-gauge, are referred to as plates.

Most steel manufacturers are adapting to mils. One mil (μm) equals $1/1,000''$ (or 0.001''), so a thickness of 0.0179'' is roughly equivalent to $18/1,000$, or 18 mils. This straightforward system allows the actual thickness of the sheet to define its mil designation.

Though gauges may become obsolete in time, many products still use them, and it is advantageous to be familiar with generally accepted sizes, even if gauge numbers represent a rough approximation of thickness. There is no equation for a strict translation from gauge to mil thickness; however—for reference purposes only—many common mil sizes may be associated with specific gauge sizes.

The gauge thicknesses as shown in the table opposite represent nominal minimum base metal thicknesses for the gauges. Design thickness is the minimum base metal thickness divided by 0.95. Further complicating matters, each gauge thickness has a tolerance range, which increases as the gauge increases.

CH. 20

Gauge Reference Chart

Mil (µm)	Gauge (ga.)	Standard Steel in.	Standard Steel (mm)	Galvanized Steel in.	Galvanized Steel (mm)	Aluminum in.	Aluminum (mm)
	3	0.2391	(6.073)			0.2294	(5.827)
	4	0.2242	(5.695)			0.2043	(5.189)
	5	0.2092	(5.314)			0.1819	(4.620)
	6	0.1943	(4.935)			0.1620	(4.115)
	7	0.1793	(4.554)			0.1443	(3.665)
	8	0.1644	(4.176)			0.1285	(3.264)
	9	0.1495	(3.797)	0.1532	(3.891)	0.1144	(2.906)
118	10	0.1345	(3.416)	0.1382	(3.510)	0.1019	(2.588)
	11	0.1196	(3.030)	0.1233	(3.132)	0.0907	(2.304)
97	12	0.1046	(2.657)	0.1084	(2.753)	0.0808	(2.052)
	13	0.0897	(2.278)	0.0934	(2.372)	0.0720	(1.829)
68	14	0.0747	(1.879)	0.0785	(1.994)	0.0641	(1.628)
	15	0.0673	(1.709)	0.0710	(1.803)	0.0571	(1.450)
54	16	0.0598	(1.519)	0.0635	(1.613)	0.0508	(1.290)
	17	0.0538	(1.367)	0.0575	(1.461)	0.0453	(1.151)
43	18	0.0478	(1.214)	0.0516	(1.311)	0.0403	(1.024)
	19	0.0418	(1.062)	0.0456	(1.158)	0.0359	(0.912)
30 \| 33	20	0.0359	(0.912)	0.0396	(1.006)	0.0320	(0.813)
	21	0.0329	(0.836)	0.0366	(0.930)	0.0285	(0.724)
27	22	0.0299	(0.759)	0.0336	(0.853)	0.0253	(0.643)
	23	0.0269	(0.683)	0.0306	(0.777)	0.0226	(0.574)
	24	0.0239	(0.607)	0.0276	(0.701)	0.0201	(0.511)
18	25	0.0209	(0.531)	0.0247	(0.627)	0.0179	(0.455)
	26	0.0179	(0.455)	0.0217	(0.551)	0.0159	(0.404)
	27	0.0164	(0.417)	0.0202	(0.513)	0.0142	(0.361)
	28	0.0149	(0.378)	0.0187	(0.475)	0.0126	(0.320)
	29	0.0135	(0.343)	0.0172	(0.437)	0.0113	(0.287)
	30	0.0120	(0.305)	0.0157	(0.399)	0.0100	(0.254)
	31	0.0105	(0.267)	0.0142	(0.361)	0.0089	(0.226)
	32	0.0097	(0.246)	0.0134	(0.340)	0.0080	(0.203)
	33	0.0090	(0.229)			0.0071	(0.180)
	34	0.0082	(0.208)			0.0063	(0.160)
	35	0.0075	(0.191)			0.0056	(0.142)
	36	0.0067	(0.170)				

33 mil is considered the thinnest material allowable for structural cold-formed steel framing

20-gauge material often comes in the following two thicknesses:

30 mil for nonstructural drywall studs;

33 mil for structural studs

18 mil is considered the thinnest material allowable for nonstructural, cold-formed steel framing

LIGHT-GAUGE FRAMING

Metal studs are generally made of cold-rolled corrosion-resistant steel in standard sizes. They work in both load-bearing and non-load-bearing capacities and as floor and roof framing elements. Studs are spaced 16" (406) or 24" (610) OC inside top and bottom tracks. Metal studs with gypsum sheathing provide greatly reduced combustibility, and can be built taller than wood stud walls. Knockouts or punchouts are provided at regular intervals to allow for bridging between studs or for the passing through of electrical conduit or plumbing.

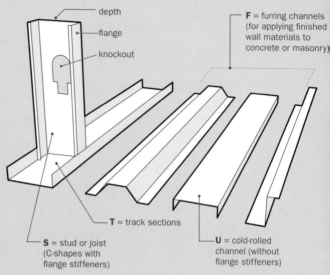

depth

flange

knockout

F = furring channels (for applying finished wall materials to concrete or masonry)

T = track sections

S = stud or joist (C-shapes with flange stiffeners)

U = cold-rolled channel (without flange stiffeners)

The Steel Stud Manufacturers Association (SSMA) designations for light-gauge steel framing members are written as follows: web depth (in $^1/_{100}$") + S, T, U, or F designation + flange width (in $^1/_{100}$") + minimum base metal thickness (in mils).

Thus, a 250S 162-33 member is a $2^1/_2$" ($^{250}/_{100}$") stud with a flange of $1^5/_8$" ($^{162}/_{100}$"), at 33 mils.

Common Metal Stud Sizes

Non-load-bearing Studs
depths: $1^5/_8$" (41), $2^1/_2$" (64), $3^5/_8$" (92), 4" (102), 6" (152)
gauges [mils]; 25 [18], 22 [27], 20 [30]

Non-load-bearing Curtain Wall Studs
depths: $2^1/_2$" (64), $3^5/_8$" (92), 4" (102), 6" (152)
gauges [mils]: 20 [30], 18 [43], 16 [54], 14 [68]
flange: $1^3/_8$" (35)

Structural C-Studs
depths: $2^1/_2$" (64), $3^5/_8$" (92), 4" (102), 6" (152), 8" (203), 10" (254), 12" (305)
gauges [mils]: 20 [33], 18 [43], 16 [54], 14 [68]
flange: $1^5/_8$" (41)

Structural Stud/Joist
depths: $2^1/_2$" (64), $3^5/_8$" (92), 4" (102), 6" (152), 8" (203), 10" (254), 12" (305)
gauges [mils]: 20 [33], 18 [43], 16 [54], 14 [68]
flange: 2" (51)

Sheet Thickness (actual size)

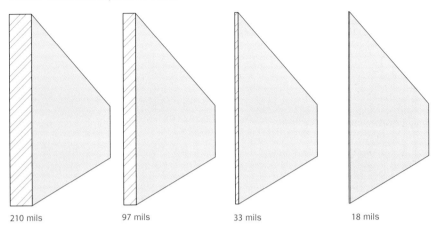

210 mils 97 mils 33 mils 18 mils

Metal Roofing Seams

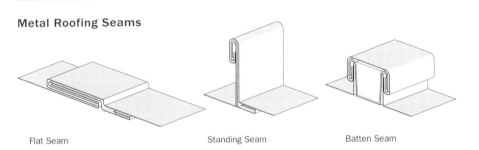

Flat Seam Standing Seam Batten Seam

Forms and Sheets

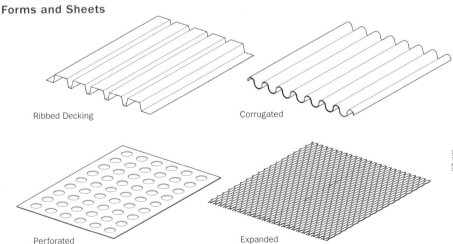

Ribbed Decking Corrugated

Perforated Expanded

CH. 26

Chapter 26: Finishes

Interior finishes encompass all
materials and surfaces that can
be seen or touched. The choice
of materials and the methods of
construction should be based on
the function of the space, the
anticipated volume of traffic,
acoustical effects, fire-resistance
ratings, and aesthetic appearance.

CEILINGS

WALL SYSTEMS

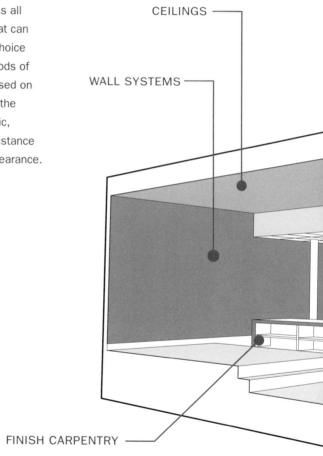

FINISH CARPENTRY

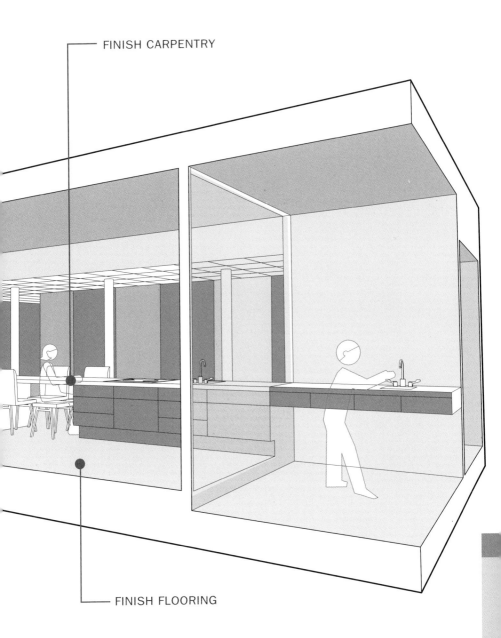

FINISH CARPENTRY

FINISH FLOORING

WALL SYSTEMS

Gypsum Board

Gypsum board goes by many names: gypsum wallboard (GWB), drywall, plasterboard, and Sheetrock (a trademarked brand name). Gypsum board is a less expensive alternative to plaster, because it requires less labor, time, and skill to install, but it still provides excellent fire-resistance and sound control.

Gypsum, a naturally occurring mineral, is formulated chemically when combined with water, starch, and other elements into a slurry and placed between paper faces to become gypsum board. When gypsum board is exposed to fire, the water is released as steam, providing a fire barrier until the water is completely eliminated (calcination). When the gypsum is completely calcined, its residue still acts as an insulating barrier to flames, preventing the structural members behind it from igniting.

Customary Sizes

Panel sizes may vary depending on the type of board, though generally they fall in the following range: 4′ (1 220) wide by 8′ (2 439) to 16′ (4 877) high.

Widths of 2′ (610) and 2′-6″ (762) and heights of 6′ (1 829) may also be available for certain prefinished boards and core boards.

SI Preferred Sizes

Standard panel size is 1 200 x 3 600 mm.

Other acceptable increments are 600 mm, 800 mm, and 900 mm.

Panel Types

Backing board: Used as a base layer when multiple layers are needed, improving fire resistance and sound control.

Coreboard: Thicker boards, 1″ (25.4) and 2″ (50.8), used to enclose vent shafts, emergency egress stairs, elevator shafts, and other vertical chases.

Foil-backed: Can work as a vapor barrier in exterior wall assemblies and as a thermal insulator.

Prefinished: Covered in a variety of finishes such as paint, paper, or plastic film for installation without further finishing.

Regular: Used for most applications.

Type X: Short glass fibers in the core hold the calcined gypsum residue in place for increased fire resistance protection ratings.

Water-resistant (green board): Water-resistant board with a water-repellent paper facing (colored light green to distinguish it from other walls) and a moisture-resistant core (also available in type X); used as base for tiles and other nonabsorbent materials in wet locations.

Board Thicknesses

1/4" (6.4)
backing board, some acoustic work

5/16" (8)
used for manufactured housing

3/8" (9.5)
used in double-layer finishes

1/2" (12.7)
used for stud spacings up to 24"
(610), most common thickness

5/8" (16)
used when additional fire resistance
or structural stiffness are required

1" (25.4)
coreboard used for shaft walls

Edge Types

Square

Rounded

Beveled

Tongue and Groove

Tapered

Rounded Taper

GWB Partition Wall Installation

Gypsum wallboard is placed over wood studs using nails or screws and over metal studs using screws. The orientation of the boards may differ based on the height of the wall, whether it is double-layer construction, and other factors.

Generally, it is best to minimize end joints between boards (boards have finished paper only on the face, back, and long edges, which themselves are finished in a variety of edge types), because these joints are more difficult to finish. If two or more layers of board are to be installed, joints between the layers should be staggered for added strength.

Joints are finished with joint compound and tape, usually in the following manner: A layer of joint compound is troweled into a tapered edge joint, then fiber-reinforcing mesh tape is applied; for some tapered edge joints, joint compound is forced through the tape to fill the V-shaped trough. After drying overnight, more joint compound is applied to completely smooth the joint, making it flush with the surrounding wall. Individual board manufacturers may suggest adding more layers of joint compound.

Nail or screw holes are also filled, and the whole wall receives a final light sanding before painting.

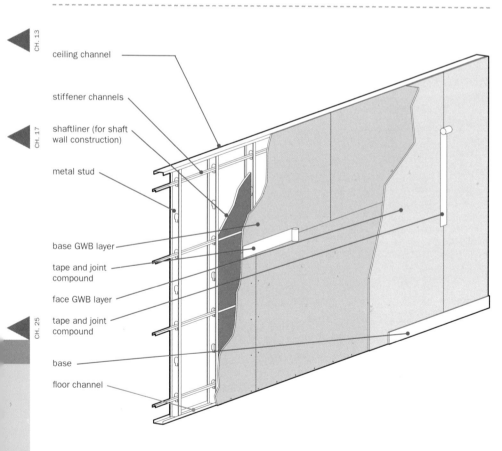

CH. 13

CH. 17

CH. 25

ceiling channel

stiffener channels

shaftliner (for shaft wall construction)

metal stud

base GWB layer

tape and joint compound

face GWB layer

tape and joint compound

base

floor channel

Common GWB Partition Assemblies

Fireproofing at Steel Structural Members

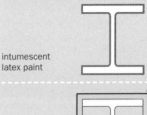

intumescent latex paint

3 5/8" **STC: 40–44**: (1 layer 3/8" GWB on either side of 1 5/8" metal studs; face layers of 1/2" GWB)

1-HR FIRE RATING

metal lath and plaster enclosure

4 7/8" **STC: 40–44**: (1 layer 5/8" type X GWB on either side of 3 5/8" metal studs)

1-HR FIRE RATING

spray-on fireproofing

5 1/2" **STC: 45–49**: (1 layer 5/8" type X GWB on either side of 3 5/8" metal studs; one face layer 5/8" GWB applied with laminating compound; 3 1/2" glass fiber insulation in cavity)

1-HR FIRE RATING

sheet-metal enclosure with loose insulating fill

6 1/4" **STC: 55–59**: (2 layers 5/8" type X GWB on either side of 3 5/8" metal studs; one face layer 1/4" GWB applied with laminating compound; 1 1/2" glass fiber insulation in cavity)

2-HR FIRE RATING

reinforced concrete encasement

multiple layers of GWB enclosure

PLASTER

Today most plaster has a gypsum base. Gypsum is calcined and then ground into a fine powder. When mixed once again with water, it rehydrates and returns to its original state, expanding as it hardens into a plaster that possesses excellent fire-resistive qualities. This formulation can be mixed with an aggregate and applied by hand or by machine directly to masonry walls or to a lath system.

Plaster Types

Gauging plaster: Mixed with lime putty for accelerated setting and reduced cracking; may be mixed with finish lime to make a high-quality finish coat.

Gypsum plaster: Used with sand or lightweight aggregate.

High-strength basecoat: Used under high-strength finish coats.

Keenes cement: High-strength with a very strong and crack-resistant finish.

Molding plaster: Fast-setting for molding ornaments and cornices.

Stucco: Portland cement–lime plaster; used on exterior walls or where moisture is present.

With wood fiber or perlite aggregate: Lightweight with good fire resistance.

CH. 22

Lath Assemblies

Plaster over Metal Lath

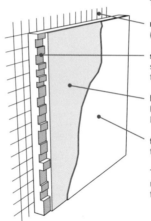

Three-Coat Plaster

metal lath: expanded metal or mesh (steel)

scratch coat: troweled on roughly and scratched to create a scored surface for the next coat

brown coat: applied over the lath and hardened scratch coat; leveled with a long straightedge

finish coat: very thin ($1/16''$) outer layer that may be smoothed or textured.

Total thickness of all three layers is roughly $5/8''$ (16) and provides good fire resistance and durability.

Plaster over Gypsum Lath

Two- or Three-Coat Plaster

gypsum lath: hardened gypsum plaster core with an outer sheet of absorbent paper to adhere to the plaster and water-resistant inner layers to protect the core; comes in 16" x 48" (406 x 1 219) boards in $3/8''$ (10) and $1/2''$ (13) thicknesses.

brown coat

finish coat

If gypsum is attached to studs, it is rigid enough to require only two coats of plaster; solid plaster walls (plaster on either side of gypsum, with no studs) require three coats. Total thickness of the plaster on one side is $1/2''$(13).

Veneer Plaster

Veneer plaster is a less expensive and less labor-intensive plaster system. The special veneer base works much like a standard gypsum board wall system and is finished smooth and flat to provide the best surface for the very dense veneer plaster. The plaster is applied in two coats in quick succession; the second coat, called a skim coat, dries almost immediately. The total plaster thickness is about $1/8''$ (3).

Plaster over Masonry

Plaster can be applied directly to brick, concrete block, poured concrete, and stone walls. Walls should be dampened first to keep the plaster from dehydrating during application. Generally, three coats will be needed, totaling $5/8''$ (16) in plaster thickness, though the roughness of the masonry surface will dictate the thickness in many cases. Where the masonry or other wall is unsuitable for direct plaster application (if moisture or condensation are present or if an air space is required for insulation), plaster and lath are applied over furring channels attached to the wall.

Wall Assemblies

Plaster and lath assemblies can be applied to truss studs, steel studs, or wood studs, in addition to furring strips. Solid plaster walls of roughly $2''$ (51) thick are sometimes used where space is at a premium. They generally consist of plaster on either side of expanded metal mesh or gypsum lath, supported at the floor and ceiling by metal runners.

Wood lath is rarely used today in favor of cheaper and more durable lath types.

TRIM SHAPES

Ceiling Moldings

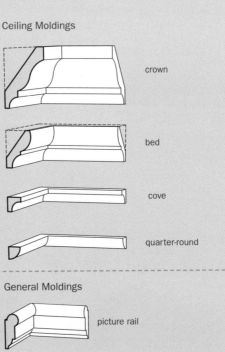

crown

bed

cove

quarter-round

General Moldings

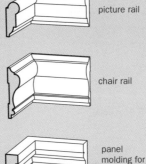

picture rail

chair rail

panel molding for wainscoting

Baseboards

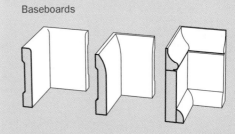

FINISH FLOORING

Floors receive regular wear and abuse, from feet, furniture, dirt, and water. Floor finish materials should be carefully chosen based on the function of the space and the amount of traffic they must endure. A wide array of finish floor types and methods of installation exist, of which the small sampling shown here represents the most common residential and commercial applications.

Carpet

Wool, nylon, polypropylene, and polyester account for most carpet fibers, with nylon the most widely used. Construction types include velvet, Axminster, Wilton, tufted, knitted, flocked, needle-punched, and fusion-bonded. Installation methods include stretch-in (using staples), direct glue down, and double glue down.

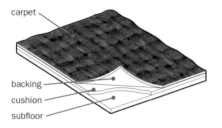

carpet

backing
cushion
subfloor

Resilient Flooring

Vinyl sheet, homogeneous vinyl tile, vinyl composition tile (VCT), cork tile, rubber tile, and linoleum are the common types. The flooring, either ±1/8″ (3) thick sheets or tiles, is glued to a concrete or wood subfloor. Most types can be installed to include a seamless integral cove base.

CH. 23

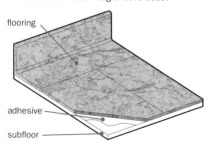

flooring

adhesive

subfloor

Wood

Wood offers a variety of widths and thicknesses, as well as methods of installation. Almost any wood can be made into strip flooring, though oak, pecan, and maple are the most common. Thicker boards should be installed in areas of heavier use.

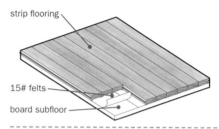

strip flooring

15# felts

board subfloor

Ceramic Tile and Quarry Tile

For thick-set installation, tiles are laid on ±1″(25) portland cement mortar. For thin-set installation, tiles are laid on ±1/8″ (3) dry-set mortar, latex–portland cement mortar, organic adhesive, or modified epoxy emulsion mortar.

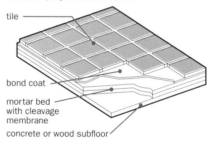

tile

bond coat

mortar bed with cleavage membrane

concrete or wood subfloor

Terrazzo

Terrazzo is a poured or precast material composed of stone chips and a cement matrix (epoxy, polyester, polyacrylate, latex, or electrically conductive).

Appearance types vary from Standard (small chip sizes) to Venetian (large chips with small chips between), Palladiana (large random marble slabs with small chips between) to Rustic (uniform texture with suppressed matrix to expose chips).

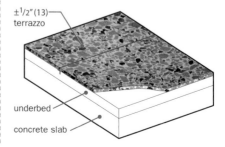

±1/2″(13) terrazzo

underbed

concrete slab

CEILINGS

Attached Ceilings

Gypsum board, plaster, metal, and other materials can be attached directly to joists, rafters, and concrete slabs. Attached ceilings are constructed in a similar manner to wall systems.

Suspended Ceilings

Suspended ceiling systems can support almost any material, although gypsum board, plaster, or fibrous board panels are most common. Regular grids of sheet metal cee channels suspended from the structure above with hanger wires support the gypsum board and plaster.

The space between the structure above and the suspended ceiling, called the plenum, provides a zone for ductwork, piping, conduit, and other equipment.

Fibrous panels known as acoustic ceiling tiles (ACT) are lightweight boards made of mineral or glass fibers that are highly sound absorptive. They are easily laid into an ex-posed, recessed, or concealed grid of light-gauge metal tees suspended with hanger wires. Good ACT has a very high noise reduction coefficient (NRC), meaning that it absorbs the majority of the sound that reaches it. The NRC for gypsum and plaster, by contrast, is very low. Lightweight panels, however, tend to pass the sound through, which limits acoustical privacy in spaces with a shared plenum. Composite panels with acoustic material laminated to a sub-strate can alleviate this problem. Acoustical panels may involve other materials such as perforated metal, Mylar, and tectum.

Ceiling tiles can be easily removed, allowing access to the plenum area for maintenance of equipment and systems.

| Common Panel Sizes in. (mm) | | |
|---|---|
| 12 x 12 | (305 x 305) |
| 12 x 24 | (305 x 610) |
| 24 x 24 | (610 x 610) |
| 24 x 48 | (610 x 1 219) |
| 24 x 60 | (610 x 1 524) |
| 20 x 60 | (508 x 1 524) |
| 30 x 60 | (762 x 1 524) |
| 60 x 60 | (1 524 x 1 524) |
| 48 x 48 | (1 219 x 1 219) |

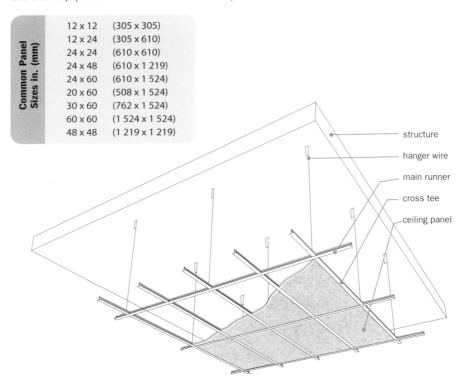

structure

hanger wire

main runner

cross tee

ceiling panel

FINISH CARPENTRY

The wood interior finish components of a building are called millwork, and their installation is known as finish carpentry. Wood used for millwork encompasses various arrangements of solid and veneer wood, but in general it is of a higher quality than that used for framing. Millwork related to cabinetry and its assembly is called casework. The Architectural Woodwork Institute (AWI) classifies cabinet quality in three grades: economy (lowest grade), custom (average grade), and premium (best grade).

Wood-based Board Types

High-density plywood: HDP has more plies and fewer voids than common plywood. Its strength and stability make it useful for cabinetry.

Medium-density fiber core hardwood plywood: MDF is produced by heat-pressing a mixture of fine wood dust and a binder into panels. Paint-grade blank sheets can be used as they are or with a veneer skin, while dyed MDF has a consistent color from face to core. Though ideal for use in cabinetry and shelving, one drawback of full MDF is its weight: A typical $^3/4$" x 4' x 8' (19 x 1 219 x 2 438) sheet may weigh as much as 90 pounds.

Medium- and high-density overlay plywood: MDO and HDO are generally typical plywood with an MDF surface, resulting in panels that weigh less than full MDF but have smoother and more stable surfaces than VC.

Particle board core plywood: PBC is the result of heat-pressing a coarse wood dust and a binder into panels. The coarser dust yields a lower-weight panel than full MDF, though with a rougher and less consistent surface, making it ideal as a substrate for many other products.

Veneer core hardwood plywood: VC, which is common plywood with a finished wood grain surface veneer, is relatively lightweight and easy to handle.

Veneers

Melamine: Melamine consists of a particle board core with a thermally fused, resin-saturated paper finish. Though the name actually refers to the resin in the paper liner, and not the paper or board, the entire product is commonly referred to as melamine. Melamine is ideal for use in cabinetry and comes in a wide variety of colors. MDF can also be used as the substrate.

Plastic laminate: P-lam is composed of layers of resin-impregnated paper, cloth, or glass cloths pressed into a solid shape. The different resins used to bind the cloths (phenolic resin, melamine resin, or epoxy resin) produce different properties in the p-lam. P-lam is inexpensive, moderately durable, and comes in various colors and textures, though it cannot withstand extremes of heat and is not impervious to staining. P-lam itself is moisture resistant, though moisture that penetrates a seam may damage the substrate.

Common Countertops

Plastic Laminate

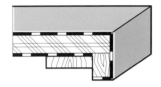

Plastic laminate counters may come postformed, with the laminate already glued to a particle board platform, complete with a backsplash and bull-nosed front edge.

It is also possible to apply p-lam as thin sheets—generally $1/16''$ (1.6) thick—using a contact adhesive. Decorative plastic laminates have a top sheet of paper printed with wood-grain patterns or other images.

Stone

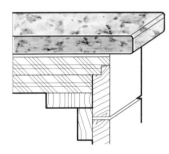

Solid stone countertops of granite, soapstone, marble, or slate (typically resting on a thin-set bed of cement) are durable and resistant to most common kitchen or bathroom wear and tear. Substrates are generally two layers of plywood or particle board. The thickness of the stone varies based on type, but is in the general range of $3/4''-1^5/16''$ (19–33).

Grouted stone tiles offer a lighter, less expensive alternative.

Solid Surface

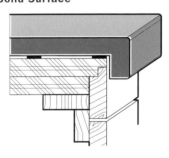

The general composition of solid surface is polymer (acrylic-based resin or unsaturated polyester resin), aluminum trihydrate filler, pigment (colorant), and a catalyst. Solid surface materials are nonporous, homogeneous (maintaining the same appearance all the way through), strong, and have UV stability and surface hardness. They resist water, impacts, chemicals, stains, and high temperatures. Moreover, solid surface can be repaired by being sanded and polished back to its original finish.

Solid surface materials are highly versatile and come in a wide variety of colors, textures, patterns, and translucencies. Though typically thought of as a counter and sink material, solid surfaces, because they are easily cut and shaped and can be thermoformed into almost any shape, are increasingly found in innovative applications for furniture, cladding, and light fixtures.

Horizontal applications generally use $1/2''$ (13) sheets.

COMPENDIUM **6.**

The art of architecture is not easily quantified or defined. It is certainly more than the sum of the systems and materials that give it shape, though architecture would not exist without the standardized procedures that erect its forms. The preceding chapters have provided the rudimentary tools for making buildings. It is in how architects use these tools to transform limitations into possibilities that allow them to navigate challenging situations and ultimately produce a better built environment.

The breadth of practical information about basic systems and concepts that this book has so far touched on is also a way of describing the world of architecture to all its users. What follows is a broad overview of how these basic systems have become a history of our overlapping cultures.

We live in the built world: Whether it is well-designed or poorly designed, it is the space and surface of our existence. By inhabiting architecture and moving around it, we have knowledge of it. To enhance our understanding, this book ends with a beginning: an introduction to a range of resources within the enormous, endless scope of architectural information and discussion.

Chapter 27: Timeline

The history of architecture is a history of civilization. Buildings are artifacts intrinsically linked to the epoch and society of their creation, clearly exposing the varied conditions of how they came to be. To understand a piece of architecture is to gain insight into countless aspects of a place and a moment in time—geography, weather, social hierarchies, religious practices, and industrialization. And because architecture is rarely portable, it is virtually impossible to disengage a building from its origins.

ANCIENT

Great Sphinx of Giza ●
(ca. 2500 B.C.E.) *Egypt*

Great Pyramids of Giza ●
(2570–2500 B.C.E.) *Egypt*

The fluidity of history can make for unwieldy attempts to classify periods succinctly, and architectural styles and movements reflect this difficulty: Though some styles may have come into sudden existence as the result of a specific event, most evolve slowly and taper off gradually. The distillation of any history presents obvious limitations; therefore, many dates shown here are approximations, serving the overall purpose of this timeline, which is to illustrate relationships among movements.

Stonehenge ●
(ca. 2900–1400 B.C.E.)
Salisbury Plain, England

B.C.E. (Before Common Era) = B.C.
C.E. (Common Era) = A.D.
b. = before; c. = century; ca. = circa

2000 B.C.E.

1000 B.C.E.

0

Hypostyle Hall at Karnak
(ca. 1300 B.C.E.)
Egypt

Egyptian
(ca. 3500–30 B.C.E.)

 Mentuhotep Mortuary Temple
(2061–2010 B.C.E.)
Deir el-Bahari, Egypt

Great Temple of Ramses II
(ca. 1285–1225 B.C.E.)
Abu Simbel, Egypt

El Castillo ●
(850 C.E.)
*Chichen Itza,
Yucatan, Mexico*

● Dome of the Rock
(687–89 C.E.)
Jerusalem

Greek
(ca. 2000–31 B.C.E.)

Temple of Hera ●
(460 B.C.E.) *Paestum, Italy*

Temple of Apollo (310 B.C.E.) *Turkey*
Paeonis and Daphnis

Palace at Knossos ●
(1700–1380 B.C.E.)
Knossos, Greece

Temple of Paestum ●
(ca. 530-460 B.C.E.) *Paestum, Italy*

Parthenon (448–432 B.C.E.) ●
Athens, Greece

Stoa of Attalus ●
(150 B.C.E.)
Athens, Greece

Romanesque
(500–1200 C.E.)

Baths of Caracalla ●
(215 C.E.)
Rome, Italy

Pantheon ●
(rebuilt 118–25 C.E.)
Rome, Italy

Arch of Constantine ●
(312–15 C.E.)
Rome, Italy

Roman
(510 B.C.E.–476 C.E.)

Colosseum (72–80 C.E.) ●
Rome, Italy

Pont du Gard ●
Aqueduct
(15 B.C.E.)
Nîmes, France

Ziggurat at Ur ●
(ca. 2100 B.C.E.)
Mesopotamia

Etruscan
(ca. 9th c.–50 B.C.E.)

Byzantine
(324–15th c.)

1000 1100 1200

MIDDLE AGES

● Kandariya Mahadeva Temple
(1025–50)
Khajuraho, India

Notre-Dame ●
Cathedral
(1163–1250)
Paris, France

○ Chartres Cathedral
(1194–1220)
Chartres, France

Amiens Cathedral
(1220–47)
Amiens, France

Salisbury Cathedral ○
(1220–60)
Salisbury, England

Romanesque
(500–1200)

○ Worms Cathedral (1110–81)
Worms, Germany

○ S. Apollinaire Nuovo
(ca. 490)
Ravenna, Italy

○ Pisa Cathedral (1063–92)
and Baptistery (1153)
Pisa, Italy

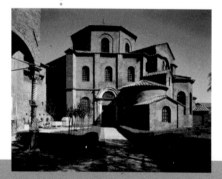

● Angkor Wat
(b. ca. 1120)
Cambodia

● San Vitale (526)
Ravenna, Italy

○ St. Mark (1042–85)
Venice, Italy

Byzantine
(324–12th c.)

○ Hagia Sophia (537)
İstanbul (Constantinople), Turkey

King's College Chapel
(1446–1515)
Cambridge, England

Gothic
(ca. 1140–1500)

Palais de Justice
(1493–1508)
Rouen, France

Milan Cathedral
(1387–1572)
Milan, Italy

Strasbourg Cathedral
(begun 1277)
Alsace, France

Hall of Supreme Harmony
(15th c.)
Forbidden City, Beijing, China

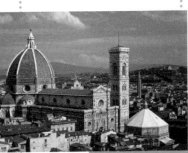

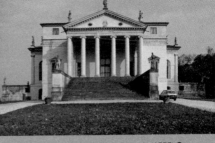

Duomo de S. Maria del Fiore
(1377–1436)
Florence, Italy
Filippo Brunelleschi

Villa La Rotonda (1557)
Vicenza, Italy
Andrea Palladio

Renaissance
(1350–1600)

Laurentian Library
(1524)
San Lorenzo, Italy
Michelangelo

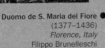

Façade of S. Maria Novella (1458)
Florence, Italy
Leon Battista Alberti

Palazzo Rucelai (1455–70)
Florence, Italy
Leon Battista Alberti

S. Giorgio Maggiore (1566)
Venice, Italy
Andrea Palladio

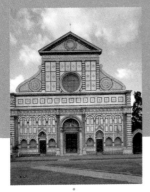

Tempietto of S. Pietro in Montorio
(1502)
Rome, Italy
Donato Bramante

PREMODERN

Façade of S. Susanna
(1603)
Rome, Italy
Carlo Maderno

Colonnade Piazza of St. Peter's
(1656)
Rome, Italy
Gianlorenzo Bernini

Karlskirche (b. 1656)
Vienna, Austria
Johann Fischer van Erlach

● **S. Carlo alle Quattro Fontane** (b. 1634) *Rome, Italy*
Francesco Borromini

Baroque
(1600–1700)

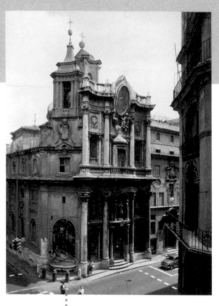

Renaissance
(1350–1600)

Taj Mahal
(1630–53)
Agra, India
Emperor
Shah Jahan

Chiswick Ho
(1725–29)
London, Eng
Lord Burling

Wollaton Hall
(1580–88)
*Nottinghamshire,
England*
Robert Smythson

Spanish Steps
(1723–25)
Rome, Italy
Francesco
de Sanctis

1750

1800

1850

"Panopticon" (1791)
Jeremy Bentham

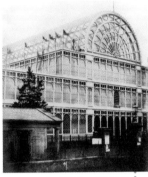

Art Nouveau
(1880–1902)

Tassel House (1893)
Brussels, Belgium
Victor Horta

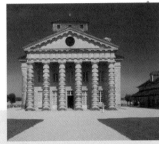

Bibliothèque Nationale
(1858–68)
Paris, France
Henri Labrouste

Crystal Palace (1851) ●
London, England
Joseph Paxton

Salt Works (1780) ●
Chaux, France
Claude-Nicolas Ledoux

Schauspielhaus (1819–21)
Berlin, Germany
Karl Friedrich Schinkel

Neoclassicism

(1750–1880)

University of Virginia (1826)
Charlottesville, Va., USA
Thomas Jefferson

Monticello (1771–82)
Charlottesville, Va., USA
Thomas Jefferson

Boston Public Library (1887–95)
Boston, Mass., USA
McKim, Mead & White

Panthéon (1764–90)
Paris, France
Jacques Germain Soufflot

Houses of Parliament ●
(1836–68)
London, England
Charles Barry

Marshall Field Wholesale Store ●
(1885–87) *Chicago, Ill., USA*
H. H. Richardson

Georgian
(1714–1830)

● Bank of England
(1788)
London, England
John Soane

Rococo
(1700–80)

1900

1920

1940

MODERN

Art Nouveau
(1880–1902)

German Pavilion (Barcelona Pavilion) ●
(1928; demolished 1930, rebuilt 1959)
Barcelona, Spain
Ludwig
Mies van der Rohe

Casa Milà (1906–10)
Barcelona, Spain
Antoni Gaudí

Eames House (1945) ○
Pacific Palisades, Calif., USA
Charles & Ray Eames

International Style Exhibition, MoMA
(1929) *New York, N.Y., USA*

Modernism
(1900–45)

Villa Savoye (1929)
Poissy, France
Le Corbusier

Goldman & Salatsch Store ○
(1910)
Vienna, Austria
Adolf Loos

Einstein Tower (1921) ●
Potsdam, Germany
Erich Mendelsohn

● **Falling Water** (1937)
Mill Run, Pa., USA
Frank Lloyd Wright

Ward Willits House (1902)
Highland Park, Ill. USA
Frank Lloyd Wright

Bauhaus (1925) ●
Dessau, Germany
Walter Gropius

● **Red House** (1859–60)
Bexleyheath, England
Philip Speakman Webb

Arts & Crafts
(1860–1925)

Art Deco
(1920s–40s)

○ **Empire State Building** (1930)
New York, N.Y., USA
Shreve, Lamb & Harmon

○ **Exposition Internationale des Arts Décoratifs et Industriels Modernes**
(1925) *Paris, France*

1960

1980

2000

Brutalism
(1950s–70s)

Hunstanton School (1954)
Norfolk, England
Alison & Peter Smithson

Palazzetto dello Sport
(1960)
Rome, Italy
Pier Luigi Nervi

ate
Modernism
(1945–1975)

Kimbell Art Museum (1967–72)
Fort Worth, Tex., USA
Louis I. Kahn

TWA Terminal (1962)
New York, N.Y., USA
Eero Saarinen

Carpenter Center (1964)
Cambridge, Mass., USA
Le Corbusier

House III (1969–70)
Lakeville, Conn., USA
Peter Eisenman

Glass House (1949)
New Canaan, Conn., USA
Philip Johnson

Seattle Public Library (2004)
Seattle, Wash., USA
Rem Koolhaas (OMA)

Addition to the Louvre (1983–89)
Paris, France
I. M. Pei

Centre Pompidou (1976)
Paris, France
Renzo Piano & Richard Rogers

Deconstructivism
(1980-88)

Parc de la Villette (1982–85)
Paris, France
Bernard Tschumi

**Wexner Center
for the Arts** (1989)
Columbus, Ohio, USA
Peter Eisenman

Gehry House (1977–78)
Santa Monica, Calif., USA
Frank Gehry

Postmodernism
(1960s–90s)

Portland Building (1982)
Portland, Ore., USA
Michael Graves

AT&T Building (1978)
New York, N.Y., USA
Philip Johnson & John Burgee

Vanna Venturi House (1964)
Chestnut Hill, Pa., USA
Robert Venturi

Chapter 28: Architectural Elements

CLASSICAL ELEMENTS

Classical architecture typically refers to the styles of both ancient Greece and Rome, which are based around the fixed columnar proportions and ornamentation of the classical orders. Both Greek and Roman classicism have been the bases of revivals throughout history, and the ideals behind their form and proportion continue to have resonance today.

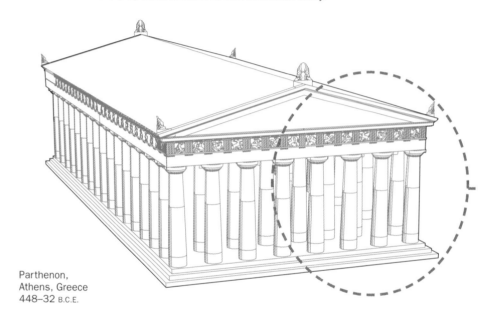

Parthenon,
Athens, Greece
448–32 B.C.E.

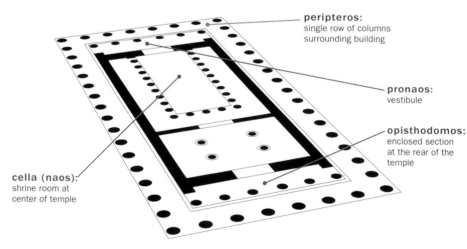

peripteros:
single row of columns
surrounding building

pronaos:
vestibule

opisthodomos:
enclosed section
at the rear of the
temple

cella (naos):
shrine room at
center of temple

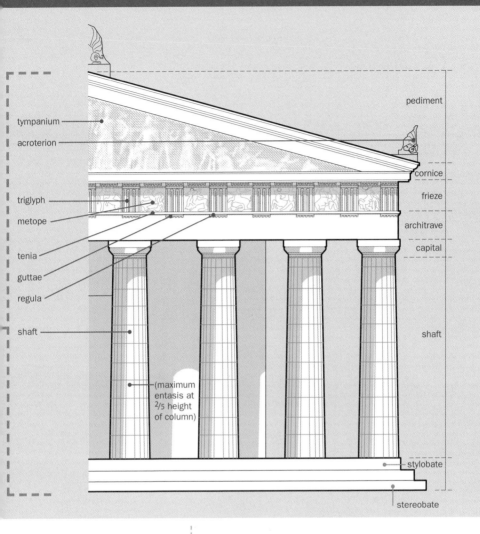

pediment

tympanium

acroterion

cornice

frieze

triglyph

metope

architrave

capital

tenia

guttae

regula

shaft

shaft

(maximum
entasis at
2/5 height
of column)

stylobate

stereobate

Entasis: Slight convex curvature of classical columns, used to counteract the optical illusion of concavity produced by straight lines. Other adjustments, such as reclining the columns slightly away from the vertical and making the end columns larger and closer together, also produce a more pleasing visual effect.

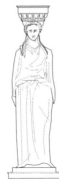

Caryatid: Sculpted female figure used as a column to support an entablature. Other forms include atlantes or telamones (male caryatids), canephorae (females with baskets on their heads), herms (three-quarter-height figures), and terms (pedestals that taper upward, terminating in a sculptured human or animal).

CLASSICAL ORDERS

Elements of the classical orders are distinguished by their unique proportioning system based on the shaft diameter of the columns, from which pedestal, shaft, and entablature heights are derived. Using a common shaft diameter, the five orders are shown here in their proportional relationship to each other.

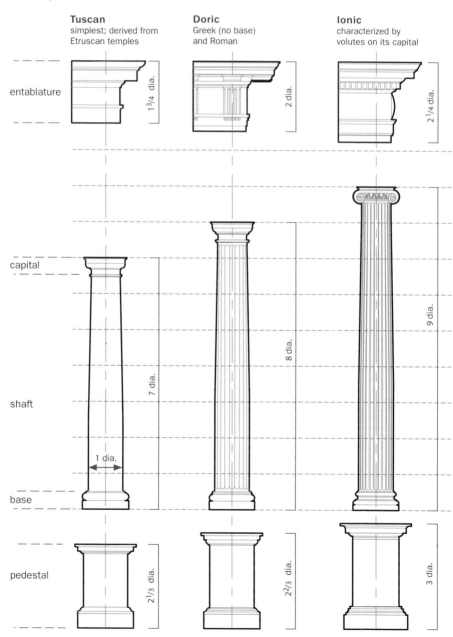

Tuscan
simplest; derived from
Etruscan temples

Doric
Greek (no base)
and Roman

Ionic
characterized by
volutes on its capital

entablature

capital

shaft

base

pedestal

Corinthian
Greek and Roman,
fluted or not;
characterized by
acanthus leaves
on its capital

Composite
Roman combination
of Ionic and Corinthian
orders

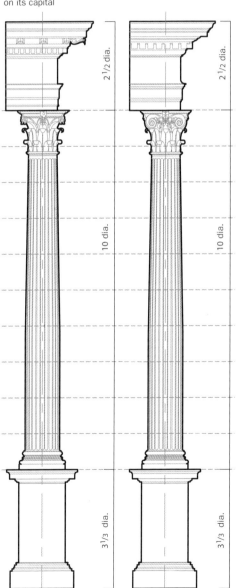

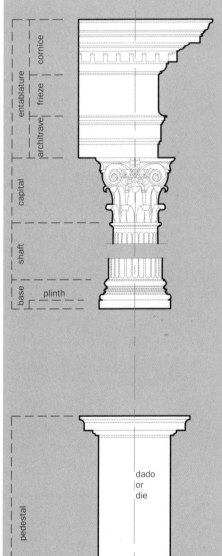

2 1/2 dia.

2 1/2 dia.

10 dia.

10 dia.

3 1/3 dia.

3 1/3 dia.

entablature — cornice, frieze, architrave

capital

shaft

base — plinth

pedestal

dado or die

plinth

GOTHIC ELEMENTS

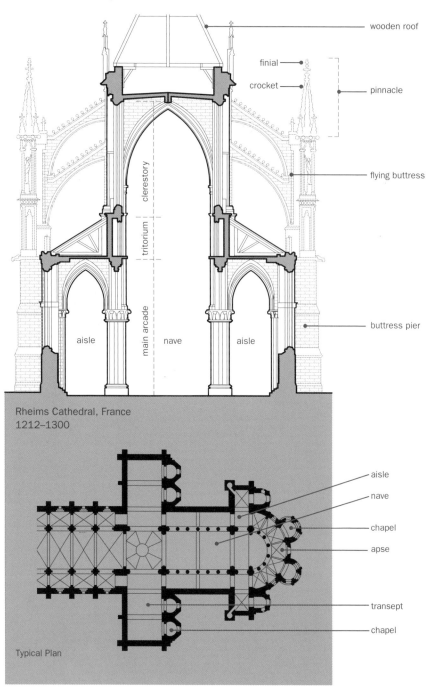

wooden roof

finial

crocket

pinnacle

flying buttress

clerestory

tritorium

main arcade

buttress pier

aisle

nave

aisle

Rheims Cathedral, France
1212–1300

aisle

nave

chapel

apse

transept

chapel

Typical Plan

ARCHES

1	abutment
2	voussoirs
3	keystone
4	intrados (soffit)
5	extrados
6	crown
7	haunch
8	span
9	springing line
10	center

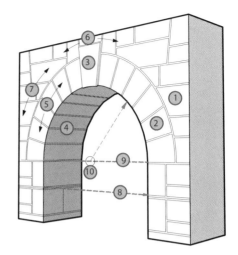

Semicircular

Semicircular Stilted

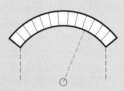

Segmental

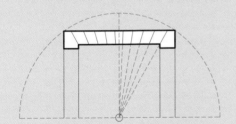

Jack

Pointed Saracenic
(Gothic)

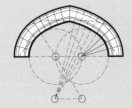

Tudor (Four-centered)

Ogee

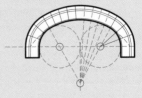

Three-centered

MODERNISM

Architectural modernism opposed following the forms and styles of the past in favor of embracing contemporary technology and opportunities. Industrialization and innovative methods of using iron, steel, and concrete for structural systems opened up new and flexible ways to design buildings that no longer depended on heavy masonry bearing walls. Swiss architect Le Corbusier developed the Dom-ino House system (1914), in which he separated building structure from enclosure, freeing up both plan and façade.

Le Corbusier's five points are supports (pilotis), roof gardens, free plans, horizontal windows, and free design of the façade. His 1929 Villa Savoye (which he dubbed a "machine for living") in Poissy, France, illustrates all five points clearly.

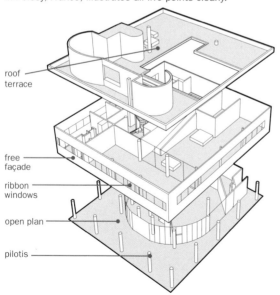

roof terrace

free façade

ribbon windows

open plan

pilotis

GENERAL

Roof Forms

Flat

Pitched

Gambrel

Gambrel

Hip

Hip Gable

Shed

Butterfly

Mansard

Barrel Vault

Pyramidal

Sawtooth

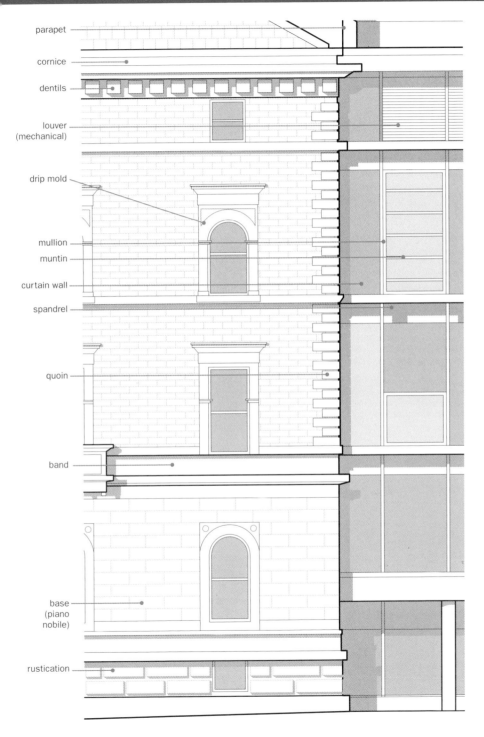

parapet

cornice

dentils

louver
(mechanical)

drip mold

mullion

muntin

curtain wall

spandrel

quoin

band

base
(piano
nobile)

rustication

Chapter 29: Glossary

AASM: Association of American Steel Manufacturers

AGCA: Associated General Contractors of America

AIA: American Institute of Architects

AISC: American Institute of Steel Construction.

AISI: American Iron and Steel Institute

ANSI: American National Standards Institute

APA: American Plywood Association

ASHRAE: American Society of Heating, Refrigerating, and Air Conditioning Engineers

ASTM: American Society for Testing and Materials

CSI: Construction Specifications Institute

IESNA: Illumination Engineering Society of North America

ICC: International Code Council

ICED: International Council on Environmental Design

ISO: International Organization for Standardization

LEED: Leadership in Energy & Environmental Design

NIBS: National Institute of Building Sciences

NFPA: National Fire Protection Association

RAIC: Royal Architecture Institute of Canada

RIBA: Royal Institute of British Architects

UIA: Union Internationale des Architectes

UL: Underwriters' Laboratory

A

Access flooring: Removable finish floor panels raised above the floor structure to allow installation of wiring and ductwork below.

Accessible: Capable of being reached by all persons, regardless of levels of disability.

Acoustical ceiling: System of fibrous removable tiles in the ceiling that absorb sound.

ADA: Americans with Disabilities Act

Adaptive reuse: Changing a building's function in response to the changing needs of its users.

AFF: Above finish floor.

Aggregate: Particles such as sand, gravel, and stone used in concrete and plaster.

Alloy: Substance made of two or more metals or a metal and another substance.

Anchor bolt: Concrete-embedded bolt that fastens a building frame to masonry or concrete.

Annealed: Metal cooled under controlled conditions.

Angle: L-shaped steel or aluminum structural section.

Arch: Structural device that supports vertical loads by translating them into axial forces.

Arcade: Series of arches on columns or piers.

Area: Quantity expressing the size of a figure in a plane or surface.

Atelier: Workshop or studio.

Atrium: Open-roofed entrance court of a Roman dwelling; also, a many-storied court in a building, usually skylit.

Axial: Force, load, tension, or compression in a direction parallel to the long axis of a structural member.

B

Ballast: In roofing, a heavy material such as crushed stone installed over a roof membrane to minimize wind uplift; in lighting, a device that provides starting voltage for a fluorescent or high-intensity discharge lamp, then regulates the current during operation.

Balloon frame: Wood-frame construction in which vertical studs run from the sill to the eave instead of resting on intermediate floors.

Baluster: Vertical member used to support a stair railing or a railing in a continuous banister.

Balustrade: Railing system, usually around a balcony, that consists of balusters and a top rail.

Band/banding: Continuous horizontal division on a wall created by different materials, colors, or textures.

Bar: Small rolled steel shape

Bar joist: Truss type used for floor and roof support, with steel members on top and bottom and heavy wire or rod web lacing.

Base plate: Steel plate between a column and foundation that distributes the column's load to the foundation.

Bay: Rectangular area of a building defined at its four corners by adjacent columns; projecting portion of a façade.

Beam: Horizontal linear element that spans an opening and is supported at both ends by walls or columns.

Bearing wall: Wall that supports floors or roofs.

Bed joint: Horizontal layer of mortar between units in a masonry wall.

Bending moment: Force acting on a structure, causing it to curve.

Blocking: Pieces of wood placed between joists, studs, or rafters to stabilize the structure or provide a nailing surface for finishes.

Blueprint: Photographic print on specially coated paper; ideal for making precise and undistorted copies of large-scale drawings. Blueprint technology is rapidly being superseded by computer plotters and printers.

Board foot: Unit of measuring lumber volume (nominally: 144 cu. in.).

Bond beam: Top course of a masonry wall, filled with concrete and reinforcing steel, and used to support roof loads.

Brise-soleil: Shading screen attached to the exterior of a building.

Building code: Legal restrictions meant to enforce safety and health in the built environment.

Built-up roof: Roof membrane composed of asphalt-saturated felt layers laminated together and bonded with bitumen or pitch.

Buttress: Masonry or concrete reinforcement applied to a wall to resist diagonal forces from an arch or vault.

C

CAD: Computer-aided drafting.

Caisson: Long cylindrical foundation element formed by drilling deep into firm clay and pouring concrete into the hole.

Canopy: Projection over doors or windows.

Cantilever: Beam or slab extending beyond its last point of support.

Capital: Uppermost element of a column.

Cavity wall: Masonry wall with a continuous airspace between wythes.

Cement: Dry powder that combines chemically with water and bonds aggregate particles together to form concrete. Also known as portland cement.

Change order: Written document between the owner and contractor of a project authorizing a change in the project.

Chase wall: Cavity wall containing electrical runs or plumbing pipes in its cavity.

Chord: Structural member of a truss.

Clear floor space: Minimum unobstructed floor or ground space required to accommodate a single, stationary wheelchair and occupant.

Clerestory: Windows placed high in a wall, usually above lower roof levels. Also called clearstory.

Coefficient of expansion: Fractional change in length, area, or volume or an object per unit change in temperature at a given constant pressure.

Cold rolling: Rolling of metal at room temperature and stretching its crystals to harden the metal.

Colonnade: Linear series of columns carrying an entablature or arches.

Column: Upright structural member.

Concrete: Mix of cement, aggregates, and water that forms a structural material.

Concrete masonry unit (CMU): Solid or hollow block of cured concrete.

Coping: Protective cap or cover on top of a wall to throw off water.

Corbel: Series of spanning stones or bricks in which each successive course projects over the course below it; also, a projecting masonry or concrete bracket.

Cornice: Projecting molding at the top of a building; also, the uppermost element of an entablature.

Course: Horizontal layer of one-unit-high masonry units.

Cricket: Component used to divert water away from roof curbs, platforms, chimneys, walls, or other roof forms.

Cripple stud: Short wood framing member in walls interrupted by a header or sill.

Cupola: Domed roof structure rising from a building.

Curtain wall: Non-load-bearing exterior wall system supported on the building's frame.

D

Deck: Horizontal surface spanning across joists or beams.

Deflection: Under an applied load, the amount of bending movement of any part of a structural member perpendicular to that member's axis.

Deliverables: Set of items such as construction documents provided by the architect to the client, and as agreed on in the owner-architect agreement.

Detail: Drawing that provides very specific information about the materials and construction of a component of a project and that is keyed into larger-scale drawings.

Dimensional stability: Ability of a section of wood to resist changes in volume at fluctuating moisture levels.

Dome: Bowl-shaped volume created by rotating an arch about its vertical axis.

Dormer: Protrusion in a sloping roof, usually containing a window.

Duct: Hollow conduit for circulating and directing air.

DWG: Computer drawing file.

E

Eave: Edge of a roof plane, usually projecting over the exterior wall.

Egress: Means of exiting safely.

Elevation: Architectural drawing of a view of the vertical planes of the building, showing their relationship to each other.

Encroachment: Portion of a building that extends illegally beyond the property owned and onto another property.

Energy efficiency: Reducing energy requirements without reducing the end result.

Engaged column: Non-free-standing column attached to a wall.

Entablature: Uppermost part of a classical order, comprised of architrave, frieze, and cornice and supported on a colonnade.

Expansion joint: Surface divider joint allowing for surface expansion.

F

Façade: Face or elevation of a building.

Fascia: Exposed vertical face of an eave.

Fenestration: Windows and window arrangements on a façade.

Finial: Ornament at the top of a spire or roof.

Fire-resistance rating: Determination of the amount of time (in fractions of an hour) that an assembly or material will resist fire.

Flashing: Continuous sheet of thin metal, plastic, or other waterproof material used to divert water and prevent it from passing through a joint into a wall or roof.

Float glass: Common plate glass made by floating the material on a bed of molten metal, producing a smooth, flat surface.

Footing: Widened base of a foundation that spreads a building's loads across the soil.

Foundation: Lowest portion of a building that transfers the building's structural loads into the earth.

G

Galvanic action: Corrosion resulting from an electrical current between two unlike metals.

Girder: Large horizontal beam that supports other beams.

Girt: Horizontal beam that supports wall cladding between columns.

Golden section: Unique proportional ratio of two divisions of a line such that the smaller of the two is to the larger as the larger is to the sum of the two.

Grab bar: Bar attached parallel to a wall to provide a handgrip for steadying oneself.

Grade: Classification of size or quality; the surface of the ground; the act of moving earth to make the ground level.

Guardrail: Protective railing to prevent falling into stair-wells or other openings.

Gusset plate: Flat steel plate to which truss chords are connected at a truss joint.

Gypsum wallboard (GWB): Interior facing board with a gypsum core between paper facing. Also called drywall and plasterboard.

H

Half-timbered: Timber wall with the spaces between filled with masonry.

Handrail: Railing running parallel to the rise of a stairway or ramp, providing a continuous gripping surface.

Hard metric: Conversion of component sizes to fall within a rational metric module, not a strict translation of other units into their exact metric equivalents.

Hardwood: Wood from deciduous trees.

Head joint: Vertical layer of mortar between units in a masonry wall.

Header: Lintel; in steel, a beam that spans between girders; also, masonry unit laid across two wythes, exposing its end in the face of the wall.

Heavy timber: Structural lumber having a minimum width and thickness of 5″(127).

Hot-rolled steel: Steel formed and shaped by being heated and passed through rollers.

HSLA: High-strength low-alloy grade of steel.

HUD: Housing and Urban Development.

HVAC: Heating, Ventilating, and Air-Conditioning.

I

IBC: International Building Code.

I-beam: Obsolete term for American Standard steel section that is I- or H-shaped.

Insulation: Any material that slows or retards the flow or transfer of heat.

J

Jamb: Vertical frame of a window or door.

Joists: Light, closely spaced beams supporting floors or flat roofs.

K

Keystone: Central wedge-shaped stone at the top of an arch.

L

Laminate: Material produced through bonding together layers of other materials.

Lintel: Beam over a door or window opening that carries the load of the wall above.

Lite: Pane of glass; also "light," though often spelled differently to avoid confusion with visible light.

Loads: Forces acting on a structure. Dead loads are fixed and static elements such as the building's own skin, structure, and equipment; live loads are the changing weight on a building and include people, snow, vehicles, and furniture.

Longitudinal: Lengthwise.

Louver: Opening with horizontal slats that permit passage of air, but not rain, sunlight, or view.

M

Masonry: Brickwork, block-work, and stonework; also, the trade of a mason.

Metrication: Act of changing from the use of customary units to metric units.

Mezzanine: Intermediate level between a floor and ceiling that occupies a partial area of the floor space.

Mild steel: Steel with a low carbon content.

Millwork: Interior wood finish components of a building, including cabinetry, windows, doors, moldings, and stairs.

Model: Physical representation (usually at a reduced scale) of a building or building component; in computer drafting and modeling, it is the digital two- or three-dimensional representation of a design.

Molding: Strip of wood, plaster, or other material with an ornamental profile.

Mortar: Material composed of portland cement, hydrated lime, fine aggregate (sand), and water, used to adhere together and cushion masonry units.

Mullion: Horizontal or vertical bar or divider in the frames of windows, doors, or other openings, and that holds and supports panels, glass, sashes, or sections of a curtain wall.

Muntin: Secondary system of horizontal or vertical divider bars between small lites of glass or panels in a sash.

Mylar: Polyester film that, when coated, can be used as drafting sheets.

N

Niche: Recess in a wall, usually for holding a sculpture.

Nominal: Approximate rounded dimensions given to materials for ease of reference.

O

Occupancy: Category of the use of a building for determining specific code requirements.

Ogee: Profile section with a reverse-curve face (that is, concave above and convex below).

Overhang: Projection beyond the face of a wall below.

P

Parametric: Having one or more variables (parameters) that can be altered to achieve different results. In parametric modeling, a database tracks changes to all elements of a design simultaneously.

Parapet: Low wall projecting from the edge of a platform, usually on a roof.

Parti: Central idea governing and organizing a work of architecture.

Partition: Interior non-load-bearing wall.

Passive solar: Technology of heating and cooling a building naturally, through the use of energy-efficient materials and proper site placement.

Pediment: Triangular space that forms the gable end of a low-pitched roof, often filled with relief sculpture.

Pendentive: Curved, triangular support that results from transforming a square bay into a dome.

Penthouse: Enclosed space above the level of the main roof used for mechanical equipment; an above-roof apartment.

Peristyle: Colonnaded courtyard.

Pier: Caisson foundation; also, a structural element that supports an arch.

Pilaster: Pier engaged in a wall.

Pillar: Columnar support that is not a classical column.

Pilotis: Columns or pillars that lift a building from the ground.

Pitch: Slope of a roof or other inclined surface, usually expressed as inches of rise per foot of run (X:12, when X is a number between 1 and 12).

Plan: Architectural drawing of a view of the horizontal planes of the building, showing their relationship to each other, and acting as a horizontal section.

Plenum: Space between a suspended ceiling and the structure above, used for mechanical ductwork, piping, and wiring.

Pointing: Process of applying mortar to the outside surface of a mortar joint after laying the masonry, as a means of finishing the joint or making repairs to an existing joint.

Portico: Entrance porch.

Precast concrete: Concrete that is cast and cured in a location other than its final position.

Prefabricated building: Buildings consisting of components such as walls, floors, and roofs that are built off-site (often in a factory), then shipped to the site for assembly.

Purlin: Beams spanning across the slope of a roof that support the roof decking.

Q

Quoin: Corner stones in a wall made distinct from the surrounding wall by being larger, of a different texture, or having deeper joints to make the stones protrude.

R

Rabbet: Notch in wood for joining pieces or recessed parts in a typical door frame.

Rafter: Roof framing member that runs in the direction of slope.

Reflected ceiling plan: Upside-down plan drawing that documents the ceiling plane.

Retaining wall: Site wall built for resisting lateral displacement of soil, water, or other material.

RFP (Request for Proposal): Official invitation for architects to submit qualifications and proposals to perform a project.

Rib: Fold or bend in a sheet of deck.

Ridge: Horizontal line created at the connection of two sloping roof surfaces.

Rise: Vertical difference in elevation, as in the rise of a stair.

Riser: Vertical face between two treads of a stair; also, vertical run of plumbing, ductwork, or wiring.

Room cavity ratio: Ratio of room dimensions used to determine how light will interact with the room's surfaces.

Rotunda: Space that is circular in plan and covered by a dome.

Run: Horizontal dimension of a stair, ramp, or other slope.

Rustication: Masonry pattern consisting of large blocks with deep joints.

R-value: Measure of the capacity of a material to resist the transfer of heat.

S

Schedule: Chart or table in a set of architectural drawings, including data about materials, finishes, equipment, windows, doors, and signage; also, plan for performing work.

Scope of work: Written range of view or action for a specific project.

Section: Architectural drawing of a view of a vertical cut through the building's components, acting as a vertical plan.

Shaft: Trunk of a column between base and capital; also, enclosed vertical clear opening in a building for the passage of elevators, stairs, ductwork, plumbing, or wiring.

Sheetrock: Brand name for gypsum wallboard, often incorrectly used to describe any gypsum board or drywall.

SI: Système International d'Unités (metric system).

Sitecast: Concrete that is poured and cured in its final position; also called cast-in-place or poured-in-place.

Slab on grade: Concrete slab that rests directly on the ground.

Soffit: Finished underside of a lintel, arch, or overhang.

Soft metric: Precise conversion between customary and metric units.

Softwood: Lumber from coniferous (evergreen) trees.

Spall: Splitting off from a surface, in concrete or masonry, as a result of weathering.

Span: Distance between supports.

Spandrel: Exterior panels of a wall between vision areas of windows that conceal structural floors; the triangular space between the curve of an arch and the rectangular outline enclosing it.

Specifications: Written instructions about the materials and means of construction for a building, and included as part of the construction document set.

STC: Sound Transmission Class, a number rating of airborne sound transmission loss as measured in an acoustical laboratory under carefully controlled test conditions.

Stile: Framing member in a door.

Stringer: In a stair, the sloping wood or steel member that supports the treads.

Sustainable design: Environmentally aware design using systems that meet present needs without compromising the needs of future generations.

T

Thermal performance: Ability of a glass unit to perform as a barrier to the transfer of heat.

Transom: Opening above a door or window that may be filled with a glazed or solid operable panel.

Transverse: Crosswise.

Tread: Horizontal surface between two risers of a stair.

Trompe-l'oeil: Two-dimensional painting or decoration made to look three-dimensional; literally, "trick the eye."

Truss: Structural element made up of a triangular arrangement of members that transforms the nonaxial forces acting on it into a set of axial forces on the truss members.

U

Undressed lumber: Lumber that is not planed.

V

Valley: Trough formed at the intersection of two sloping roofs.

Value engineering: Analyzing the materials and processes in a project in an effort to achieve the desired function at the lowest overall cost.

Vault: Arched form.

Veneer: Thin layer, sheet, or facing.

Vernacular: Structures built with indigenous materials, methods, and traditions.

W

Waler: Horizontal support beam used in concrete formwork.

Winder: L-shaped staircase that used wedge-shaped treads to turn a 90-degree corner.

Wythe: One-unit-thick vertical layer of masonry.

Z

Ziggurat: Stepped-back pyramid temple.

Chapter 30: Resources

The contents of this book offer a quick-reference reflection of numerous sources of information on architectural design and construction—the tip of a formidable iceberg. Any reader wishing to find out more on a specific topic is advised to consult the listing of sources that follow, which is itself an abridged acknowledgment of a wealth of available information. Many of these sources can be found in a well-stocked architecture firm's in-office library, in the libraries of most schools of architecture, and even in some local libraries. Websites have quickly established themselves as excellent resources for (usually) free information on many subjects, and are especially invaluable for exploring the offerings of product manufacturers or trade-related information. It should be noted, however, that Web-based content and addresses are always subject to change.

Architecture and Design Professions

JOURNALS & PERIODICALS

Architecture (monthly, USA); www.architecturemag.com

Architectural Record (monthly, USA); www.archrecord.com

Architectural Review (monthly, UK); www.arplus.com

Arquitectura Viva (bimonthly, Spain); www.arquitecturaviva.com

a+u (Architecture and Urbanism) (monthly, Japan); www.japan-architect.co.jp

Casabella (monthly, Italy)

Detail (bimonthly, Germany); www.detail.de

El Croquis (five times yearly, Spain); www.elcroquis.es

JA (Japan Architect) (quarterly, Japan); www. japanarchitect.co.jp

Lotus International (quarterly, Italy); www.editorialelotus.it

Metropolis Magazine (monthly, USA); www.metropolismag.com

WEBSITES

www.archinect.com

www.archinform.net

www.architectureweek.com

www.archinform.net

General Standards

Architectural Graphic Standards, 10th ed.
Charles George Ramsey, Harold Sleeper, and John Hoke; John Wiley & Sons, 2000
The CD-ROM, version 3.0., is also available.

Neufert Architects' Data, 3rd ed.
Blackwell Publishers, 2000

Fundamentals of Building Construction: Materials and Methods, 4th ed.
Edward Allen and Joseph Iano; John Wiley & Sons, 2003

Understanding Buildings: A Multidisciplinary Approach
Esmond Reid; MIT Press, 1994

Building Construction Illustrated
Francis D. K. Ching and Cassandra Adams; John Wiley & Sons, 1991

Skins for Buildings: The Architect's Materials Sample Book
David Keuning et al.; Gingko Press, 2004

Anual Book of ASTM Standards
American Society for Testing Materials, 2005
Seventy-plus volumes contain more than 12,000 standards available in print, CD-ROM, and online formats.

01 Measurements

Measure for Measure
Thomas J. Glover and Richard A. Young; Sequoia Publishing, 2001

Metric Handbook Planning & Design, 2nd ed.
David Adler, ed.; Architectural Press, 1999

www.onlineconversion.com

www.worldwidemetric.com

www.metrication.com

02 Basic Geometry and Drawing Projections

Pocket Ref, 3rd ed.
Thomas J. Glover; Sequoia Publishing, 2001

Basic Perspective Drawing: A Visual Approach, 4th ed.
John Montague; John Wiley & Sons, 2004

02 Basic Geometry and Drawing Projections

Graphics for Architecture
Kevin Forseth with David Vaughan; Van Nostrand Reinhold, 1980

Basic Perspective Drawing: A Visual Approach, 4th ed.
John Montague; John Wiley & Sons, 2004

03 Architectural Drawing Types

Design Drawing
Francis D. K. Ching and Steven P. Juroszek; John Wiley & Sons, 1997

04 Project Management and Architectural Documents

The Architect's Handbook of Professional Practice, 13th ed.
Joseph A. Demkin, ed.; American Institute of Architects, 2005

www.uia-architectes.org

www.aia.org

www.iso.org

www.constructionplace.com

www.dcd.com (Design Cost Data)

05 Specifications

MasterSpec Master Specification System for Design Professionals and the Building/Construction Industry
ARCOM, ongoing; www.arcomnet.com

Construction Specifications Portable Handbook
Fred A. Stitt; McGraw-Hill Professional, 1999

The Project Resource Manual–CSI Manual of Practice
Construction Specifications Institute and McGraw-Hill Construction, 2004

www.csinet.org (Construction Specifications Institute)

06 Hand Drafting

Architectural Drawing: A Visual Compendium of Types and Methods, 2nd ed.
Rendow Yee; John Wiley & Sons, 2002

Architectural Graphics, 4th ed.
Francis D. K. Ching; John Wiley & Sons, 2002

07 Computer Standards and Guidelines

U.S. National CAD Standard, version 3.1
2004; www.nationalcadstandard.org

AutoCAD User's Guide
Autodesk, 2001

AutoCad 2006 Instructor
James A. Leach; McGraw-Hill, 2005

www.nibs.org (National Institute of Building Sciences)

www.pcmag.com

08 The Human Scale

The Measure of Man and Woman: Human Factors in Design, rev. ed.
Alvin R. Tilley; John Wiley & Sons, 2002

Human Scale, vol. 7: Standing and Sitting at Work, vol. 8: Space Planning for the Individual and the Public, and vol. 9: Access for Maintenance, Stairs, Light, and Color
Niels Diffrient, Alvin R. Tilley, and Joan Bardagjy; MIT Press, 1982
Both above-cited books draw on information produced by Henry Dreyfuss Associates, a leading firm in the development of anthropometric data and its relationship to design.

09 Form and Organization

Architecture: Form, Space and Order, 2nd ed.
Francis D. K. Ching; John Wiley & Sons, 1995

Harmonic Proportion and Form in Nature, Art and Architecture
Samuel Colman; Dover Publications, 2003

10 Residential Spaces

In Detail : Single Family Housing
Christian Schittich; Birkhäuser, 2000

Dwell Magazine (bimonthly, USA); www.dwellmag.com

www.residentialarchitect.com

www.nkba.com (National Kitchen & Bath Association)

11 Public Spaces

Time-Saver Standards for Interior Design and Space Planning, 2nd ed.
Joseph De Chiara, Julius Panero, and Martin Zelnik; McGraw-Hill Professional, 2001

The Architects' Handbook
Quentin Pickard, ed.; Blackwell Publishing, 2002

In Detail: Interior Spaces: Space, Light, Material
Christian Schittich, ed.; Basel, 2002

12 Parking

Parking Structures: Planning, Design, Construction, Maintenance & Repair, 3rd ed.
Anthony P. Chrest et al.; Springer, 2001

The Dimensions of Parking
Urban Land Institute and National Parking Association, 2000

The Aesthetics of Parking: An Illustrated Guide
Thomas P. Smith; American Planning Institute, 1988

Parking Spaces
Mark Childs; McGraw-Hill, 1999

www.apai.net (Asphalt Paving Association of Iowa – Design Guide)

www.bts.gov (Bureau of Transportation Services)

13 Building Codes

2003 International Building Codes
International Code Council, 2003
The complete collection is available in book or CD-ROM format at www.iccsafe.org.

Building Codes Illustrated: A Guide to Understanding the International Building Code
Francis D. K. Ching and Steven R. Winkel; John Wiley & Sons, 2003

Code Check series
Redwood Kardon, Michael Casey, and Douglas Hansen; The Taunton Press, ongoing
This series is available at www.codecheck.com.

Illustrated 2000: Building Code Handbook
Terry L. Patterson; McGraw-Hill Professional, 2000

14 ADA and Accessibility

ADA Standards for Accessible Design
U.S. Department of Justice
www.usdoj.org/crt/ada; 1-800-514-0301 (voice) or 1-800-514-0383 (TDD).

ADA and Accessibility: Let's Get Practical, 2nd ed.
Michele S. Ohmes; American Public Works Association, 2003

Guide to ADA & Accessibility Regulations: Complying with Federal Rules and Model Building Code Requirements
Ron Burton, Robert J. Brown, and Lawrence G. Perry; BOMA International, 2003

Pocket Guide to the ADA: Americans with Disabilities Act Accessibility Guidelines for Buildings and Facilities, 2nd ed.
Evan Terry Associates; John Wiley & Sons, 1997

www.signs.org

15 Sustainable Design

Sustainable Architecture White Papers (Earth Pledge Foundation Series on Sustainable Development)
David E. Brown, Mindy Fox, Mary Rickel Pelletier, eds.; Earth Pledge Foundation, 2001

Cradle to Cradle: Remaking the Way We Make Things
William McDonough and Michael Braungart; North Point Press, 2002

www.greenbuildingpages.com

www.buildinggreen.com (Environmental Building News)

www.usgbc.org (U.S. Green Building Council)

16 Structural Systems

LRFD (Load and Resistance Factor Design) Manual of Steel Construction, 3rd ed.
American Institute of Steel Construction, 2001; www.aisc.org

Steel Construction Manual
Helmut Schulitz, Werner Sobek, and Karl J. Habermann; Birkhäuser, 2000

Structural Steel Designer's Handbook
Roger L Brockenbrough and Frederick S. Merritt; McGraw-Hill Professional, 1999

Steel Designers' Manual
Buick Davison and Graham W. Owens, eds.; Steel Construction Institute (UK).

Graphic Guide to Frame Construction: Details for Builders and Designers
Rob Thallon; Taunton Press, 2000

www.key-to-steel.com

www.awc.org (American Wood Council)

17 Mechanical Issues

Mechanical and Electrical Systems in Construction and Architecture, 4th ed.
Frank Dagostino and Joseph B. Wujek; Prentice Hall, 2004

Mechanical and Electrical Equipment for Buildings, 9th ed.
Ben Stein and John S. Reynolds; John Wiley & Sons, 1999

Mechanical Systems for Architects
Aly S. Dadras; McGraw-Hill, 1995

www.homerepair.about.com

www.efftec.com

www.saflex.com

18 Lighting

Lighting Handbook Reference, 9th ed.
Mark S. Rea, ed.; IESNA, 2000

Lighting the Landscape
Roger Narboni; Birkhäuser, 2004

1000 Lights, vol. 2: 1960 to Present
Charlotte and Peter Fiell; Taschen, 2005

www.archlighting.com

www.iesna.org (Illuminating Engineering Society of North America)

www.iald.org (International Association of Lighting Designers)

19 Stairs

Stairs: Design and Construction
Karl J. Habermann; Birkhäuser, 2003

Staircases
Eva Jiricna; Watson-Guptill Publications, 2001

Stairs: Scale
Silvio San Pietro and Paola Gallo; IPS, 2002

20 Doors

Construction of Buildings: Windows, Doors, Fires, Stairs, Finishes
R. Barry; Blackwell Science, 1992

21 Windows and Glazing

Glass Construction Manual
Christian Schittich et al.; Birkhäuser, 1999

Detail Praxis: Translucent Materials—Glass, Plastic, Metals
Frank Kaltenbach, ed.; Birkhäuser, 2004

www.GlassOnWeb.com (glass design guide)

www.glass.org (National Glass Association)

22 Wood

Laminated Timber Construction
Christian Müller; Birkhäuser, 2000

Wood Handbook: Wood as an Engineering Material
Forest Products Laboratory, U.S. Department of Agriculture

Timber Construction Manual
Thomas Herzog et al.; Birkhäuser, 2004

Detail Praxis: Timber Construction—Details, Products, Case Studies
Theodor Hughs et al.; Birkhäuser, 2004

AITC Timber Construction Manual, 5th ed.
American Institute of Timber Construction, 2004

AWI Quality Standards, 7th ed., 1999

www.awinet.org (Architectural Wood Institute)

www.lumberlocator.com

23 Masonry

Masonry Construction Manual
Günter Pfeifer et al.; Birkhäuser, 2001

Masonry Design and Detailing for Architects and Contractors, 5th ed.
Christine Beall; McGraw-Hill, 2004

Complete Construction: Masonry and Concrete
Christine Beall; McGraw-Hill

Design of Reinforced Masonry Structures
Narendra Taly; McGraw-Hill Professional, 2000

Reinforced Masonry Design
Robert R. Schneider; Prentice-Hall, 1980

Indiana Limestone Handbook, 21st ed.
Indiana Limestone Institute, 2002

www.bia.org (Brick Industry Association)

24 Concrete

Concrete Construction Manual
Friedbert Kind-Barkauskas et al.; Birkhäuser, 2002

Construction Manual: Concrete and Formwork
T. W. Love; Craftsman Book Company, 1973

Precast Concrete in Architecture
A. E. J. Morris; Whitney Library of Design, 1978

Concrete Architecture: Design and Construction
Burkhard Fröhlich; Birkhäuser, 2002

www.fhwa.dot.gov (Federal Highway Administration)

www.aci-int.org (American Concrete Institute)

25 Metals

SMACNA Architectural Sheet Metal Manual, 5th ed.
1993

Metal Architecture
Burkhard Fröhlich and Sonja Schulenburg, eds.; Birkhäuser, 2003

Steel and Beyond: New Strategies for Metals in Architecture
Annette LeCuyer; Birkhäuser, 2003

www.corrosion-doctors.org

www.engineersedge.com

26 Finishes

The Graphic Standards Guide to Architectural Finishes: Using MASTERSPEC to Evaluate, Select, and Specify Materials
Elena S. Garrison; John Wiley & Sons, 2002

Interior Graphic Standards
Maryrose McGowan and Kelsey Kruse; John Wiley & Sons, 2003

Detail Magazine—Architectural Details 2003
Detail Review of Architecture, 2004

Extreme Textiles: Designing for High Performance
Matilda McQuaid; Princeton Architectural Press, 2005

Sweets Catalog
McGraw-Hill Construction, ongoing; www.sweets.com

27 Timeline

History of Architecture on the Comparative Method: For Students, Craftsmen & Amateurs, 16th ed.
Sir Banister Fletcher; Charles Scribner's, 1958

Modern Architecture: A Critical History, 3rd ed.
Kenneth Frampton; Thames & Hudson, 1992

A World History of Architecture
Marian Moffett et al.; McGraw-Hill Professional, 2003

Source Book of American Architecture: 500 Notable Buildings from the 10th Century to the Present
G. E. Kidder Smith; Princeton Architectural Press, 1996

Architecture: From Prehistory to Postmodernism, 2nd ed.
Marvin Trachtenberg and Isabelle Hyman; Prentice-Hall, 2003

Encyclopedia of 20th-Century Architecture
V. M. Lampugnani, ed.; Thames and Hudson, 1986

28 Architectural Elements

A Visual Dictionary of Architecture
Francis D. K. Ching; John Wiley & Sons, 1996

De architectura (Ten Books on Architecture)
Marcus Vitruvius Pollio, ca. 40 B.C.

29 Glossary

The Penguin Dictionary of Architecture and Landscape Architecture, 5th ed.
John Fleming, Hugh Honour, and Nikolaus Pevsner; Penguin, 2000

Dictionary of Architecture, rev. ed.
Henry H. Saylor; John Wiley & Sons, 1994

Dictionary of Architecture and Construction, 3rd ed.
Cyril M. Harris; McGraw-Hill Professional, 2000

Means Illustrated Construction Dictionary
R. S. Means Company, 2000

Architectural and Building Trades Dictionary
R. E. Putnam and G. E. Carlson; American Technical Society, 1974

Index

PHOTOGRAPHY CREDITS

ACKNOWLEDGMENTS

Special thanks to Adam Balaban, Dan Dwyer, John McMorrough, Rick Smith, and Ron Witte.